MALINOWSKI'S KIRIWINA

MALINOWSKI'S KIRIWINA

Fieldwork Photography 1915–1918 ❧ *Michael W. Young*

THE

UNIVERSITY

OF CHICAGO

PRESS

CHICAGO AND

LONDON

MICHAEL W. YOUNG is senior fellow in the Department of Anthropology of the Research School of Pacific and Asian Studies at The Australian National University. He is author of *Fighting with Food* and *Magicians of Manumanua,* and he is currently writing a biography of Malinowski.

The University of Chicago Press, Chicago 60637
The University of Chicago Press, Ltd., London
© 1998 by The University of Chicago
All rights reserved. Published 1998
Printed in the United States of America
07 06 05 04 03 02 01 00 99 98 1 2 3 4 5

ISBN: 0-226-87650-0 (cloth)

Library of Congress Cataloging-in-Publication Data

Young, Michael W., 1937–
 Malinowski's Kiriwina : fieldwork photography 1915–1918 /
 Michael W. Young
 p. cm.
 Includes bibliographical references.
 ISBN 0-226-87650-0 (hardcover : alk. paper)
 1. Photography in ethnology—Papua New Guinea—Trobriand Islands—
History. 2. Malinowski, Bronislaw, 1884–1942—Contributions in
photography. 3. Ethnology—Papua New Guinea—Trobriand Islands—
Field work. 4. Trobriand Islanders—Portraits. 5. Trobriand Islands (Papua
New Guinea)—Social life and customs.
 I. Malinowski, Bronislaw, 1884–1942. II. Title.
 GN671.N5Y68 1998
 779'.99541—dc21 98-23064
 CIP

IN MEMORY OF DIGIMRINA KAWEYAMI OF OKEBOMA

AND CHARLES WILLIS YOUNG OF SALTDEAN

Contents

Maps

Acknowledgments

Several people deserve special thanks for their crucial assistance at various stages of the project which resulted in this book: Nicolas Lewis, whose keen photographer's eye helped me sort and select worthy images from Malinowski's cumbersome collection of photographs; Linus Digim'Rina, whose ethnographically informed comments enhance the captions and who enabled fellow Trobrianders to bring their local knowledge to bear upon the subject matter of the photographs; Patsy Asch, who gave technical advice and took time to explain to me some elementary principles of visual anthropology; Borut Telban, who offered invaluable advice on the first draft of the book; Helena Wayne, née Malinowska, who corrected the final draft with scrupulous care and checked the page references to her father's works; Elizabeth Brouwer, who also read the final draft and helped me assemble the complicated package for the Press; and Elizabeth Edwards, who, at the eleventh hour, made a critical but considerate reading of my introduction (incidentally rescuing me from my own ignorance of the history of photography). I am deeply grateful to all of the above for their personal encouragement and enthusiasm for the venture.

I thank also the following people for their professional assistance: Angela Raspin and her staff in the Archive Room of the British Library of Political and Economic Sciences at the London School of Economics; Karl Fulton of the Photography Unit of the London School of Economics; Bob Cooper of the Photography Unit of the Research School of Pacific and Asian Studies at The Australian National University; Jenny Sheehan and Neville Minch of the Cartography Unit of the same institution;

and the library staff of the National Film and Sound Archive, Canberra. Special thanks, as ever, to Ann Buller, Fay Castles, and Ria van de Zandt.

For permission to quote extensively from Malinowski's *Argonauts of the Western Pacific* (1922), *The Sexual Life of Savages* (1932 edition), *A Diary in the Strict Sense of the Term* (1967), and also from Helena Wayne's *The Story of a Marriage* (1995), it is a pleasure to thank Routledge Ltd. For permission to quote from Malinowski's *Coral Gardens and Their Magic* (1935), I am obliged to acknowledge HarperCollins Publishers Ltd.

This book would not have been possible, of course, without Helena Wayne's permission to reproduce her father's photographs. But her cordial cooperation in this project is simply the latest episode in a series of extended "conversations," spanning several years, concerning Bronislaw Malinowski's life and works. I thank her warmly for the trust and friendship she has shown in admitting me to her family.

Introduction

Thought of publishing my photographs in an album with explanatory notes.
MALINOWSKI, *A Diary in the Strict Sense of the Term*

The name of Bronislaw Malinowski is indissolubly linked with the Trobriand Islands of eastern Papua New Guinea. They brought to one another a fame which extends beyond anthropology and the South Pacific. It is thanks to Malinowski that "there exists a mystique about the Trobriands . . . one of the most sacred places in anthropology."[1] Not only anthropologists associate Malinowski with the Trobriands; every visiting journalist and travel writer conjures his name. For Paul Theroux, as for so many professional tourists, it was the alluring image of "the Islands of Love, described in graphic detail in Malinowski's *The Sexual Life of Savages*," that drew him there.[2] Numerous ethnographic films and travel documentaries for television also have acknowledged the link between Malinowski and the Trobriands. A documentary on Malinowski's fieldwork is being filmed by a Polish crew even as I write.

Although Malinowski was more famous as an ethnographer than as a photographer, he did much to create a singular visual image of the islanders. Anyone who has glanced through his three major monographs will have been struck by the narrative force of his photography, the capacity of his images to evoke a distinctive and, to European eyes, exotic way of life. His photographs do more than simply embellish his texts, they recreate a distant world in quotidian detail.

The main purpose of this book is to bring to light a selection of the fieldwork photographs Malinowski left unpublished. They represent about one-fifth of his total

collection. This introductory essay is both a discursive exploration of his photography and an appraisal of Malinowski the photographer. Beginning with a biographical sketch which situates Malinowski in the Trobriands, I review in turn his ambivalent attitude toward photography, his place in a developing tradition of ethnographic recording by camera, and some recent critical evaluations of his work. I then discuss the influence of others on his photography, especially that of his friends Staś Witkiewicz and Billy Hancock. In attempting to define Malinowski's characteristic photographic style and technique, I relate them to the methodological functionalism for which he was renowned as a founding father of social anthropology. I then account for my selection of photographs for this book and follow this with a description of the means by which Trobriand villagers were enabled to remark on them and to contribute to the commentary. Finally, I offer the rationale for my arrangement of the photographs into a sequence of fourteen photo-essays. This book, then, is a visual ethnography of the Trobriands, presented with a reflexive eye on the historical and personal circumstances of Malinowski's legendary fieldwork.

BORN IN CRACOW, Austrian Poland, Bronislaw Kasper Malinowski (1884–1942) was exposed to photography at a very tender age. The earliest portraits, taken in a Warsaw studio, show him at two years dressed in a frock. As a young man he studied mathematics, physics, chemistry, and philosophy at the Jagiellonian University, where in 1908 he was awarded a doctorate with the highest academic honors in the Habsburg Empire. During a year at the University of Leipzig, Malinowski became interested in ethnology and primitive sociology and in 1910 went to the London School of Economics (LSE) at the University of London to pursue British advances in these fields. Anthropology was then becoming a professional vocation. Its call, chorused by some of Malinowski's British mentors, A. C. Haddon, W. H. R. Rivers, and C. G. Seligman (all veterans of the Cambridge Torres Strait Expedition of 1898–99), was for "intensive studies of restricted [ethnographic] areas"—in other words, for extended fieldwork by trained investigators.[3] In 1914 Malinowski answered that call and sailed for New Guinea, the huge, rugged—and at that time largely unexplored—island that hovers like a prehistoric bird above the continent of Australia. The outbreak of war in Europe almost induced Malinowski to abort his plans, but despite his status as an "enemy alien" the Australian authorities allowed him to proceed with his fieldwork in Papua, the southeasterly portion of New Guinea.

Thus arose the myth that for the duration of the First World War Malinowski was interned in the Trobriands where he invented the research procedures that were to

become the hallmark of British social anthropology. The facts are that Malinowski was not interned but merely kept under light surveillance, and that he spent only two years in Papua, not four. His three "expeditions" (the first to the small island of Mailu off the south coast of Papua, the second and third to Boyowa, or Kiriwina Island, in the Trobriands) were interrupted by more or less lengthy periods of writing and recuperation in Melbourne, the capital city of the state of Victoria and at that time the seat of the Australian Federal Government.[4]

The second part of the legend is less easy to demystify, for it is largely true that Malinowski's "heroic" model provided a charter myth for the revolution in British anthropology that he led between the wars.[5] Edmund Leach, one of Malinowski's most eminent pupils and an arch-demystifier himself, could write that Malinowski's Trobriand fieldwork "set precedents which later became established as part of the orthodox procedure of all field research in social anthropology."[6] Among these precedents are "participant observation" and a mastery of the local vernacular (Malinowski's own remarkable facility for languages was crucial to the success of this innovation). Together with the fundamental precept that it is essential to live right among the people one is studying, these procedures made possible an intimately detailed kind of ethnography, the goal of which is "to grasp the native's point of view, his relation to life, to realise *his* vision of *his* world."[7]

It was not only his exemplary, epoch-making fieldwork among the Trobrianders that promoted Malinowski's revolution in anthropology; it was thanks also to his militant self-publicity, his inspiration as a Socratic teacher, his capacity to find funding for his cause, his out-maneuvering of academic rivals. But most of all, his revolution was nourished by the powerful scientific and popular appeal of his unique Trobriand works. Comprising three major monographs and two shorter ones, this corpus remains one of the most comprehensive, valuable, and widely read in world ethnography.[8]

It is fitting that Trobrianders, too, have their legends about Malinowski (his name recalled in the garbled form of *Misikambati* or *Kisimbati*). In Omarakana, the "capital" of Kiriwina, villagers have wittily commemorated him by placing a knee-high stalactite, broken from the roof of a coral cave, upon the spot where his tent once stood. Not only is this an appropriately phallic monument to the author of *The Sexual Life of Savages,* but also a pointed allusion to the mode of conception of Tudava, the legendary Trobriand culture hero.[9] In Oburaku, a village on the lagoon, Malinowski is remembered by at least three nicknames: *Tolilibogwa* (the historian or collector of stories); *Tosemwana* (the show-off or performer); and *Topwegigila* (the man with loose shorts)—the last apparently a reference to his habit of hitching his

trousers while trying to focus his camera. Rendering photography as a risible activity, this clownish image would have delighted Malinowski, who told his fiancée Elsie Masson that he hated photography "above all other things."[10]

IT IS A TRUISM that photography and anthropology were born about the same time in the mid-nineteenth century and have followed parallel historical trajectories.[11] In photography, as in anthropology, it seems Malinowski appeared at a particularly interesting moment of its development. I shall highlight just one aspect.

In 1892, Everard im Thurn (botanist, anthropologist, explorer, colonial governor) addressed the Anthropological Institute of Great Britain, of which he was president, on the subject of photography. He deplored the "scientific" anthropometric photography of the day with its "lifeless bodies" and advocated instead the photography of unposed native subjects under "natural" conditions. Im Thurn urged the use of the camera "for the accurate record, not of the mere bodies of primitive folk . . . but of these folk regarded as living beings."[12] Some twenty-five years later, having renounced anthropometry and physical anthropology altogether, Malinowski had almost completed his ethnographic and photographic record of "living" Trobrianders in a manner of which im Thurn would surely have approved.

By the turn of the century, within an increasingly professionalized and institution-based anthropology, advances in photographic technology combined with the changing role and status of visual recording in anthropology to authorize an unmediated, "naturalistic" style of photography. Alfred Cort Haddon's expedition of 1898–99 to the Torres Strait (which separates Australia from New Guinea) not only decisively changed British anthropology but also greatly expanded the ethnographic uses of photography. As a zoologist turned anthropologist, Haddon favored a "naturalistic" style of photography. Other ethnographers of the period had begun to deploy the camera as a "mute recording device . . . a transparent method of visual note-taking," but, as Elizabeth Edwards has shown, Haddon also used photography in the service of "salvage ethnography" by photographing reenactments of rites and dances, as well as reflexively, as a means of social engagement, by showing Torres Strait islanders photographs of themselves.[13] Haddon wrote an influential guide to photography for the third edition of *Notes and Queries on Anthropology,* published in 1899, and it was a revised version of this essay that Malinowski took with him to the field.[14]

Malinowski's photography has attracted respectful attention in recent years.[15] For Terence Wright, Malinowski was "a prolific and accomplished photographer" whose photographs "themselves bear witness to [his] structured, reflective approach in his use of the medium" and whose "photographic innovations deserve wider recognition

in the history of photography." Wright argues further that Malinowski's "methods of visual enquiry" influenced contemporary photography more generally and "made a major contribution to the methods of documentary practice. . . . The success of Malinowski's fieldwork photographs was due to both his visual awareness and his emphasis on observation and detail as exhibited in his methods of participant observation. Both were brought to bear on the [British] Mass Observation project of the 1930s."[16]

In another recent article, Étienne Samain examines Malinowski's published photography in considerable detail and focuses particularly on the relationship of image to text in the three principal Trobriand monographs.[17] Samain notes the extraordinarily high ratio of photographs to text, averaging one to every seven pages. Malinowski places his photographs with didactic intent, and a functional integration of image and text is achieved by means of scrupulous cross-referencing between text and caption. There is "maximal symbiosis" between written description and visual representation. Malinowski went beyond simple illustration, however, for the reader is directed to other places in the text beyond the first referent, and then back again to other images. This device gives a "narrative force" to the photographs within the larger narrative of the monograph. Samain demonstrates how, by following the trail set by the caption to a single photograph, the reader is led on a dialectical journey between image and text and back again, directed each time by Malinowski's instructions, so that the reader is invited to visit different visual aspects of the same topic. In this way as many as a dozen photographs, each with its own place and illustrative function within the text, are brought together to form an "ensemble."

No other anthropologist of Malinowski's generation made photographs work so hard in the service of ethnographic narrative. Malinowski did so not only in the manner described by Samain, but also in the way he occasionally used identical images in different contexts to convey different messages (incidentally attesting to their versatility). Moreover, his juxtapositions sometimes create an extra dimension. One photograph informs another and together they produce an image (a correlated visual function) of sets of dyadic human relationships, as in the logical pairings of kin relations: photographs of mother and son, father and daughter; two brothers, two sisters; husband and wife, a widow and a widower.

MALINOWSKI'S RELATIONSHIP to his cameras was not a happy one. Given his self-admitted "characteristic helplessness," his compliance with the technical demands of photography was grudging. In an era when equipment was heavy, cumbersome, and liable to develop mechanical defects (particularly in a tropical climate), when

the activity itself was time-consuming and demanding of good-humored patience (a virtue Malinowski did not possess in great measure), photography could seem, as he once put it in colorful hyperbole, "a monstrous cross on the Golgotha of life."[18] His fieldwork diaries are replete with forceful expressions of the aggravation photography caused him. He refers early on to "the large amount of time I have wasted dabbling in photography," later to the massive frustration it induced ("losing control several times, cursing and raging"), and still later to the sheer tedious bother of it all ("I forgot to load the camera!"; "I had difficulties with taking pictures; characteristic helplessness"). An entry from near the end of his stay on Mailu Island reads, "Went to the village hoping to photograph a few stages of the *bara* [dance]. I handed out half-sticks of tobacco, then watched a few dances; then took pictures—but results very poor. Not enough light for snapshots; and they would not pose long enough for time exposures. —At moments I was furious at them, particularly because after I gave them their portions of tobacco they all went away." Almost three years later, in the village of Oburaku in Kiriwina, he notes, "I decided to take pictures. I blundered with the camera, at about 10—spoiled something, spoiled one roll of film. Rage and mortification. *Up against fate. After all it will probably do its work.* Photographed females. Returned in a state of irritation."[19] Yet emerging from all this frustration and apparent incompetence came one of the largest and most remarkable collections of anthropological photographs of the pre-Leica era.

Malinowski frequently mentioned his photography in letters to Charles Seligman, his academic supervisor in London, who had directed him to investigate Mailu: "My weakest points are photographs and phonographic records. I have taken very few photos so far—but I have ambitious schemes of recording much of their dances, children's plays [sic], economic activities (fishing, making gardens etc.) & technology. But whenever skill comes into play I am not much good."[20] Seligman replied with encouragement and practical advice: "So cheer up, even if the photographs are not coming out just as well as you'd like them to. Still don't be too saving of your plates, remember they won't improve with keeping."[21]

Several months into his first Trobriand field trip, Malinowski wrote from Omarakana, "I am getting some photos & I'll send you a few samples as soon as I get them printed. But I have to go up to Losuia (Govt. Station) as I could not do any photo work in my tent (alas lack of clean water)."[22] Disrupted by the war, sea mail suffered interminable delays, and the prints Malinowski sent to Seligman took nine or ten months to reach him. But Seligman eventually acknowledged them and offered cautious praise: "[T]he first fruits of your photography, about two dozen prints, have come to hand; they are all right, in fact I should think most of the negatives were very good indeed. The detail in nearly all the prints will stand a hand lens. I very

much look forward to the rest, about 100 which you say are on the road. What camera have you got? I see that they were not taken with the one I lent you. Don't stint yourself in plates or other photographic gear, now that you have really learnt to get results. I shall be quite prepared to send you anything up to £20 as a private matter."[23]

Malinowski did not, indeed, stint himself in photographic expenses, and they accounted for a significant portion of his fieldwork budget. Surviving invoices indicate that this may have been as high as 10 percent (see appendix 1). This is evidence enough, despite his disclaimers, that he took photography very seriously while in the Trobriands.[24]

IN WHAT HAS BEEN CALLED a "self-flagellating review," at the end of his last Trobriand monograph Malinowski recounted his sins of photographic omission.[25] As this is the only published statement he ever made on the subject of his photography, I cite it at length.

One capital blot on my field-work must be noted; I mean the photographs. Perhaps if you compare my books with other field-work accounts you will not realise how badly mine are documented in their pictorial outfit. The more reason for me to insist on it. I treated photography as a secondary occupation and a somewhat unimportant way of collecting evidence. This was a serious mistake. In writing up my material on gardens I find that the control of my fieldnotes by means of photographs has led me to reformulate my statements on innumerable points. . . . I have committed one or two deadly sins against method of field-work. In particular, I went by the principle of, roughly speaking, picturesqueness and accessibility. Whenever something important was going to happen, I had my camera with me. If the picture looked nice in the camera and fitted well, I snapped it. . . . [I]nstead of drawing up a list of ceremonies which must at any price be documented by pictures and then making sure that each of these pictures was taken, I put photography on the same level as the collecting of curios—almost as an accessory relaxation of field-work. And since photography was no relaxation for me, because I have no natural aptitude nor bent towards this sort of thing, I only too often missed even good opportunities. . . . A general source of inadequacies in all my material, whether photographic or linguistic or descriptive, consists in the fact that, like every ethnographer, I was lured by the dramatic, exceptional and sensational.[26]

If this retrospective evaluation of his field photography was intended to disarm criticism, he does himself less than justice. In his own defense, it might be pointed out that it was written about fifteen years after he had completed his fieldwork. If he was disappointed with his photography in retrospect, it was because it did not live

up to the stringent demands of the functional fieldwork he had been propagating for the past decade. While he assigns photography's role as "secondary" (presumably to the "primary" activity of note taking and text recording), he acknowledges the value of the photographic record as a "control." As for his confession concerning the choice of subjects according to criteria of "picturesqueness and accessibility," he simply overstates the case. The internal evidence of his photographic corpus as well as the occasional on-the-spot record of his field diaries prove abundantly that it was not only these considerations which prompted him to "snap." Nor was he beguiled unduly by aesthetic considerations ("if the picture looked nice in the camera"). Like most photographers, Malinowski would have composed the majority of his shots intuitively rather than according to a set of abstract directives. Insofar as the aesthetic leaked into his scientific vision, so much the better for his photographs. It would be perversely puritanical to prefer a picture that did not look "nice" over one of the same subject that did. The additional charge that he put photography "on the same level as the collecting of curios" is hardly serious and may well have been a covert boast. Malinowski was an assiduous collector of artifacts (well over one thousand items from the Trobriands alone), and he conscientiously collected the entire range of everyday household objects that most professional "curio" hunters would have spurned as worthless.

Finally, Malinowski had perhaps forgotten how much forethought he gave to his photography. In addition to the evidence of his diaries in their frequent reference to photographic expeditions, there is a single, telling page among his fieldnotes.[27] It is a handwritten list of topics arranged into three seemingly arbitrary categories. I reproduce it here as testimony to Malinowski's photographic intentions and strategies, however unsystematic they may seem.

PHOTOS

I 1) 1 view of lagoon shore. 1 mangroves with crab catching or Kudu'tay [tying in bundles]. Raiboag [coral ridge], Odila [bush], [Wa]Luma (Wawela) [east coast]. One approach to a village.

 2) Get yourself photographed in some half dozen films. Tent with niggers. Self on a native house.

II 1) Photo illustrating Gumasila, Domdom, Dobu (landscape).

 2) a) General view of a village from scaffolding.

 b) Original hole, [illegible] Labai.

 c) Whole population

3) Totemism—none!

4) Family group in front of house

5) Chief and his attendants

 Chief in his full ornaments & in his house

 Chief & his full complement of wives

 The Kavagina [obeisant posture in front of chief]

III 1) Getting out [?] of the village

 Night entertainment. Village in rain (?)

2) Dress: Native Adam & Eve

 Women in various forms of petticoat (coconut, gaudy petticoat, thigh [?] dress)

 Dobe [skirt] making series

 Armshells & Soulava [shell necklace]

 Earring, Kuwa [short shell necklace], Kwasi [arm and leg bands], Grassbelt, Nosebone

 Cleaning and cutting of yams with a small kuria [cooking pot]

 Kumkumla [earth oven]

 Gabu [burning of gardens]

 A group of people eating

3) Sex. Group of small girls with their lemans (Teyava).

 Sex magic

Although undated, this list almost certainly refers to Malinowski's second expedition to the Trobriands and was probably drawn up just before he returned in October 1917. The photographs in his collection testify to the fact that he fulfilled these self-instructions almost to the letter.

HAVING ESTABLISHED that Malinowski had at the very least a dutiful scientific interest in photography, I now consider the likely influence of others on his photographic style and technique. In the search for precursors or teachers from whom he might have learned something about photography, two names are prominent: Staś Witkiewicz and Billy Hancock. Theirs were indeed important influences on Malinowski's photography (in the case of Witkiewicz, I believe, in a paradoxically negative way), and I shall deal with them separately below. But there are also a number of lesser candidates.

Cast in the role of academic supervisor of Malinowski's forthcoming research in New Guinea, Charles ("Sligs") Seligman, who enjoyed private means and was generous to a fault, lent Malinowski a camera of an unspecified type and make, which

Malinowski tested thoroughly in London in the weeks before departing for Australia. He took photographs of "business houses" and many more of his married lady friend Tośka.[28] What Malinowski learned from Seligman about field photography is not known, but we can be sure that his supervisor stressed its importance.[29]

Another plausible influence on Malinowski's way with a camera came from a more unlikely source. In April 1915, while staying at the Adelaide home of Sir Edward Stirling (who was director of the South Australia Museum), Malinowski became enamored of his youngest daughter, Nina. Their relationship was to cause mutual heartache and something of a scandal some two years later, but its immediate effect on Malinowski's photography may have been inspirational, for Nina Stirling was a keen and accomplished amateur photographer. She probably fanned Malinowski's fickle interest in photography, if only because he needed to prove himself to her. The frequent letters they exchanged while he was in the field are lost, but a collection of what must be Nina's sepia photographs of the Australian bush and the Stirlings' gardens at Mt. Lofty lie unrecognized and unannotated in the Yale University archive. The landscapes are technically and artistically superior to any that Malinowski produced, and it is poignant that he preserved these photographs until the end of his life. Thus, insofar as there was any technical improvement in Malinowski's photography following his Mailu field trip of 1914–15, Nina Stirling may have been a cause. It was her father, after all, who edited Malinowski's ungainly prose for his first fieldwork monograph, *The Natives of Mailu*.[30]

A word needs to be said here about the thirty-four photographs Malinowski published in this comparatively minor work which preceded his famous Trobriand monographs. The originals (prints, plates, and negatives) are lost, and the reproductions appearing in the report are of dubious quality. Depicted are coastal landscapes, crab-claw sail canoes (including toy ones), village scenes, pottery and armshell manufacture, a few portraits of standing figures dressed in their best skirts or finery, and a half-dozen shots of dancers framed by steep-roofed village dwellings. The overall impression of this set of photographs is of its variety. The individual images were carefully composed and the effect is usually pleasing. The stilted, static air of his human subjects testifies as much to the limitations of Malinowski's camera as to his personal antipathy to the Mailu. They are mostly posed in frontal view and, with two or three exceptions, wear wooden expressions; even the dancers appear frozen in their postures. None of Malinowski's photographs of Mailu are in the same league of technical accomplishment as those of the Australian photographer Frank Hurley, taken in 1921, and many are surpassed by those of the local missionary, W. J. V. Saville, whom Malinowski complimented on his "excellent photographs, both artistic and precise" in a generous foreword to Saville's own book on the Mailu.[31]

Another proximate influence on Malinowski during this period was Sir Baldwin Spencer, director of the National Museum in Melbourne. Until his discovery of Malinowski's duplicitous relationships with Nina Stirling and Elsie Masson, Spencer was one of Malinowski's chief Australian patrons.[32] Assisted by fellow field-worker Frank Gillen, Spencer had been a pioneer in the ethnographic use of still and moving photography among the Aborigines of central Australia at the turn of the century.[33] There are some strikingly intimate portraits of Aborigines among Spencer's photographs, unmatched by any that Malinowski took of Trobrianders.[34] During his sojourn in Melbourne in 1916–17 Malinowski was given the use of a room next to Spencer's in the museum, and it was there that he wrote his *Baloma* essay, which in draft form he read to Spencer.[35] It was there too that he organized the photographs from his first trip to the Trobriands, and it would have been odd indeed if he had not shown his collection to Spencer and discussed it with him. But if Malinowski learned anything from Spencer or derived any inspiration from his photography, he remained silent on the matter.

UNTIL THE WAR separated them in August 1914, Malinowski's friendship with Stanisław Ignacy Witkiewicz was the most important of his life. A year younger than Malinowski, Staś Witkiewicz was a flamboyant artistic intellect of astonishing precocity (he began painting in oils at the age of five and writing plays when he was seven) who matured into a creative artist displaying an extraordinary diversity of talents. "Witkacy" (as he became best known) was a playwright, novelist, painter, aesthetician, philosopher—and photographer. Although he received only limited recognition in his time (he died by his own hand in 1939), Witkiewicz is now ranked among Poland's most celebrated figures of the twentieth-century avant-garde.[36]

For two decades from late childhood Witkiewicz was Malinowski's closest friend and confidant, arguably the most stimulating companion it would have been possible for him to find. They influenced one another profoundly. They shared holidays, books, and lovers and all manner of experiences, including at least one homosexual "experiment." It was a remarkable friendship which did much to shape the personalities, if not the careers, of both young men. Yet they disagreed fundamentally on many "metaphysical" issues central to romantic modernism—on life and art, for example. For Malinowski art should decidedly serve life; for Witkiewicz the base metal of life should be transmuted into the gold of art.

Witkiewicz had begun to explore the possibilities of photography in about 1899; his earliest photographs are of shiny locomotives and the snowy landscapes of Zakopane. Later, when he and Malinowski spent time together in Cracow (where

Witkiewicz stayed at the boarding house kept by Madame Malinowska) and in Zakopane (where Malinowski stayed at the pension run by Madame Witkiewicz), the two friends experimented with photography among many other things. Most of the surviving photographs of Malinowski from this era were taken by Witkiewicz.[37]

With some reluctance Malinowski conceded Witkiewicz's greater artistic talents, realizing how fruitless it was to compete with his friend's almost effortless creations, whether in prose fiction, in sketching and painting, or in the dramatic arts, and perhaps also in photography. By such an invidious measure Malinowski was artistically impotent. By the age of twenty he had begun to bend his will and apply his considerable powers of concentration to becoming a scientist. Although he did not finally decide on anthropology until about 1910, Malinowski was determined to excel in a field of study in which Witkiewicz, owing to his undisciplined intellect and informal education, could not compete.

Their lives were closely intertwined until their separation in 1914 ("Nietzsche breaking with Wagner," as Malinowski dramatized it in his diary), after which the trajectories of their fates diverged in the abrupt way only war can effect. They met only a few times more after their bitter parting in Australia, but had it not been for the outbreak of war it is very likely that Staś would have accompanied Malinowski to Papua.

When Witkiewicz's fiancée killed herself in February 1914, Malinowski tried to rescue his friend from suicidal despair by inviting him on his forthcoming expedition. Witkiewicz grasped at this prospect as at a straw: "Only the thought of travelling with you to some savage country offers any hope. A change so radical that everything would be turned upside down."[38] A few weeks later he wrote again to Malinowski in London: "Couldn't I serve as a photographer and draftsman? I draw fast and render likenesses well. Write and tell me what you think of the idea; in the frightful void that engulfs me, thinking about going on the trip with you is the only bright spot."

But the voyage to Australia was a nightmare for Witkiewicz. He composed a series of suicide notes (unsent) and a last will and testament, leaving to Malinowski his camera and the choice of any of his paintings. They broke their journey at Colombo and spent two weeks touring Ceylon. It was in an inland village that Malinowski witnessed (as he noted in his diary) his "first magic ceremony." Although he and Witkiewicz took many photographs in Ceylon, none of them have survived.

Shortly after their arrival in Australia, war was declared in Europe, and soon the two friends quarreled and went their separate ways. News of the war had given Witkiewicz some hope for himself: "The time has come to set aside personal matters, renounce suicidal thoughts . . . and make something of one's life and of what is left of one's strength."[39] Malinowski went on to Papua and his first stint of fieldwork

on Mailu Island. Witkiewicz sailed back to Europe to join the tsar's army in St. Petersburg.

They did not meet again until 1922, when Malinowski (by now married with two baby daughters and having successfully launched his *Argonauts*) visited Poland to inspect, and then to refuse, a professorial chair at the Jagiellonian University. They saw little of one another thereafter, and Witkiewicz would later say disapprovingly of his old friend that he had become "Anglicized to the core." Toward the end of his own life, after hearing confirmation of Staś Witkiewicz's sorry death in the Ukraine, Malinowski confessed, "[H]e was the only man I ever met . . . whom I knew from first and last to be a real genius."[40]

Jeremy Coote and Terence Wright have wondered how much Malinowski learned from Witkiewicz in the way of "visual skills."[41] Insofar as the "success" of Malinowski's photography "was due both to his visual awareness and his emphasis on observation and detail," I suspect there was little that Witkiewicz could teach him.[42] Malinowski's acute visual sense, his keen eye for detail, his appreciation of line and color, are all evident from his earliest diaries. The importance of Witkiewicz's influence on Malinowski's photography is, I suggest, not for what he might have taught him (which in any case cannot be determined), but what, in contrast to Witkiewicz's, Malinowski's photography is *not*. In personal style Malinowski's is almost the antithesis of that of his friend; as in life, they were complementary opposites. Malinowski appears to have resisted the experimental, art nouveau trends indulged by Witkiewicz. If Witkiewicz's photography leaned toward surrealism, then Malinowski would ensure that his own exemplified realism. Whereas Witkiewicz treated photography as an expressive art form to be explored, Malinowski treated it purely as a visual aid to his science.

The tantalizing hypothetical must be posed. If the war had not diverted Witkiewicz back to Europe, and he had instead accompanied Malinowski to the field as his "photographer and draftsman," how different would have been Malinowski's fieldwork among the Mailu? (It stretches probability too far to imagine them spending the following year together in the Trobriands.) More pertinently here, how would Witkiewicz have represented the same Melanesians who, in the event, Malinowski alone photographed? As a more technically adventurous and self-consciously creative photographer, Witkiewicz's images certainly would have surpassed Malinowski's in shock value, in surrealist representation of the "tropical madness" which infected Staś's imagination (he gave to one of his plays that very title). They would have focused on the bizarre, cultivated the alien, visually enhancing the savagery; one might even imagine him creating a photographic version of *Heart of Darkness* (a somber subtext of Malinowski's own diaries). His images would, one suspects, have

"said" a great deal more about the white European's predicament in a black man's world than about Melanesian villagers themselves. It may well be that, as Coote suggests, Witkiewicz's return to Europe in September 1914 was a "loss" to the history of anthropology.[43] But insofar as his photographic style is concerned, one cannot imagine him being content with precise, realist documentation in the Malinowskian mode.

That his field photography aspired so unwaveringly to realism does suggest a curious limitation on Malinowski's part. Nowhere in his collection are to be found the extravagantly experimental shots one would expect of a close confrere of Witkiewicz. Even if we accept that he sought to define his own "scientific" style in opposition to that of his artistic friend, one might suspect him of being tempted occasionally to do with his camera what he was already doing with his diary: that is, explore the mysterious strangeness of others with the same fascinated intimacy with which he explored the nooks and crannies of his own mind. But there are no modernist tricks, no metaphysics in Malinowski's photography.

Here then is a striking and stubborn difference in viewpoint. For Malinowski, "the purpose in keeping a diary and trying to control one's life and thoughts at every moment must be to consolidate life, to integrate one's thinking, to avoid fragmenting themes."[44] Witkiewicz, in contrast, sought and relished "fragmenting themes" as essential kindling for his creative art (his experiments in drug taking were similarly motivated). He was intrigued by masks and multiple identities (he coined hundreds of nicknames for himself), seemingly indifferent to the "unified personality" for which Malinowski so earnestly yearned. In a word, Witkiewicz sought dislocation rather than integration. "The whole charm of life lay in staying undefined," his youthful alter ego Bungo had said.[45]

In his photography, too, Witkiewicz sundered rather than integrated. He photographed himself in grotesque, misshapen postures, caricaturing his multiple masks. His subjects are often alienated in their settings, or clowning like the characters in his plays. His portraits often violate their subjects' personal dignity by pitiless scrutiny of the blemished human face. This was precisely his intention: to push the camera in close to capture the metaphysical face behind the surface appearance. In Malinowski's photography there are very few portraits of any kind, and whether out of respect or timidity he kept a serene distance from his subjects.

DURING HIS TIME in Papua many of Malinowski's European associates were also indulging in photography. In addition to the Reverend Saville of Mailu, Malinowski mentions the wife of another missionary, Mrs. Rich of Suau, and an official in Sama-

rai called Wilkes.[46] On Kiriwina, at least two white traders practiced photography as a hobby: Billy Hancock and Rafael Brudo. Even Cyril Cameron, a trader "gone native" on nearby Kitava Island, seems to have owned a camera. The Wesleyan missionary at Oiabia, the Reverend Johns, apparently did not. His inadvertently hilarious invitation to Malinowski to join the missionaries for Christmas dinner requested: "Will be pleased if you can take a few photos on Saturday—expect over 5000 natives."[47]

The most important influence on Malinowski's photography in the Trobriands was undoubtedly Billy Hancock, an English-Australian pearl trader who leased an acre of land at Gusaweta. He ran a small cutter and a trade store and his wife was the daughter of another local European trader and a Trobriand woman. Billy's was a large, untidy, and boisterous household, in which Malinowski became a welcome if sometimes ruffled guest. Despite enormous differences in education and occupation (Billy had once been a gold prospector), the two men became firm friends, though Billy never overcame the respectful habit of addressing Malinowski in his letters as "Dear Doctor" and signing himself "W. H. Hancock." He had taken up photography some time before Malinowski's arrival in June 1915 and had already equipped himself with a darkroom. To this Malinowski added his own photographic equipment and chemicals, and when he returned to Australia in 1916 he continued to order photographic supplies for Billy's use.

It was probably Hancock's enthusiasm for photography rather than any special talent or expertise that encouraged Malinowski in his own endeavors. They discussed techniques and technical problems and compared their results. Not only did they make camera-toting expeditions to local villages, but they spent long evenings together in Billy's darkroom, developing their plates and printing their films. Sometimes it went well: "Bill developed three rolls, all of them good. Only the picture of us two is bad." At other times it went less well: "I began to develop films . . . 24 plates in the evening. At night, storm; two plates broken; then three ruined by insects. Unhappy about this." On another occasion: "In the evening, somewhat depressed and sluggish; we developed pictures. Almost all of Billy's unusable; I failed to expose three of them."[48]

During Malinowski's absence in the village, Hancock would sometimes develop his films and send him the prints with critical comments: "Gusaweta, 9th Tuesday, 9am. . . . Am sending plates by Ginger [Malinowski's Sariba Island cook]. They are more or less fogged (more I should say), the 'dead meat' ones will give fair prints, but I am doubtful about the others with gaslight. I made 3 or 4 hurried prints last night to see how they would come out. I am sending them, there are far better prints to be made than the ones I am sending, they were made in a hurry." On another occasion: "I developed films. Yours are awfully thin, try 1/15 sec. instead of 1/50. My

lot are no good. I moved the camera every exposure. Am sending a roll of film & would ask you to take two exposures of anything you think may interest me. Anything suitable as postcards."[49]

Billy was a fan of postcard prints (the current fashion was to print photographic images on developing paper with a postcard format on the reverse), and many of them found their way into Malinowski's own photographic collection. These letters of Hancock's contain the only surviving clues to Malinowski's darkroom procedure. For example, while Malinowski was staying in Omarakana he sent Ginger to Gusaweta with film for Billy to develop.[50] Hancock returned the prints with the following note: "20 pcs [postcards]. Developed films as per instructions 20 minutes, 15 drops bromide. Come along any time you feel like it. I've finished all the printing I want to do and there is absolutely nothing to do in the evenings and no reading matter."[51]

The difference between the two men's photography might crudely be characterized in terms of Christopher Pinney's dichotomy, "indexical" versus "iconic."[52] In striving to represent his subjects with verisimilitude, Malinowski produced photographs that are invariably indexical; in seeking to be symbolic of "the Trobriander" and his or her way of life, Hancock created photographs that are very often iconic. The difference, of course, lay in the professional scientific interest Malinowski took in his Trobriand subjects. It is perhaps this kind of difference to which Malinowski casually alludes in his diary: "We set out. I felt tired all the time. The camera seemed too heavy. I reproached myself for not having mastered the ethnographic situation and Bill's presence hindered me a little. *After all,* he is not as interested as I am, in fact he thinks all this is rather silly."[53]

FROM THE POINT OF VIEW of its execution, Malinowski's photography can be characterized by several positive and negative features. These are not, in the first instance, my own interpretative judgements, but rather empirical deductions based on an assessment of the full collection.

1. Landscapes or wide-ranging views are comparatively rare. Malinowski's photographs do not incline to the "picturesque." His technical limitations (or his equipment) probably denied him good landscapes, even in the rocky Amphlett Islands, the scenery of which he found so refreshingly spectacular after the "uniform green monotony" of the flat and featureless Trobriands. The only landscape shots of any significance are those of Samarai, where he was admittedly short of suitable native subjects to photograph, and those of Kula voyages, in which coastal seascapes naturally (and unavoidably) frame the canoes.

2. The height of the camera is commensurate with the height of the subject. Malinowski crouched when photographing children or seated people; he neither looked up nor down at his subjects. The effect is one of directness.

3. Vertical framing was foreign to Malinowski's style, and horizontal framing massively predominates in the collection. Indeed, so rare are vertically framed photographs that the few which do exist immediately arouse suspicion: were they cropped horizontal ones, or had they been taken by Billy Hancock, who often favored this format?

4. There are correspondingly few portraits or close-ups, and most of these feature two or more people; single figure portraits are extremely rare. Even his "favourites," Tokulubakiki and the Omarakana chief's sons Dipapa and Namwanaguyau, who reappear in so many photographs, are never portrayed in close-up.

5. Many sequences or series occur, consisting of several photographs of the same subject or event, taken, as Wright has noted, "in fairly quick succession from a variety of viewpoints." Malinowski, in short, "used the camera to explore his subject."[54] (Witkiewicz too used this technique to scrutinize his human subjects.)

6. Demonstrations or reenactments in which the photographer posed his subjects have a relatively inconspicuous place in the collection. Malinowski most certainly preferred to photograph social action in "real time," though he was not in principle averse to reenactments, commenting, "If you know a subject-matter well and can control native actors, posed photographs are almost as good as those taken *in flagranti*. Yet I am sad to say that I have never resorted to this device except when, as in one or two photographs of war magic, I knew that I should never be able to see it performed in earnest."[55]

What can we deduce from these characteristics of Malinowski's corpus of Trobriand photographs? While each offers clues to the definition of Malinowski's photographic style, two appear to be of paramount significance. The overwhelming predominance of horizontally framed shots taken from a middle distance means that, conversely, there is a conspicuous absence of vertically framed portrait photographs. I estimate that these visual parameters describe more than 95 percent of Malinowski's photographs. In the published sample of 283 appearing in the three major monographs there are a total of twenty vertical close-ups. But at least eight of these were taken by Billy Hancock, and several others are possibly cropped versions of horizontal shots.[56]

Malinowski's apparent disdain for the intimate portrait cannot be an inadvertent feature of his style, nor can it have been in some way determined by technical constraints. With very similar equipment, Billy Hancock produced many photographs which were the exception to Malinowski's rule. Ironically, we know of them only because, lacking close-up shots of his own making, Malinowski resorted to using

Billy's. It might seem odd that Malinowski, so willing to engage Trobrianders face-to-face with the utmost openness, retreated when it came to taking photographs of them. In view of his sometimes comradely, sometimes confrontational fieldwork style, and (perhaps more to the point) in view of what we know about his ebullient personality, it is difficult to believe that it was any personal distaste for his photographic subjects that made him keep his distance. The only plausible explanation is that his marked preference for the middle distance was methodologically driven, albeit of an unarticulated nature. The implication is that Malinowski invariably felt obliged (wittingly or not, though derived from an informed notion of "relevance") to capture a background, a setting, a situation, a social context. He sought to inscribe visual clues to what he was later to define in a theoretical contribution to linguistics as "context of situation."[57]

Take for example the photograph of Molilakwa carving a canoe prowboard which appears as plate XXVI in *Argonauts of the Western Pacific*. This would have made a fine close-up, vertically framed. The focus of the image is the action of the carver's hands. The caption also draws attention to the technical aspect of the act being performed by Molilakwa's hands. Now Malinowski could have made a stronger impression by closing in. Instead, he kept his distance and chose to include other, seemingly irrelevant objects in his shot. One sees the platform on which Molilakwa is sitting, and next to him a large and chiefly limepot and limestick in a basket. A pleasing arrangement of wooden posts behind the carver to one side helps to balance the composition. But on the assumption that Malinowski was not seeking (consciously at any rate) an aesthetic effect, and that his decision to include "setting" was methodologically inspired, what did he expect to show? The context captured here tells us things a closer portrait could not have: that the carver is working alone and without an audience; that he is seated on a platform in the middle of a village (in the background is what appears to be a sleeping mat); that there are resonances of rank in the conspicuous presence of a handsome limegourd, reminding the careful reader that Olivilevi is a chiefly village, and that Molilakwa would probably have been hired by the chief to execute this carving. Such signs can only be read, of course, because the photograph contains them; had Malinowski gone in as close as the technical operation he was photographing invited him to, he would have had to forego them.[58]

Some such sense of "appropriate contextual relevance" probably informed the great majority of Malinowski's photographs, and there are any number of examples to be found in this book. Invariably he went for the optimum distance that would include enough situational, background information to read, "see," or interpret the

image in terms of its social context. There is not a single portrait among the 116 photographs in *Coral Gardens and Their Magic*; nor are there any shots which lack natural backgrounds. In *The Sexual Life of Savages* there are three photographs (plates 25, 36, and 38) in which backcloths were used, but I would question whether it was Malinowski who took them. There are only two photographs in *Argonauts* which lack any background, and, being of armshells (plate XVI) and necklaces (plate XVIII), they were probably taken in a museum. But Malinowski quickly repaired the omission of ethnographic context by placing two photographs of his own illustrating the ornamental "use" of the valuables immediately after the sterile museum shots. (These two charming photographs, showing respectively two young men and two young women wearing shell valuables, are admittedly posed. They are also, incidentally, about as close as Malinowski ever got to portraiture.)

The point here is that Malinowski refused to take photographs of artifacts or other manufactured things out of their social contexts; he pictured them in use, within a visual framework of action.[59] Whenever he photographed items of material culture it was always in relation to their human owners or manipulators, and their use (and sometimes their value) could often be conjectured from the way the object was held or displayed. So his rooted objection to the biometrical genre of anthropological photography, with its backcloths and measuring rods, extended also to the museological genre of photographing artifacts arranged against backcloths, similarly bereft of the social context which gave them meaning. His nascent functionalism demanded that the relationship between visible material culture and invisible social organization be discernable to the trained eye of the anthropologist.

I suggest, then, that Malinowski saw his own photographs as capturing (or to the degree that they were posed, as representing) ephemeral moments of social life, visual analogues of equally ephemeral verbal utterances. Both could be (*should be,* according to his later functionalist theory) analyzed in terms of "context of situation"; likewise both were to be used as forms of "concrete documentation." Photographs which excluded or deliberately erased context were worthless as ethnographic documents; they could neither illuminate nor explain. While Malinowski had not yet, at the time he was taking his Trobriand photographs, articulated the functional method for which he later became renowned, it had become second nature to him to "see" things in their contexts. Functional integration was everything: in his daily life as inscribed in his diary, and in the Trobriand ethnography he sought to record for posterity.

Such partly formulated principles seemed to underlie his photographic method. A resistance to the "fragmenting" tendencies of photography, and a resolve to mini-

mize them. A perception of the interconnectedness of everything he witnessed. A notion that form mattered less than function—though photography, being a mute recorder of surfaces, was in itself unable to distinguish between them. Functions could only be inferred from the forms which constituted the subject matter of the photographs; for inferences to be valid there had to be a penumbra of visible clues in the image. It followed that it was sacrilege to doctor photographs, to relieve them of "irrelevant" or "unsightly" details crowding the edges. A glance through any of the three major monographs will reveal many photographs that could have been aesthetically "improved" by judicious cropping. But the evidence is that only infrequently did Malinowski yield to the temptation to crop. The message of his crowded images, alive with movement (only color being lost), is that there can never be too much information in the photograph.

So any adequate theory of Malinowski's photography must take into account his incipient "functionalist" methodology, an approach influenced by an epistemology borrowed from Ernst Mach concerning the "economy of thought" (the subject of Malinowski's doctoral dissertation) and the integration of sensory impressions in the human, social animal. In prescriptive terms, a photograph should capture not only the image of whoever or whatever was the focus of the photographer's attention, but also the visible context for that focus, and it should provide sufficient clues to the meaning of the object, person, or act which was the subject of the photograph. The middle distance he favored optimized this strategy. If the context did not always make immediate sense to the viewer (in the first instance the photographer), this did not undermine the general principle. Capture some of the background and you capture whatever social context is immediately available.[60]

Malinowski was nevertheless aware that the "truth" of a social institution or the "reality" of a custom was often invisible to the camera—and to this extent, perhaps, the medium of photography ultimately frustrated him. One could capture the form of the digging stick, yes, but not its function, unless one took care to photograph it being *used* as such. I understand this to be what he meant by the following mea culpa:

In photography, my failure to snap a group of men sitting in front of a hut because they just looked like an everyday group of men sitting before a hut is an example of this [i.e. his captivation by the dramatic and sensational]. It was also a deadly sin against the functional method, the main point of which is that form matters less than function. Twelve people sitting round a mat in front of a house, because they came there by accident and stayed gossiping, have the same "form" as the same twelve people collected on important garden business. As a cultural phenomenon, the two groups are as fundamentally separate as a war canoe from a sago spoon.[61]

MY MANDATE for this book was to select and annotate approximately two hundred of Malinowski's previously unpublished photographs. There are some 1,100 images in the Malinowski archive at the London School of Economics. The exact number is difficult to ascertain. There are glass plates as well as film negatives and prints; some negatives lack prints and vice versa; there are negatives and prints of some, but not all, glass plates. With a handful of exceptions, all of the photographs were taken during Malinowski's second and third expeditions to New Guinea, so the great majority are of the Trobriands and fewer than one hundred are of other islands. The series from his first expedition of 1914–15 are lost.

In his publications Malinowski used 270 photographs (283 minus those he published twice) in his three major monographs and fewer than a dozen elsewhere. The photographs in this book have therefore been selected from a residual corpus of about 800 images. The process of selection, in which I was expertly assisted by Nicolas Lewis, involved examining every negative, print, or plate at least once. On the first inspection we eliminated all those that Malinowski had already published, together with those which were of the poorest quality—that is, those considerably under- or over-exposed, hopelessly unfocused, or irreparably damaged. More than half of the 800 unpublished images lack sharpness of image. Whether it was due to his defective eye-sight, a technical deficiency of the cameras, or hand-shake when wielding the "post-card" camera borrowed from the Australian government (see appendix 1), poor focus is the besetting technical flaw of Malinowski's photographic endeavors.

A second round of elimination resulted in the selection presented in this book. My criteria of final selection took into account subject matter as well as technical quality. I wanted the photographs to be as representative of Malinowski's unpublished corpus as could be achieved consistent with quality of reproduction. Certain images were retained for their uniqueness, despite technical or compositional imperfections, and none were excluded on aesthetic grounds alone. Guided by the subject categories of his collection, this is a representative sample of the full range of Malinowski's unpublished Trobriand photography.

In only one instance have I excluded photographs on the grounds of poor taste. In *The Sexual Life of Savages* Malinowski had written in defense of the "regrettable but hardly to be remedied" omission of photographs of erotic life: "Since this, however, takes place in deep shadow, literally as well as figuratively, photographs could only be faked, or at best, posed—and faked or posed passion (or sentiment) is worth-less."[62] Worthless or not, Malinowski took a series of six posed photographs of the sex act performed in the characteristic Trobriand manner so graphically described in his monograph (it goes without saying that his publisher would not have permitted

him to use them as illustrations). The offense they would cause to modern Trobrianders, however, has less to do with the depiction of the act itself than with the fact that the actors in the photographs are both male. They would regard this as a lewd misrepresentation of their sexuality, since the casual viewer (Trobriander or other) could be forgiven for assuming that it was a homosexual act that was being pictured. It is to avoid this innocent misunderstanding that I do not include any of these images.

I have been unable to determine to what extent Malinowski was responsible for arranging the collection as it now exists. This is something of a palimpsest, for it is quite likely that he rearranged it several times, reshuffling the contents of the categories and perhaps inserting new ones each time he raided the collection for illustrations for his books. But there has probably also been some later disturbance of Malinowski's deposits, perhaps by research assistants or archivists or both. I believe, however, that only Malinowski can have bestowed upon the collection its mysterious numbering system (see appendix 2).

The collection fills six standard archive boxes and is arranged under thirty-one general rubrics, such as "Amphletts," "Canoes," "Mortuary," "Dancing," "Pregnancy," "Physical Types," "Cooking," "Village Scenes," "Kula," "Sex," "Chieftainship," "Contact," "Gardening and Harvest." A complicating factor is the existence of several of the same categories in a smaller, "B" series of photographs which uses a different numbering system from the main series. I might add that so far as I could judge, the 496 prints in the Malinowski archive at Yale University are copies of ones from the original collection housed in the LSE archive.

Technical information on the photographs published here is almost nonexistent. There are comparatively few references to photography in Malinowski's fieldnotes, significantly more in his diaries as we have seen, but nothing at all resembling a systematic record of the photographs he took. Occasionally he jotted down cryptic lists of numbered subjects, together with exposure times and f-stops. As often as not these were scribbled on the backs of used envelopes. One such list of six photographs is dated 25 June 1918 and can be cross-referenced to his diary entry for that day, which was toward the end of his fieldwork in Omarakana: "In the morning worked calmly, without *surchauffage,* and took pictures."[63] The first photograph on the list ("No. 1 Toulu [*sic*] & Co. 1/2—f/11, dull") could well refer to one of those presented below as plates 17 and 18, showing Chief Touluwa with his sons and other men at harvest time, but it could equally well refer to several others of "Toulu & Co." on a dull day. This is illustrative of the difficulty of matching Malinowski's fieldnotes to his photography with any precision.

HAVING PRINTED the selection and mined Malinowski's fieldnotes and other sources for detailed notes on individual photographs, the next stage of research was to learn what modern Trobriand Islanders might have to say about them. All of Malinowski's Trobriand subjects have long since died, of course, but their descendants (in the broadest sense) live today in the same villages and pursue many of the same activities that Malinowski photographed eighty years ago.

The "photo-interviewing" and "photo-elicitation"[64] deployed in this case was a two-stage affair, the first direct, the second indirect. Although I was unable to revisit the Trobriand Islands myself, I was able to engage the services of a young Trobriand anthropologist—the *only* academically qualified anthropologist from Milne Bay Province. Linus Digim'Rina (as he insists on spelling his name) had been a Ph.D. student who worked under my supervision at The Australian National University during the years 1989–93, after which he returned to Port Moresby to teach at the University of Papua New Guinea. In late 1996 I secured him a short visiting fellowship, and he came to Canberra to work with me on an intensive scrutiny of the photographs. Linus's local knowledge was invaluable and many of his observations are included in the commentary.

Linus then returned to his home village in Kiriwina for Christmas (as I, too, returned for Christmas to my home village in England). Armed with photocopies of the prints we had studied in Canberra, Linus visited a number of Kiriwina villages and handed the copies around for inspection and comment by different groups of villagers in Okeboma, Omarakana, Tukwaukwa, and Teyava.

To be precise (as Linus, and no doubt Malinowski, would wish), the photographs were examined by about thirty people in Okeboma, of which ten were women. Linus's father, Digimrina, in his late seventies, another old man named Yaluba, and his middle-aged sister's son, Toguwagewa, were Linus's chief informants. In Omarakana, in addition to Chief Daniel Pulayasi, his daughter Elsie, three of his younger brothers, and one of his youngest sons (a high school teacher), there were four of Pulayasi's affines from the village of Mtawa. Pulayasi, the current paramount chief of Omarakana, is in his early forties and traces relationship to Malinowski's Chief Touluwa as his mother's mother's mother's brother. In Tukwaukwa, Linus consulted Chief Kwewaya (his mother's father's sister's son) and his wife together with Kwewaya's younger brother and their aged father. In Teyava four men and six women studied the photographs, the most informative being Giyomatala and an elderly woman named Itirikibi.

Linus was about to visit Oburaku and Sinaketa also, but sadly this festive fieldwork, done on my behalf with instant rapport and native linguistic fluency, was

abruptly terminated by the sudden death of his father. In England, a world away and a month later to the day, my own father died a more lingering death. Our respective funeral obligations delayed this project by a couple of months, but finally Linus sent me his informants' comments on the photographs he had circulated. Many of these observations appear in addition to or in combination with those I had earlier elicited from Linus, hence the "laminated" structure of many of the longer commentaries.

I must stand aside a moment in a way that Linus, despite his training as an anthropologist, probably cannot.[65] I was struck by a number of things that Linus and his own local informants saw in these photographs that were initially invisible to me. There was a characteristic style of looking, of searching for information. The first thing Linus appeared to ask of each image was, "Where is it? What village, what beach, what island have we here?" Second, "Who is it? What person, what group, of what subclan or rank?" Third, "What is he, she, or the group doing?" Linus also became interested, as I certainly was, in when a particular photograph was taken, as Malinowski wrote no dates on the backs of his prints. We had clear benchmarks separated by two years: Malinowski's first field trip of 1915–16 and his second of 1917–18. Once Linus had alerted me to various clues, such as telling the season of the year by glimpsing the contents of the yam houses, judging the growth of a person's hair following the obligatory shaving of mourning, inspecting known characters' faces for signs of aging, I found that I could place many of Malinowski's photographs into one period or the other.

If most of these questions (where, who, what, and when) could be answered, Linus and his informants were satisfied; the photograph was "explained" and there was no further attempt at interpretation. Sometimes, however, there occurred a fairly mechanical recital of material items in the photograph. These "inventories" were interesting, for Linus and his compatriots again saw many things that I did not even notice, let alone identify. Linus occasionally espied things that Malinowski himself seems to have ignored or failed to note, such as the maize plants growing in a garden (see plate 25 below). I shall say no more at this point about the Trobriand contribution to the project, for I want their comments to spring their own small surprises concerning what is visible to modern Trobrianders in photographs taken eighty years ago.

AMONG THE UNPUBLISHED NOTES at the back of Malinowski's fieldwork diary for 1917–18 is a simple, undated entry in English. It occupies the upper quarter of an otherwise blank page:

The idea for this monograph had not been idly conceived just as Malinowski embarked on his second visit to the Trobriands. It had taken shape during his extended stay in Melbourne as he worked over his fieldnotes from the first field trip. Several draft synopses are preserved in the LSE archive. The book was to be divided into seven parts, each devoted to major topics: social structure, "tribal life," economics, magico-religious ideas, language, knowledge, and art. It was clearly an ambitious, almost encyclopedic work; the economics section alone comprised fifteen chapters. There were to be in addition four large appendices offering a separate ethnography of the Amphlett Islands, a conjectural culture history of the northern Massim, an account of recent culture contact, and a comprehensive survey of Trobriand technology.

It is evident from letters to Elsie Masson that Malinowski took with him to Papua in October 1917 a substantial first draft of this hefty monograph.[66] During this final field trip he checked and cross-checked—"controlled" was his term for data validation—the information contained in its topical chapters against fresh information gathered from different informants. His fieldnotes reveal that in this respect Malinowski's fieldwork was indeed exemplary in its concern for accuracy of detail.

It seemed appropriate to incorporate "Kiriwina" into the title of the present book, not because it would commemorate a compendious monograph Malinowski never completed (choosing instead to launch a far more adventurous *Argonauts*), but because the name Kiriwina best captures the ethnographic location (anthropology's "sacred place") so abundantly pictured here. This book makes no attempt to follow the plan of the aborted monograph any more than it tries to be the "album" of photographs, referred to in my epigraph, that it fleetingly crossed Malinowski's mind to publish. By eliding the two imagined projects, however, a faint echo of both may be captured in a book which, although primarily a visual ethnography of Kiriwina, can also be read as a visual biography of Malinowski's Trobriand experience.

In his published ethnography Malinowski often generalizes (as do all anthropologists) from one or two witnessed events. The specificity of persons involved, of time

and place, are erased in the generalizing ethnographic account. Photography enables us, nay obliges us, to move in the other direction and refer the general back to particular persons, sites, and events: it has the *appearance* of history. The photographs can only be read as referring to their historical moment of execution, thereby enabling us (given additional information) to restore the events Malinowski annulled in his ethnography.

I have seen my primary task as one of presentation, and I have allowed Malinowski to speak for himself about what he was seeing or thought he was seeing. The readings of the photographs I offer myself are mainly surface ones, as are those given by contemporary Trobrianders. I have contextualized them ethnographically and, wherever possible, historically in terms of Malinowski's fieldwork as documented by his own diaries, fieldnotes, and letters. However, a fully Malinowskian interpretation of most of the photographs is greatly handicapped by the absence of his own captions, for he was only occasionally given to scribbling a word or two on the back of his prints. It seemed wise to resist the academic temptation to weave into my commentary interpretations of Trobriand ethnography by later scholars, as this would have introduced an additional layer of distracting complexity. To turn one of Malinowski's most famous phrases back upon himself, it is *his* vision of *his* Trobriand world that the photographs represent: thus my title. To have diluted this vision would have defeated the purpose of the book.

MALINOWSKI'S KIRIWINA can be viewed as a collation of linked photo-essays, grouped into sections (I wish to avoid the self-contained connotations of "chapters"). I make no special claim for their coherence or for the cogency of the themes that supposedly unites them. Photographic images overflow with implicit meanings, saying a great deal more than any written commentary, which can always be subverted by another, closer look. Photo-narratives likewise are inherently unstable structures, prone to subversion and collapse once their constituent images are mentally rearranged. Verbalized meanings are easily contradicted by a skeptical eye or an alternative arrangement of images in which previous meanings may collide, dissolve, or coalesce.

The sequencing of the fourteen sections of this work, then, should be regarded as indeterminate, a publishing convenience. It does, however, follow an ethnographic logic of sorts, one informed by Malinowski's own fieldwork. Initially, it occurred to me that I might be able to arrange the photographs in the chronological order of their execution. This soon proved to be impossible as Malinowski neither dated them nor kept lists of his collection, while the numbering system he devised offers no sure guide to chronological sequence (see appendix 2). Still, I have been able to

project a biographical dimension onto the ethnographic logic of many of the sections, a reflexive aspect augmented by citations from his diaries, letters, and field notebooks. The scheme of the book might be criticized for endorsing the heroic "euhemerist" myth of Malinowski the anthropologist ("A whole generation of [Malinowski's] followers were brought up to believe that social anthropology began in the Trobriands in 1914"[67]) by somehow denying its historicity (if only insofar as his two field trips seem here to have been collapsed into one). So be it. But the critical reader will find ample visual material here for further demystification.

Let me summarize briefly the photo-narrative of this book. The story begins in the colonial port of Samarai, Malinowski's "gate" to the Trobriands. What he would have regarded as an obligatory section on ethnographic method follows: a self-conscious attempt to locate himself in the field and to establish by visual means his ethnographic authority. Next we descend on Omarakana, heart of Kiriwina, home of the paramount chief, and the locus classicus of Malinowski's Trobriand fieldwork. Photographs of harvest gifts to Chief Touluwa lead us into another assemblage depicting the agricultural year, beginning with the burning of the gardens and concluding with yam harvest displays. Harvest is followed by a festive period of public dancing. Next we survey the variety of "physical types" Malinowski encountered on the imaginary Trobriand beach on which he was famously "set down"; there are European types on this beach, too, also deserving of scrutiny. Then we pause a moment to view a cluster of images of magical acts. Fishing and bartering on the Trobriand lagoon introduce additional activity, which is followed by a sequence of more static scenes of village life. Prominent in these are the daily activities of women. Visual exploration of their domain leads us, by way of pregnancy rites, into a "children's republic" of games and competitions. Next, we leap to the end of the life cycle which is represented by images of death, mortuary rites, and distributions of food and wealth. In part a bid for immortality, Kula is the most celebrated and spectacular Trobriand institution, and the longest section is devoted to a roughly chronological series of photographs of sailing and other Kula activities. The ethnographer's movements are here coordinated with those of an overseas expedition. Finally, as I believe Malinowski would have proposed, a group of photographs explores the visual interface between "black and white." The culture of colonialism here revealed loops back to the earlier images of Samarai and resonates iconically (and ironically) with the key tenet of Malinowski's ethnographic method, that of "living right among the natives."

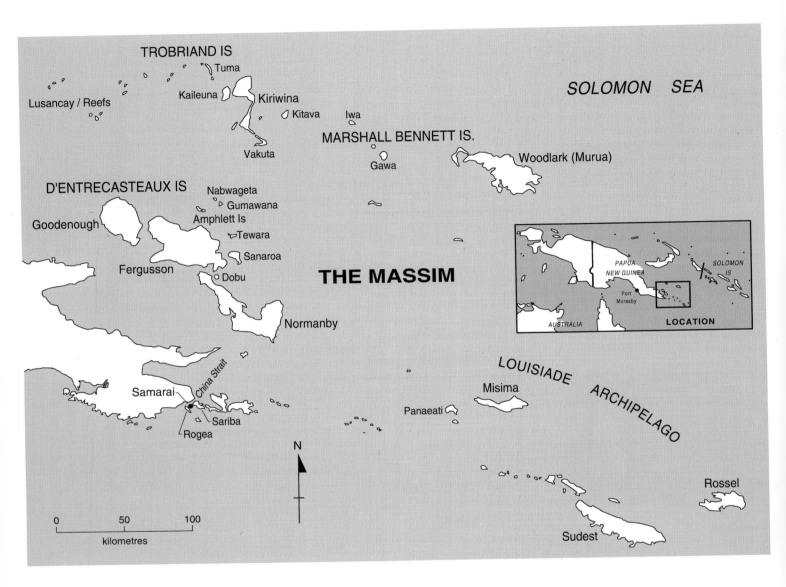

MAP 1 Location map of the islands of the Massim

A Note on Orthography

The Melanesian language of Kiriwinan (better known to linguists as Kilivila) belongs to the Oceanic branch of the great Austronesian family of languages. Malinowski's orthography is somewhat anomalous by modern standards. He made liberal use of the semivowel *y* which is less frequently used today, and the orthography of literate Trobrianders usually dispenses with the glottal stop: for example, "Tukwaukwa," though Malinowki's "Tukwa'ukwa" better conveys the pronunciation.

As in Italian and Spanish, vowels in Kiriwinan are voiced with a full, open value. Stress or accent, sometimes barely perceptible, usually falls on the penultimate syllable, though in longer words it may fall on the antepenultimate syllable. "Omarakana," for instance, is lightly accented on the second *a*.

It has proved impossible to be wholly consistent in the spelling of place names. While it is inadmissible to change Malinowski's spelling when directly quoting him, it seemed equally unacceptable to bring modern usage into line with his orthography. I have generally adopted the compromise solution of spelling a term or a name according to the context of its use, sometimes offering both versions.

Fortunately, Trobriand Islanders, perfectly accustomed to dialect differences between districts, are tolerant of inconsistency. They will have no difficulty in recognizing that Malinowski's "Olivilevi," "Okaiboma," "M'tava" and "Kwaybwaga," for example, are the same villages as "Oluvilevi," "Okeboma," "Mtawa" and "Kwebwaga." I trust other readers will make similar allowances.

A glossary of Trobriand terms can be found on page 283.

Trobriand Islands *Bronislaw Malinowski*

This general introduction to the Trobriands was written by Malinowski as a "label" to accompany the "collection of ethnological specimens from the Trobriand Islands" he presented to the National Museum in Melbourne in late 1919. The collection, which Malinowski named after his chief benefactor, Robert Mond, consisted of 282 artifacts and 33 photographs. This "label" is dated 20 February 1920. A lightly corrected copy accompanied the larger collection of over 600 items which Malinowski donated, on behalf of C. G. Seligman, to the British Museum in 1922. The typescript is in the possession of Helena Wayne and has not previously been published. —M. W. Y.

The Trobriand Islands, situated at the east end of New Guinea, are an archipelago of flat coral islands and reefs, placed around a very extensive lagoon, the Lusançay lagoon. There is one larger island, called by the natives Kiriwina or Boyowa, and a number of smaller ones.

They are rather densely populated—the total number of inhabitants may be estimated in 1920 at about 10,000—by natives belonging to a Melanesian tribe. These natives possess the same physical, cultural and linguistic characters [*sic*] as the numerous peoples living on the long chain of Melanesian islands and on the shores of the eastern half of New Guinea.

They are of a light brown colour, slightly built, and not very tall, with frizzly [*sic*] hair which grows into a big mop, though, as a rule, it is shaved off. Temperamentally they are merry, talkative and easy-going, and their skill, industry, and artistic capacities put them, culturally, into the first rank of Melanesian tribes.

Living on islands in a sea covered with archipelagoes, they are in constant commerce with their neighbours to the east, south, and southwest, though they never cross the seas to their north, which divide them from the big island of New Britain. Their sailings are connected with commercial exchange, as they are manufacturers of many important objects for export and keen traders. They never undertook [sic] for war expeditions overseas, and their external relations with the natives of the other archipelagoes (Woodlark Island, the Marshall Bennett Islands, d'Entrecasteaux Group and Amphlett Islands) were always peaceful.

Within their own archipelago they speak the same language, possess identical or closely similar institutions, produce and use the same type of material objects. In other words, culturally, they form one tribe. Politically, they were divided into several districts, each acknowledging one supreme leader, and these districts were often at war; and, in times of peace, the intercourse between them was restricted. Now, of course, under white influence, their wars are at an end and friendly relations obtain within the tribe. War was conducted according to well defined rules, and the bulk of fighting was done with spears and shields on an open space cleared in the bush.

Sociologically, the natives of the Trobriands are totemic, being divided into four clans with birds, animals and plants as linked totems. They count descent in matrilineal succession and the maternal uncle has a great influence over his nephew. Both sexes have a great deal of influence, and women have their own share in work, magic and tribal life in general. There is a good deal of freedom before marriage, laxity obtaining in the relations of the sexes, but, once married, a woman is expected to be faithful, and she is punished for adultery.

They live in large villages, often forming clusters. A village numbers, on the average, some 20–100 inhabitants, and a cluster of several villages might number several hundreds. Certain villages are mainly engaged in fishing, others carry on industries such as wood-carving, stone-polishing (now extinct), shell-ornament making, basket plaiting, etc. The products of such industries are traded all through the tribe and also exported. All villages own garden lands; agriculture is their main economic pursuit, and yam-food their staple nourishment. Hunting is of no account, as game—wild boars and wallabies—is very scarce in the densely populated district. Fishing is the second important pursuit, and, although only certain villages have access to sea and fishing facilities, there exists a system of exchange of fish for yam-food, which supplies the whole of the district with fish.

The life in the villages differs much according to season. They have a festive time after the main harvest, falling towards the end of the trade-wind (dry) season. Then the villages for about a month are full of life and colour and music; work ceases

almost completely and the natives spend their time in dancing, eating, and in visiting each other. At that season also, the dress becomes festive. The men put on new and well-finished pubic leaves, apply paint to their faces, and use ornamental walking sticks or other "ceremonial" weapons. On very festive occasions, nose sticks are put through the septum, aromatic leaves into the armlets, flower wreaths hung on the heads and shoulders. The dancers have a special head-dress of white feathers with red feather topping, and they wear cassowary feather tufts in their belts and armlets. They dance holding a pandanus streamer or with a carved dancing shield in their hands. The women, who decorate their bodies with almost exactly the same ornaments, use, moreover, the elaborate and gaudily coloured dress petticoats, so characteristic of this district.

The festive period lasts, as a rule, from July till October, but not all villages take part in it simultaneously. Then there follows the season of intense garden-making, the period when the selected garden site in the bush has to be cleared, burned off, cleaned, fenced round, and the yams planted. At times of garden work the villages look different: during the cool hours of the day men and women are away at work, the village is empty, festive dress and decorations are absent, and large crowds of people assemble for purposes of communal work, usually paid for by food, cooked and distributed by the garden owner to his helpers. Such food is usually cooked in large clay pots imported from the Amphlett Islands. The taro is prepared by beating, and, in cooking it, long wooden spoons are used.

Later on, when the bulk of the garden work is over, comes the trading season. Large bodies of overseas tribesmen visit the Trobriands. The articles of trade that loom by far most conspicuously in the native mind are the valuable armlets made of conus shell and the long necklets of red shell discs. There is a standing partnership in the trade of these two articles, which embraces thousands of natives living all over a wide area in the East Papuan Archipelago. This partnership comprises a ring, along which the two articles are constantly moving in opposite directions, as they pass from hand to hand. Thus a chief in the Trobriands will receive at a certain time a number of armshells, coming from Kitava, an island in the east. His partners in the west and south hear about it and come to him soliciting the armshells. He will give them a pair of armshells each, and, sooner or later, this [gift] will be repaid by a shell necklace. The transactions are never simultaneous; a man always gives or receives an article from his partner first, and the repayment follows.

This main trade in valuable, but useless objects of ornament—which are even very rarely used as ornaments—is accompanied with subsidiary trade in articles of actual practical value. In olden days the indispensable stone implements were thus

conveyed from Woodlark Island to the Trobriands, and pottery was imported from the Amphlett Islands. Again, industrial articles produced in Kiriwina were distributed by export over a large portion of the surrounding archipelagoes.

A most important point with reference to the natives of the Trobriand Islands is their belief in the all-embracing efficacy of magic. All their economic activities, gardening, fishing, trading, canoe-building and sailing, house-building and yam-storing, were intimately connected with complex magical systems, in which many spells and rites had to be uttered and performed before, during, and after ever so many acts. The rain or droughts, conduct of war, success in love, success and safety in the great overseas expeditions, inspiration for carving, the propitious conduct of great festivals—all of these phenomena or activities are, in the natives' mind, inseparable from magical ritual. Professional magicians, heirs to traditional lore, are the most important men in the community, side by side with the chiefs, and they receive large payments. The magical virtue resides in the traditional spell, whence it is imparted by the magician's breaths to some leaves or some other definite substance, and then by contact to the object or person bewitched. Or else the spell is uttered directly over the things or people.

Of all forms of magic the most important is sorcery. There are several causes of disease in the native mind. Evil beings of non-human nature may cause sweeping epidemics or innocuous pains. Female witches, who know how invisibly to fly through the air, attack people and cause their sickness and death, usually by removing or injuring some internal organ. But by far the most prevalent cause of disease is black magic uttered by a male sorcerer. The power of the sorcerer—or the fear thereof—was, and even now is, used as the main social force to avenge wrongs and punish crimes under tribal law, as well as to blackmail, attack and coerce an innocent victim. The Bwa'ga'u, as the sorcerer is called, is the object of fear and reverence, and men suspected or boasting of such powers have a high social status.

The spirits of the dead are not an object of fear, although they are supposed to manifest themselves to the natives at times. After death, the spirit goes to Tuma, an inhabited island to the northwest of the Trobriands, where he or she leads an existence similar to earthly life, and, once a year, during the festive season, all spirits of the dead return to their native villages. On such occasions their shadowy forms sometimes appear to the natives.

It is remarkable that, after the death of a man, the spirit leaves the body immediately and goes directly to the other world, without troubling at all about the many mourning and burial rites carried out by the survivors. These rites are complex and numerous, and they completely modify tribal life, especially after the death of a notable. There is also a series of ceremonial distributions of food, some four to eight,

extending over two or more years, according to the status of the deceased. In these distributions the maternal kinsmen of the dead one give payment to his other relatives, who had to perform the bulk of the mortuary duties. These consist of living in confinement, wearing black paint and relics of the dead; more especially, however, in cutting out and using as a lime-spoon the dead man's tibia bone; in using his jawbone as a necklet, and, in some cases, in using his skull as a lime-pot.

The pre-eminence of the Trobriand Islanders in wood carving is evident from a glance at any collection of their products. The carved prow boards on canoes, the ornaments on a chief's house, the dancing shields and the minor ebony carvings all possess real artistic value. There are professional carvers in most villages who hand down their art and the magic connected with it from maternal uncle to nephew. The beautiful art of burning in designs of lime pots, now extinct, was restricted to about four inland villages. The natives do not attach any magical importance to their carvings, nor can they give any consistent account of the meaning of their designs, which must be considered merely as traditional patterns handed down generation after generation.

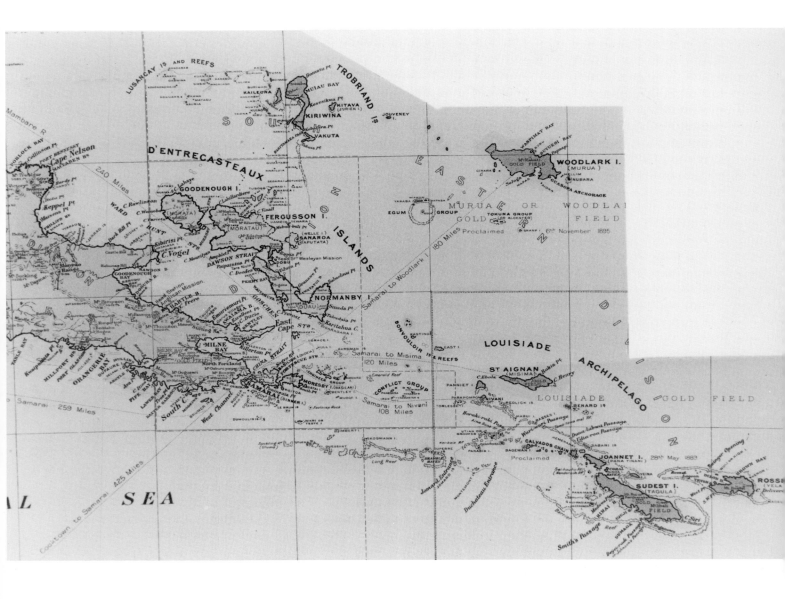

MAP 2 The eastern and southeastern divisions of Papua from a map appended to the second edition of
the *Handbook of the Territory of Papua*, compiled by Staniforth Smith in 1909 (Melbourne: J. Kemp). It was
the best general map available at about that time, and Malinowski would have studied it closely. Note the
number of gold fields indicated. The map domesticated a European frontier and evoked a gratifying sense of
colonial possession through the proliferation of English (and French) names. On the south coast, far left, is
the island of Toulon, better known as Mailu, which Malinowski studied in 1914–15.

Samarai, "Gate to the Field"

≒ 1 ≒

In July 1888 the British flag was raised over Samarai, a coral islet in the China Strait at the eastern end of New Guinea. It soon became a busy colonial port, exporting gold, pearls, copra, pearl shell, and bêche-de-mer. By the end of the century it had a wharf, a naval coaling station, administrative offices, a courthouse, a jail, and two general stores. A haven for gold prospectors and other white adventurers, Samarai boasted three hotels (one complete with lace iron balcony, shipped piecemeal from Cooktown in Queensland), where transient Europeans could play billiards, brawl, and drink incessantly.

For Samarai's hundreds of itinerant Papuans (for whom alcohol was forbidden by a native regulation), the island was a labor recruitment center where they "signed on" or were paid off at the end of their terms of employment in mines or on plantations.

To one Australian visitor, Samarai was "a mystic island, a toy domain . . . all palms and crotons set in a crystal sea."[1] By 1907 there was a population of about one hundred Europeans (which doubled within five years), a school for white children (the first in New Guinea), a rectory, a church, government buildings, and private residences (all of wood and roofed with iron). A few years later two hospitals were built, one for Europeans and the other for Papuans.[2]

By 1914, when Malinowski first entered this colonial scene, Samarai had already yielded its primacy as a port and center of government to Port Moresby, three hundred miles to the west. When bound for the Trobriands, however, he was obliged to call at Samarai to show his papers to the authorities, recruit his "native boys," purchase stores from Burns Philp, and await a small vessel to carry him one hundred

and fifty miles north through the D'Entrecasteaux Archipelago to Kiriwina. In June 1915 and November 1917 he was thus marooned on Samarai for several weeks; he enjoyed shorter visits in November 1914, March 1916, and September 1918.

The charm of Samarai's setting entranced Malinowski. Of his first approach, on 29 November 1914, he recorded, "We passed quite near Roge'a. . . . The palm trees bent over the sea protrude from the hedges of green thicket. . . . The hills and the all-powerful, lovely jungle a dark green, the transparent water bright green, the sky frozen in perpetually good weather, the sea a deep azure blue. Over it the outlines of countless distant islands; closer to me, I distinguished bays, valleys, peaks. The mountains of the mainland—everything immense, complicated, and yet absolutely harmonious and beautiful. —In front of me, Samarai in the calm languor of a beautiful Sunday afternoon."[3]

PLATE 1 The view to the mainland from near the top of the hill where the resident magistrate's bungalow was situated.

Samarai is really beautiful . . . and if I had you here even the tropical veil could be pierced and we could be in full possession of this venomous, exaggerated beauty. It is the contrast between this wonderful little island bathed in light and sea, with its palm-fringed walks and wide perspectives on smooth blue bays—and the miserable existence of the white men absolutely out of harmony with all this. *Malinowski to Elsie Masson, 12 November 1917, in Wayne,* The Story, *51*

PLATE 2

China Strait, looking toward the mainland. Malinowski sailed through this strait in February 1915, heading for Woodlark Island.

Sea perfectly smooth, two abysses of blueness on either side. To the right the indentations of Sariba, islands, islets, covered with tall trees. To the left, the shadows of distant mountains—the shores of Milne Bay. Farther, the shores move away on either side; to the left only the high wall of East Cape, covered with clouds, forming the threatening point of the horizon; to the right pale shapes loom up out of the eternity of blueness, slowly turning into volcanic rocks, sharp, pyramid-shaped, or else into flat coral islands: phantom forests floating in melting blue shapes. One after the other comes into being and passes away. Diary, *91*

[At sunset] the poisonous verdigris of Sariba lies in the sea, the color of blazing or phosphorescent magenta with here and there pools of cold blue reflecting pink clouds and the electric green or Saxe-blue sky.—Last night: sea and sky of a calm, intense blue, the hills shimmering with deep purples and intense cobalt of copper ore, and above them two or three banks of cloud blazing with intense oranges, ochers, and pinks. Diary, *115–16.*

SAMARAI, "GATE TO THE FIELD" 40

PLATE 3
Samarai wharf. The departing ship can be identified as a Burns Philp Company vessel, probably the *Makambo* on which Malinowski sailed from Sydney in late October 1917. The *Makambo* was built in Glasgow in 1907 and weighed 1,159 tons. While waiting on Samarai, Malinowski saw her revisit the island several times ("she arrived early this morning and now I can see her bridge and her grey funnel above the tin roofs of some houses").[4]

PLATE 4

Imagine one broad and short street with wooden and corrugated iron houses on both sides, all glaring white: the walls, the sand strewn street. . . . And a number of self-important mandarins strutting about, reserved and dignified and mixed with them the birds of passage, eager to expand and to spend, to shout [drinks] and chat. Which sort is the more dangerous and repulsive, I could not decide yet. I think the shouting invaders are better. *Malinowski to Masson, 29 November 1917, Malinowski Papers, LSE; see also Wayne,* The Story, *66*

PLATE 5

This quarry supplied dead coral fill for the malarial swamp in the center of the island, which by 1900 had been drained, filled, and converted into a cricket ground. In Malinowski's time the quarry was being used to maintain the seawall which ringed the island. The uniform waist-cloths of the laborers identify them as prisoners; 329 served time on Samarai in 1914–15 (200 of them for desertion from European employers).[5] On his first visit to Samarai, Malinowski was permitted to select informants from the jail ("the prisoners lined up; I picked out a few for the afternoon").[6] Three years earlier Diamond Jenness had taken similar advantage of the inpatients of Samarai hospital.[7] The anthropometry, linguistics, and ethnology of the period owed not a little to captive informants.

Malinowski too was a kind of prisoner. Although he felt "at home" on Samarai, its minuscule size induced a sense of "captivity." It became for him a symbol of "imprisonment in existence. . . . To get up, to walk around, to look for what is hidden around the corner—all this is merely to run away from oneself, to exchange one prison for another." Yet he could also view it in quite pragmatic terms: "I look upon my temporary imprisonment on Samarai as inevitable and desirable, provided I use this time to collect myself and prepare for ethnological work."[8]

PLATE 6 Samarai is encircled by a palm-shaded coral path which hugs the shoreline. It was named "Campbell's Walk" after the resident magistrate who built it with prison labor. It took only twenty minutes to circumambulate the fifty-five-acre island. Malinowski walked around it two or three times a day for exercise, sometimes sitting on a bench to write his diary entries.

Walked around the island with Ball. Lovely view. Sea at its Sunday best, the shore perfectly elegant, surf breaking, depositing a silvery foam at the foot of the gently tilting palms. Diary, *95 (25 February 1915)*

Then walked around the island: many people; boys eating *coconuts* and playing the flute. The half-civilized native found in Samarai is to me something a priori repulsive and uninteresting; I don't feel the slightest urge to work on them. Diary, *111 (12 November 1917)*

Walked around the island a second time; marvelous richly colored sunset. Roge'a: dark greens and blues framed in gold. Then many pinks and purples. Sariba a blazing magenta; *fringe* of palms with pink trunks rising out of the blue sea. —During that walk I rested intellectually, perceiving colors and forms like music, without formulating or transforming them. Diary, *125 (22 November 1917)*

❦

PLATE 7

"Gate to the field. No.1" was Malinowski's inscription on the reverse of this print, suggesting that he intended to use it as the first plate in his introduction to *Kiriwina*. The view is to the northeast: the Suau mainland on the left, Sariba Island on the right.

Waiting for a boat to the Trobriands, Malinowski wrote to Elsie Masson from his hotel room, "I am getting up and looking over the verandah railing to my right, where between the mainland and the island of Sariba, there opens a narrow strip of the sea, the China Straits, through which some happy day there will sail in the Ithaca, a cutter-rigged launch."[9] The cutter with the sail shown above might be the long-awaited *Ithaca*.

MAP 3 Malinowski's hand-drawn map of the
Trobriand Islands, showing the districts of Kiriwina.
(Original in Loose Fieldnotes X, folder 124, Malinowski
Papers, LSE.)

⊰ 2 ⊱ Picturing the Ethnographer

"Imagine yourself suddenly set down surrounded by all your gear, alone on a tropical beach close to a native village, while the launch or dinghy that has brought you sails away out of sight."[1] This romantically alluring opening to a famous passage at the beginning of *Argonauts of the Western Pacific* presages one of the principal methodological tenets of Malinowski's fieldwork: "to live without other white men, right among the natives."[2] Paradoxically, in order to illustrate this photographically he was obliged to recruit the assistance of a fellow white man, Billy Hancock.

Malinowski planned to write a methodological introduction to his *Kiriwina* monograph. No draft survives, but it was conceivably along the lines of what became his prescriptive introduction to *Argonauts,* which presented his innovations in fieldwork practice. First were the necessary conditions for intensive fieldwork: to live alone for a long period of time "right among the natives" and to learn to communicate with them through their own language. Second were various strategies for the collection of different classes of information, including the "statistical documentation of concrete evidence," the minute observation of the "imponderabilia of actual life and everyday behaviour," and the painstaking collection of a *corpus inscriptionum,* comprising vernacular texts of every kind.

Malinowski placed most of the photographs of himself in the field in a category labeled "Intro. the Ethnographer," by which he meant, presumably, not simply to introduce himself as the ethnographer, but to situate himself in the introduction as the instrument of ethnographic observation (as in "I am a camera").

It was toward the end of June 1915 when Malinowski first sailed to Kiriwina, the

largest of the Trobriand Islands, to be "suddenly set down," not on a tropical beach but on a rickety wharf. The islands had suffered a drought and the yam harvest was poor. Malinowski spent a few weeks as the guest of Assistant Resident Magistrate R. L. Bellamy before crossing the island to pitch his tent in Omarakana. The population of the Trobriands was estimated to be about 8,500 in 1915; the white residents numbered thirteen, all but four of them pearl traders and plantation owners.[3]

PLATE 8

Malinowski's caption on the back of this photograph reads, "Government Station, Trobriands." The site is locally known as Kebutu, though the station is called Losuia (which, along with other European sites, Malinowski deliberately omitted from his hand-drawn map of Kiriwina).

Colonial power is seemingly incarnated in this sturdy house, with its sweeping verandas and vaulted iron roof in typical Queensland style. Modern Trobrianders were impressed by this image; the house is evidently larger and better built than any of the present-day buildings in Losuia. It was the living quarters of the assistant resident magistrate. "Doctor" Bellamy lived here until October 1915, when he left to fight in the Great War. He was replaced by A.R.M. John Norman Douglas Campbell—nicknamed "30%" by Malinowski and Billy Hancock, presumably as a reflection on his intelligence.

"I fancy my district will show its heels to the rest," Bellamy had claimed, and under his administration Losuia was indeed one of the best-governed and most progressive stations in Papua.[4] But on his return to Kiriwina in 1917, Malinowski felt only contempt for the white inhabitants of Losuia. In reference to John Campbell and H. A. Symons, another A.R.M., he noted, "Depressed by what I have seen in Losuya: rotten people and life [both their lives and functions are disgusting]. I shudder at the thought of how life looks from their point of view. . . . These fellows have such fabulous *opportunities*—the sea, ships, the *jungle,* power over the natives—and don't do a thing!"[5]

·彩·

PLATE 9

This photograph of Malinowski's tent in Omarakana is distinguished by the *absence* of the Ethnographer, whose seated, silhouetted profile appears in its companion image, reproduced by George Stocking as an "ironic icon" of Malinowski's "ethnographic method and anthropological (cum colonial) authority." The group outside the tent, Stocking suggests, are "observing their momentarily non-participant observer self-absorbed in the work of representing them."[6] (Malinowski was equally likely, of course, to have been writing to his fiancée.)

The observer standing stiffly in front of the tent is Malinowski's "favourite informant" and "best friend," Tokulubakiki, the son of Molubabeba, a member of the chiefly Tabalu subclan. The roof of Bagidou's house can be seen behind him, a house that was built in 1917 and therefore dates the photograph to Malinowski's second sojourn in Omarakana. His camp bed is clearly visible, as is his table of patent medicines to the right.

On 7 June 1918, the day he arrived in Omarakana, Malinowski wrote to Elsie Masson, "Then I supervised the erecting of my tent, which was put up quickly and well (sometimes they make it crooked or too low or too high). . . . Then turned up my favourite Tokulubakiki a decent, honest, straightforward man, as far as they make them here. There were of course all the guya'us [chiefs]: Toulu[wa], cadging [tobacco] right out. There was Bagido'u, his *kadala* (sister's son) and heir apparent. . . .

I am writing this about 9 P.M. The bulk of my friends have dispersed after energetic requests. A few select ones are still here, perched on my boxes, all round my table, looking at my writing and from time to time passing some remark sotto voce about some of my things."[7]

PLATE 10

Billy Hancock with camera in Tukwaukwa, a village near his place at Gusaweta. Judging by the fresh pandanus roof of the yam house, the month is July or August, and the year must be 1918. As many other photographs show, this particular corner of the *baku* (central place) of Tukwaukwa seems to have been a favorite location for posing subjects.

PLATE 11

Malinowski with his "snapshot" camera in a complementary take by Billy. The identity of the bored-looking individual with the camera box slung over his shoulder intrigued Linus Digim'Rina, "His face isn't that of a Trobriander and his stomach is too fat for him to be a regular gardener. His waist-cloth suggests that he works for a white man." Could this be Ogisa, we wondered, the manservant Malinowski "abducted" from Dobu?[8]

PLATE 12

On the reverse of this print is the caption "Village scene (and Methods)." The method being demonstrated is perhaps that of the itinerant village census (complete with line of compliant informants and Ethnographer with camp chair and table). But certain details do not support this interpretation. The majority of the seated "informants" are children. The water tank to the left and the nontraditional design of the dilapidated house betray a European settlement of some kind. The curiously disengaged pose of the Ethnographer suggests a tea break—are those cups on the table? Glimpsed through the wall to the right is a white object which Linus identified as the *tabuyo* (prowboard) of a toy canoe.

Linus guessed that this might be the abandoned house of Billy Hancock at Sinaketa in which Malinowski stayed for about a week in April 1918 ("I have an overgrown wilderness of betel palms, pawpaws, coconuts—all chokeful [*sic*] of weeds—in front of me"). But it is unlikely that Malinowski would have described this house to Elsie Masson as "pleasant-looking."[9]

PICTURING THE ETHNOGRAPHER

THE FOLLOWING GROUP of photographs was probably intended to illustrate Malinow-
ski's close working relationship with his informants—the intimacy of his ethno-
graphic style. With one exception they must have been taken by Billy Hancock. The
occasion may have been 2 January 1918, when Malinowski was at Billy's place at
Gusaweta and "Fellows from Omarakana" turned up. Malinowski and Billy then
spent a busy day doing photography ("used up 6 rolls of film").[10]

PLATE 13

Malinowski holds up a *solava* (shell necklace) decorated with shaped and crimped
pandanus leaves. Partly obscured by the necklace is Namwanaguyau, Chief Touluwa's
favorite son, who seems to be holding his father's limepot, as is his privilege. The
man wearing a waist-cloth and holding a staff is probably a village policeman (a
government-appointed official). Left to right from Namwanaguyau: Tokulubakiki,
Mitakata (brother of Bagidou), Kalogusa (another son of Tolouwa), Touvesei (Mali-
nowski's Towese'i, brother of Bagidou), and two unidentified boys, the last holding a
valuable whalebone spatula.

PLATE 14

From youth everyone in the Trobriands chews betel (or areca) nut, a mild narcotic and social lubricant. Hancock (left) is applying powdered lime to his mouth; Malinowski appears to be merely pretending to chew. (In 1917–18 his new false teeth would have frustrated any enjoyment.) All three men hold chiefly limepots. Now it is Malinowski who holds the whalebone limestick, which only "nobility" are privileged to rattle noisily in the gourd. The *solava* with its pandanus streamers dangles from his arm. The Trobriander seated next to Malinowski is Toguguwa (Malinowski's Tugugu'a), "a sorcerer of some repute and a good informant." He appears here without his wig.[11]

PLATE 15

Malinowski inspecting the *solava* of a Tukwaukwa girl. According to a note on the back of the print, he proposed to use this provocative image as the frontispiece to *The Sexual Life of Savages.* He was presumably dissuaded from doing so by his wife or his publisher. A companion shot taken on the same occasion was published as plate XIX in *Argonauts* ("Two Women Adorned with Necklaces") to illustrate the manner of wearing *solava*.[12]

PLATE 16

Linus identified the village as Kasanai, which adjoins Omarakana, and the decorated house as therefore belonging to Chief Kwewaya. The man holding Malinowski's briefcase cannot be identified.[13] Malinowski's caption on the print states only that it is a *bukumatula,* or bachelors' house (which they share with their lovers). The interpretations are quite compatible; "A young chief's *lisiga* [today *ligisa*] (personal hut); is as a rule used also to accommodate other youths and thus becomes a *bukumatula* with all that this implies."[14]

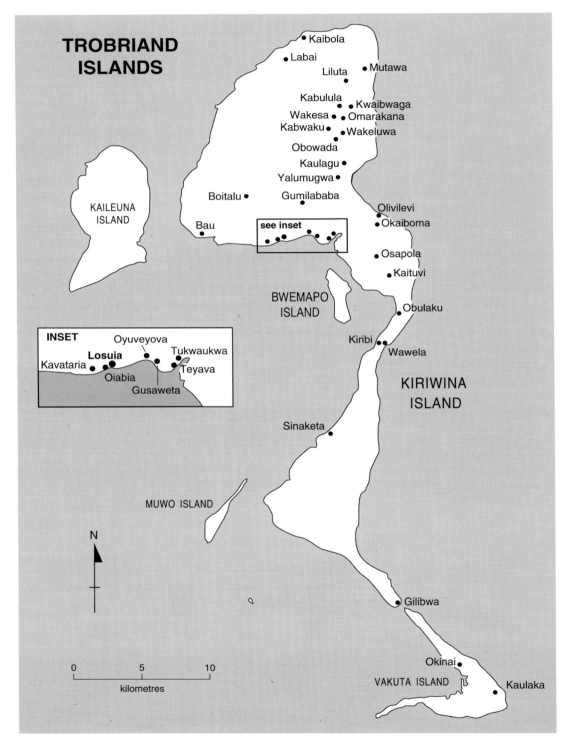

TROBRIAND ISLANDS

- Kaibola
- Labai
- Mutawa
- Liluta
- Kabulula
- Kwaibwaga
- Wakesa
- Omarakana
- Kabwaku
- Wakeluwa
- Obowada
- Kaulagu
- Yalumugwa
- Boitalu
- Gumilababa
- Bau
- see inset
- Olivilevi
- Okaiboma
- Osapola
- Kaituvi
- Obulaku
- Kiribi
- Wawela

KAILEUNA
ISLAND

BWEMAPO
ISLAND

KIRIWINA
ISLAND

INSET

- Oyuveyova
- **Losuia**
- Tukwaukwa
- Kavataria
- Teyava
- Oiabia
- Gusaweta

- Sinaketa

MUWO ISLAND

N

- Gilibwa

- Okinai
- Kaulaka

VAKUTA ISLAND

0 5 10
kilometres

MAP 4 The Trobriand
Islands, showing only
those villages mentioned
in the text. The spellings
of some names are inde-
terminate.

Touluwa, Chief of Omarakana

The village of Omarakana is, in a sense, the capital of Kiriwina, the main district of these islands. It is the residence of the principal chief, whose name, prestige, and renown are carried far and wide over the Archipelagoes, though his power does not reach beyond the province of Kiriwina.
MALINOWSKI, *The Sexual Life of Savages*

Malinowski spent most of his first year's fieldwork based in Omarakana. As a minor Polish nobleman himself, he had a natural affinity for the chiefly subclan of Tabalu of Malasi clan (the highest ranking Trobrianders), from among whom he recruited many of his best informants. There is little doubt that his long sojourn among the chiefly Tabalu (whose families occupied more than half of the village) shaped and colored his perspective of Trobriand society as a whole. He certainly took a strongly Omarakana-centric view on some matters, most evident in his disdainful depictions of the "pariah communities" of Bwoitalu and Bau, as if he had internalized the disgust of the highest rank for "the lowest of the low."[1] Even so, it would have been unduly perverse to have shunned Omarakana as a first field base in favor of a "commoner" village. In 1918 Malinowski deliberately sought to balance his "aristocratic" perspective by living for three months in nonranked Oburaku, though he was pleased to return to Omarakana for six weeks toward the end of his fieldwork.

Malinowski's rhetorical usage of "aristocrat," "commoner," "vassal," "court," "tribute," "insignia of rank," "hereditary office" and so forth is redolent of feudal Europe rather than Melanesia. Several commentators have claimed that he exaggerated the degree of rank and power of the so-called paramount chief (a designation applied

cautiously by Charles Seligman) by casting him in a Polynesian mold and generally glorifying his precontact status.[2]

Although their relationship did not always run smoothly (to Malinowski's annoyance, Touluwa refused to take him on Kula expeditions), Malinowski photographed Chief Touluwa more often, and wrote more about him, than any other Trobriand individual. He features in several plates in all three monographs, and many other photographs of him in the collection are variously categorized under "Chieftainship," "Kula," "Canoes," and "Personalities."

Something of the flavor of the relationship between ethnographer and chief is conveyed in Malinowski's diary and in his letters to Elsie Masson. For example, on 15 December 1917, a few days after settling into Oburaku, Malinowski was paid a "state visit" by Touluwa. It was their first meeting for almost two years. In his diary Malinowski noted, "We greet each other as friends. He spoke about me and praised me. Despite everything there is a certain residue of sympathy. He stood over me with a half-ironical, half-indulgent smile, telling about my exploits. Joke about our *kula*."[3] The account he wrote for Elsie is much more detailed:

I was in the middle of my census working . . . when word went round that To'uluwa is approaching the beach on the way to Sinaketa, going there for *kula* purposes. . . . He stopped some distance and one of his sons Namwana Guyau came to me. You know him by name, no doubt: it is the favourite son of T., the one who had been banished from Omarakana, a young but dangerous Sorcerer and one of my best informants. He was not sure of the reception, but I gave him at once a stick of tobacco as a pledge of my good and friendly feelings and we both unbent and I think there was just a shadow of real friendliness in our meeting. . . . Then I promised 1 stick of tobacco to T[ouluwa] and he came and stood over my chair, with a grin—half-indulgently ironical, half friendly and propitiary. T. is in mourning, two of his fourteen wives having died some months ago. He is quite blackened and looks rather funny. He had a long harangue to the audience, recording scenes from our acquaintance and explaining [to] them my work, aims and habits. It was meant quite benevolently and in general it was the silhouette of an innocent lunatic that emerged from his descriptions. . . . The whole time the poor man had to stand on his legs, to preserve his dignity, till after about an hour, he scrambled high up near the roof of a *bwaima* [yam house] and perched there his enormous body.[4]

The banishment of Namwanaguyau from Omarakana was "one of the most dramatic" incidents Malinowski witnessed in the Trobriands.[5] It was rooted in the long-standing feud between Touluwa's numerous sons (who lived in Omarakana and whose company he preferred) and his maternal kinsmen and heirs (notably his classificatory sister's sons Bagidou and Mitakata). Mitakata aggravated matters by con-

ducting an intrigue with Namwanaguyau's wife, Ibomala. Namwanaguyau responded by bringing his rival before the white resident magistrate at Losuia and having him charged with adultery. Mitakata was convicted and sentenced to a month in jail. That same evening, Bagidou, supported by other maternal kin of the chief, publicly spoke "the formula of chasing away," a decree of exile, which gave Namwanaguyau no choice but to leave Omarakana. Before the night was out he had departed to live thereafter in Osapola, his own (that is, his mother's) village. Malinowski described the reactions of Namwanaguyau's immediate family: "For weeks his mother and sister wailed for him with the loud lamentations of mourning for the dead. The chief remained for three days in his hut, and when he came out looked older and broken up by grief. All his interest and affection were on the side of his favourite son, of course. Yet he could do nothing to help him."[6]

Malinowski's notebooks indicate that Namwanaguyau's banishment occurred on 9 December 1915, some six months after the ethnographer's arrival in Kiriwina.[7] The "acute upheaval" this incident caused influenced his fieldwork and his photography in subtle ways.

The chief's resentment against his kinsmen was deep and lasting. At first he would not even speak to them. For a year or so, not one of them dared to ask to be taken on overseas expeditions by him, although they were fully entitled to this privilege. Two years later, in 1917, when I returned to the Trobriands, Namwana Guya'u was still resident in the other village and keeping aloof from his father's kinsmen, though he frequently visited Omarakana in order to be in attendance on his father, especially when To'uluwa went abroad. His mother had died within a year after his expulsion. [She was Kadamwasila, Touluwa's favorite wife.] As the natives described it: "She wailed and wailed, refused to eat, and died." The relations between the two main enemies were completely broken and Mitakata, the young chieftain who had been imprisoned, had repudiated his wife, who belonged to the same subclan as Namwana Guya'u. There was a deep rift in the whole social life of Kiriwina.[8]

PLATE 17

When a chief is present, no commoner dares to remain in a physically higher position; he has to bend his body or squat. Similarly, when the chief sits down, no one would dare to stand. The institution of definite chieftainship, to which are shown such extreme marks of deference, with a sort of rudimentary Court ceremonial, with insignia of rank and authority, is so entirely foreign to the whole spirit of Melanesian tribal life, that at first sight it transports the Ethnographer into a different world. Argonauts, *52*

Touluwa seated on his platform (*kubudoga*) outside his decorated house (*ligisa*) in Omarakana. The humble hut of the garden magician, Bagidou, is in the background, and situated behind that was Malinowski's tent. The roofed shelter to the left is for visitors. (On the same spot today is the *ligisa* of Daniel Pulayasi, the present chief of Omarakana.) A number of empty baskets suggests that this is harvest time and that the seated men (no women are visible) have just delivered their customary donations (*urigubu*) to the chief's yam stores. They are perhaps watching others construct heaps of yams for display.[9]

Linus commented, "According to Chief Pulayasi, the two long poles leaning

against the roof of Touluwa's *ligisa* are called *kenobiluma* and *kenobeu*. They are specially carved and are used for scaffolding (*unawana*) for the repair of Touluwa's main yam-house, *Dubirikwayai*." The renovation occurred in July 1918, so the photograph can be dated accordingly.[10] Namwanaguyau can clearly be seen seated to the left of Touluwa's platform.

PLATE 18 This photograph probably was taken on the same occasion as plate 17, that is, the yam harvest of July 1918. Touluwa is squatting on the ground, left. The reverse of the print has "Personalities."

On seeing this picture of his squatting maternal ancestor, Chief Pulayasi exclaimed, "*Giyopwawa!*" ("Ruling with his wrinkled testicles!"). He intended it as an expression of respect for the aging but still powerful chief.

Linus remarked, "No one can walk in front of him, so he would have to stand up if anyone wanted to leave. He is holding his *dum,* decorated bamboo pipe. According to Chief Pulayasi, this pipe was taken by Namwanaguyau as a relic when his father died. And when Namwanaguyau himself died the pipe was buried with his body, though this had to be authorized by Chief Mitakata, his old enemy. (Mitakata had succeeded Touluwa, despite Malinowski's doubt that he would.) There are two conch shells ('symbols of chieftainship,' as Malinowski called them) on Touluwa's sitting platform. The men immediately in front of him are mostly his sons. At the back is Bagidou, his heir (though he died before Touluwa). In the middle, with a characteristic *butia* garland around his head, is Namwanaguyau. And nearest to the camera, his brother Yobukwau with his head shaved. Namwanaguyau looks older. This is two years after his expulsion from his father's village."[11]

Recalling the photograph in *The Sexual Life of Savages* and the legend in which Malinowski notes the fraternal similarity between Namwanaguyau and Yobukwau, Linus remarked, "Malinowski describes how he upset people by saying this.[12] Even today, one has to be careful how to phrase physical resemblance if it refers to the female line. We can say vaguely that 'He has the look of such-and-such a *dala.*' But we cannot say pointedly that he looks like a particular member of his *dala.* It's very subtle. People still get upset if they are likened to their brothers or sisters. It's perfectly all right, of course, to say that you look like your father."

—※—

PLATE 19 Another view of the center of power in Kiriwina, with Touluwa standing on the left in his characteristic pose.

[Touluwa] was a conspicuous presence in the village, sometimes squatting on the ground in front of his hut or storehouse, sometimes perched high on his *kubudoga*. . . . He was a shrewd, well-balanced man, but his pride had been broken by the European invasion, and he had retired from most of his offices. He also had a bad memory and was not well versed in magical lore. The garden magic he had therefore delegated to his matrilineal nephew and direct successor, Bagido'u, the heir-apparent to the chieftainship. Coral Gardens, *84*

The "broken pride" of the chief was in part accomplished by Bellamy, the A.R.M. at Losuia. In 1910–11 he convicted Touluwa (who in that year had seventeen wives) of conspiring to sorcerize his traditional enemy, Moliasi of Kabwaku, and jailed him. It amused Bellamy that even in jail the other prisoners "bent double" in Touluwa's presence. "No man can use a crowbar properly lying on his stomach."[13] He then tried to humiliate Touluwa by forbidding the men to adopt their postures of obeisance.

Touluwa's yam house appears to have its new roof, so the photograph was probably taken in July 1918.

TOULUWA, CHIEF OF OMARAKANA

In that year it became necessary to rebuild the main storehouse of To'uluwa which was falling to pieces, and to repair a number of his smaller storehouses, each of which was assigned to a special wife. Also in that season (1917–18) the natives of Kiriwina wanted to express their loyalty to the chief, very largely, I think, to remove the tension and hostility which had crept into the relations between the villages after the expulsion of the chief's eldest son in 1915. Coral Gardens, *211*

PLATE 20

This is the recently re-roofed yam house of Touluwa, taken from the side closest to his *ligisa*. "The main storehouse of the Trobriands," is Malinowski's caption to a companion shot, taken from the other side.[14] The scaffolding ladders used when thatching the roof are still in place. Just behind it to the right is the *milamala* platform, and in the background to the right of that, Malinowski's tent.

The headman of Omarakana, and chief of Kiriwina, is supreme in rank, power, extent of influence and renown. His tributary grasp, now considerably restricted by white men and crippled by the disappearance of some villages, used to reach all over the northern half of the island and comprise about a dozen communities, villages, or sub-divisions of villages, which yielded him up to sixty wives. . . . Each of these brought him in a substantial yearly income in yams. Her family had to fill one or two storehouses each year containing roughly five to six tons of yams. The chief would receive from 300 to 350 tons of yams per annum. The quantity which he disposes of is certainly sufficient to provide enormous feasts, to pay craftsmen for making precious ornaments, to finance wars and overseas expeditions, to hire dangerous sorcerers and assassins—to do all, in short, which is expected of a person in power. Sexual Life, *112–13*

The Omarakana chief's yam house is called *Dubirikwayai* (a term Malinowski does not mention). According to Pulayasi, "*Dubirikwayai* means something like 'darkening-dusk.' The name itself commands respect and awe. The storehouse is dark and shadowy from the mass of yams inside, which allows no light to penetrate. It is well known that when men climb inside to remove yams for feasts, they become saturated with sweat, feel suffocated, and their skins are pierced by the prickles of the germinating tubers."

Bagidou can just be seen peering around the back of the yam house, and that is probably his wife squatting to the left weeding the *baku*, a rubbish basket behind her. Chief Pulayasi recalled of Bagidou, "In addition to being a famous garden magician (*towosi*), he was a seductive and mischievous singer. After the death of his wife he moved his house closer toward the *baku*, so that he could woo the wives of his neighbors and lure them into his house at night."

⊰⊱

PLATE 21

Malinowski with his favorite Omarakana informants in Tukwaukwa, seated on the same coconut logs that appear in many other photographs. Namwanaguyau, who now holds the whalebone limestick (see plate 13), is on Malinowski's right, and next to him is his "implacable enemy" Mitakata. Tokulubakiki is on Malinowski's left, then Kalogusa, Touvesei, and the anonymous village policeman.

It was Chief Pulayasi who identified the man sitting beside Namwanaguyau as Mitakata. Linus had earlier rejected this identification, arguing that in view of the enduring hostility between them Mitakata and Namwanaguyau would never be seen in such close proximity. (Malinowski had written that in 1917 Namwana-guyau's "hatred of Mitakata was as implacable as ever."[15]) But if Pulayasi is right and this man is indeed Mitakata, the photograph suggests he and Namwanaguyau had settled some of their differences by early 1918.

Malinowski spoke ambivalently of Mitakata ("my most faithful adherent, though personally I don't like him so much"[16]) and rarely referred to him in the role of informant, but he continued to seek out Namwanaguyau and photographed him frequently. There are comparatively few photographs in which Mitakata appears.[17]

PLATE 22

Another arrangement of the same group of Omarakana men in a somewhat differ-
ent location. Malinowski clutches his leather attaché case, and it is now Kalogusa
who holds the *solava*.

Pulayasi was inspired by these photographs to recall the legendary attributes of
two of these men: "Mitakata, who became chief after Tolouwa, is remembered for
his meticulous attention to his appearance. He would take an hour to complete his
toilet. Tokulubakiki is remembered for his great skill in decorating the gable boards
(*bomelai*) of the chief's dwelling house and yam hut, as well as for his 'clear mind'
(*kwegivayelu* or *sopi*)."

Malinowski documented the amorous affairs and characterized the marriages of
several of these men in *The Sexual Life of Savages*. For example: "Kalogusa and his wife
. . . I found as good comrades after two years of marriage as in the days of courtship.
And Kuwo'igu, the wife of my best informant and chief favourite, Tokulubakiki,
made him a good mate, for the two were well-matched in looks, in dignity, in decen-
cy of character and in sweetness of temper. Mitakata and his wife Orayayse, before
their divorce, Towese'i and Ta'uya; Namwana Guyau and Ibomala were all, in spite
of occasional differences, excellent friends and companions."[18]

4 Coral Gardens and Their Harvests

The Trobriander is above all a cultivator, not only by opportunity and need, but also by passion and his traditional system of values. MALINOWSKI, Coral Gardens

Malinowski's own passionate interest in the magic of gardening was quickly engaged. Barely weeks into his first stay in Kiriwina, he wrote enthusiastically to his supervisor, Seligman (who had done some survey fieldwork in the Trobriands eleven years earlier), "There are lots to be done . . . and things of extreme interest. There is their whole system of 'ceremonial gardening'—almost an agricultural cult (in the Durkheimian sense)."[1]

In his magnum opus on Trobriand gardening, Malinowski returned again and again to "the relation between purely economic, rationally founded and technically effective work on the one hand, and magic on the other," claiming grandly that "[t]he organising function of magic and of belief is, from the theoretical point of view, perhaps the most important contribution which our knowledge of Trobriand agriculture will allow us to make to the study of man."[2]

Despite a great decline in magical observances, modern Trobrianders continue to take immense pride in their gardens. They are no less proud of their reputation of being the best gardeners in the Massim, a reputation dating back to the mid-nineteenth century, when whalers and other sailing ships took to calling at Kiriwina to exchange hoop-iron for yams.

In gardening the natives produce much more than they actually require, and in any average year they harvest perhaps twice as much as they can eat. Nowadays this surplus is exported by Europeans to feed plantation hands in other parts of New Guinea; in olden days it was simply allowed to rot. Again, they produce this surplus in a manner which entails much more work than is strictly necessary for obtaining the crops. Much time and labour is given up to aesthetic purposes, to making the gardens tidy, clean, cleared of all débris; to building fine, solid fences; to providing specially strong and big yam poles. All these things are to some extent required for the growth of the plant, but there can be no doubt that the natives push their conscientiousness far beyond the limits of the purely necessary. The non-utilitarian element in their garden work is still more clearly perceptible in the various tasks which they carry out entirely for the sake of ornamentation, in connection with magical ceremonies and in obedience to tribal usage.[3]

Malinowski published 116 of his best photographs on the subject of gardening in Coral Gardens. Those that appear here are gleanings from the residual collection of about fifty in his category "Gardens and Harvest."

PLATE 23

Bukuyoba, the eldest of Touluwa's inherited wives, and Molubabeba, father of Malinowski's informant Tokulubakiki, burning the garden (wagabu) in Omarakana.[4] They are using special torches bespelled by Bagidou, the garden magician, for this inaugural rite of ritual burning called vakavaylau. Bukuyoba wears a rolled up skirt on her shaven head as protection from the sun.

Malinowski described this scene in Coral Gardens: "When I accompanied Bagido'u on the Vakavayla'u ceremony of September 11th, 1915, the chief himself went with us, rather in attendance on me than on the garden I suspect. The chief's eldest wife, Bukuyoba, came also, and about half a dozen men. . . . At my first vakavayla'u, the chief, Touluwa, himself took one torch, his eldest wife another, Molubabeba, the chief's maternal first cousin, another, Bagido'u yet another and, standing to the windward of the garden, they applied the torches simultaneously to the cut scrub."[5] Linus commented, "It doesn't burn thoroughly if you stay to windward. The best strategy is to walk at right angles to the wind, so the rubbish burns behind you as you move on."

CORAL GARDENS AND THEIR HARVEST

73

PLATE 24

"Bwaydeda at Gibuviyaka" is Malinowski's caption on the back of the print. Gibu-viyaka, literally "the big burning," is the second inaugural burning performed the day after the first firing of the scrub. Unburned debris is collected into heaps, into which bundles of magical herbs are inserted, and then burned.[6] Bwaideda was the towosi of Obowada village, near Omarakana. The photograph appears to have been posed.[7] Linus remarked, "The line of men behind the squatting magician probably comprises his sons, sisters' sons, and other men of his dala [subclan]. Some are hold-ing torches made of coconut spathes, the ends of which have been split open and bespelled. Others hold digging sticks and spears."

Plate 25 shows one of the kamkokola ceremonies Malinowski witnessed in October 1915 in Kurokaywa (now Kulokwaia), near Omarakana. Kamkokola are "magical prisms," "non-utilitarian, geometrical erections at the corner of each [garden] plot."

PLATE 25
They are erected soon after the tetu yams (Malinowski's taytu, Dioscorea esculenta) have been planted. "Thus, at one stroke, the garden is provided with a third, the vertical dimension. . . . I have no doubt that [the gardeners'] aesthetic appreciation merges into a mystical feeling that the height and strength of their vertical system, and above all of the kamkokola, has a stimulating effect on the young plants."[8]

On the left, shouldering his ceremonial ax, is Nasibowai, the towosi and headman of Kurokaywa.[9] Linus commented, "Nasibowai is charming two bunches of leaves hung on the pole held by the man in front of him. According to Chief Pulayasi, after the towosi has bespelled the leaves he distributes them to each gardener for them to bury at the base of their kamkokola poles. The seated women have baskets and platters of food. Recently introduced maize can be seen growing on the left."[10]

Shortly after this, a food distribution (sagali) was held in the garden, which was both an offering to the ancestral spirits and a payment to the towosi and his helpers.[11]

PLATE 26

Taytu, the staple food, is to the native *kaulo,* vegetable food *par excellence,* and it comes into promi-
nence at harvest and after. This is the sheet-anchor of prosperity, the symbol of plenty, *malia,* and
the main source of native wealth. Coral Gardens, *81*

Malinowski's caption is simply "Gardens." These small boys would have their own
garden plots. "The age at which boys begin to make their own gardens is exceeding-
ly early [as young as six]. . . . The heavier labour is, of course, done for them by their
elders, but they have to work seriously for many hours at cleaning, planting and
weeding, and it is by no means a mild amusement to them, but rather a stern duty
and a matter for keen ambition."[12] The boys are almost camouflaged by the foliage.
The staked tetu behind them shows that the garden is on the other side of the stile.
Such stiles are "the centre of most magical activities throughout the cycle."[13] The
luxuriant growth of the yam leaves suggested to Linus the end of the period called
basi, late March or early April. Harvesting will soon begin.

PLATE 27 "Public display of first-fruit yams after the preliminary garnering in Teyava" is Malinowski's caption on the reverse of this print. (Linus guessed correctly: "The baku of Teyava. The men are deliberating over the distribution of first-harvest yams.") To this Malinowski added his idea for placing it in *Coral Gardens*: "In Intro. or Ch. I or as Frontispiece to Ch. V." In the event, he discarded it altogether and used what became plate 50 instead, a closer shot of the same group of men.

The garden magician performs magic called isunapula. Taking taro tops and one kui yam (Dioscorea alata) from his exemplary garden, he places them in the rafters of his house as offerings to the ancestral spirits. "On the third day after all this the men repair to the garden and each one pulls up a few taro plants and digs a few yams from his plot. These first-fruits of the gardens are brought to the village, and a part of them is displayed on the baku, the central place. Another part is put as an offering on the graves of the newly dead by their relatives."[14]

PLATE 28

"Display of first-fruits: taro harvested after the inaugural rite" is Malinowski's caption to a companion photograph.[15] The legend identifies the village as Tukwaukwa, points out that the yam storehouses are quite empty, and indicates the pig, "still alive and trussed on a pole," slung beneath the beams of the largest yam house.

Linus commented, "Isunapula was inaugurated by the garden magician in February or March, between the lean period and the main harvest. The pragmatic reason for this preliminary feast is to keep people going with taro and yams that have ripened early. The village is Tukwaukwa; you can see the inlet through the trees. This is the baku where Malinowski and Billy Hancock seem to have taken so many of their shots, especially to the side of that large yam house to the right. This must be the Tabalu Chief Mosiribu's bwema. He died in 1952, having always asserted the primacy of the Tukwaukwa Tabalu over that of Omarakana."[16]

Malinowski considered Mosiryba [sic] to be "worthless as an informant," and some thirty years later Father B. Baldwin, a Catholic missionary and long-term resident of Tukwaukwa, found him "laborious to talk with," though "there was always more thought in his conversation than there was in [Chief] Mitakata's."[17]

MALINOWSKI'S CAPTION on the reverse of the next three photographs is "Sagali at Kaytuvi" (a village to the north of Oburaku in Luba district). The only record in his diary of a sagali at Kaytuvi (now Ketuvi) is 6 March 1918: "In Kaytuvi I worked honestly for 3 hours, with camera and notebook, and learned a great deal, lots of concrete details."[18]

Unfortunately, he says nothing about the occasion of the sagali. These photographs show what is evidently an impressive display of long yams (kui), in heaps, hanging from horizontal poles, and packed into upright containers (pwatai). If the sagali distribution was held in March, the yams can only have been first-fruits of the "early gardens."[19]

Linus pointed out that Ketuvi is a village which does not engage in Kula and has no chiefly line, although there is a dala which supplies wives and kui yams to the chief of Omarakana. Indeed, before he had been told of Malinowski's own cryptic identification of sagali at Ketuvi, Linus interpreted the event depicted here as a milamala feast. This is quite plausible in view of Malinowski's legend to one of his published photographs of the same event: "Yams are heaped on the ground and fill the pwata'i (prism-shaped wooden receptacle); coco-nuts, sugar cane, bananas and bunches of areca nut are displayed on top—the whole producing on the native a strong impression of beauty, power, and importance. This is done at the milamala (annual return of the spirits) as well as at mortuary and other distributions (sagali)."[20]

PLATE 29

PLATE 30 At harvest of the early yams (*kuvi*) there is an offering of first fruits to the memory of the recently dead. Argonauts, *170*

Linus gave the following interpretation of this photograph: "The woman is in mourning attire and probably the widow of the deceased. She is wearing a cowrie shell necklace doubled across her chest. Her husband was probably a big man. I suspect she is the widow because she is not holding a basket, as a sister or mother would have done. Chief Pulayasi guessed this might be milamala in Kasanai or Katagava of Kwebwaga village." Neither Linus nor Pulayasi knew that Malinowski had labeled the photograph "Sagali at Kaytuvi" or that his diary dated the event to March, far too early for milamala.

⸙

CORAL GARDENS AND THEIR HARVEST

80

PLATE 31

The most striking objects of display in these images are coconuts. In this photograph they seem to float like bubbles, and Malinowski was surely alert to the aesthetic effect of a diminishing perspective. Their presence in such great numbers is no less astonishing to present-day Trobrianders. Linus explained:

Traditionally coconuts were valued like yams. Only chiefs could accumulate and display them in large numbers, as in principle they owned all the palms in their districts. They were tabooed at certain times to make them plentiful then displayed when the taboo was lifted—usually at *milamala,* the main harvest festival. When coconuts are displayed like this it is called *lubwala* (literally, "coconut-house"). In these pictures we see *lubwala* together with *pwatai* containers of yams, which makes me suspect they are *samaku,* a special tribute to the chief in the form of coconuts. For example, the chief of Omarakana received his *samaku* from Luba district (which includes Ketuvi and specializes in coconuts, betel palms, and *kui* yams). Coconuts also used to play an important part in contracting chiefly marriages. The gift of four coconuts to the parents of a young woman, strategi-

cally selected by the chief and his advisors, could not be refused and within days she would join him in Omarakana. Among ordinary villagers, coconuts were also symbolically important in courtship. It was a matter of pride for a girl to return from an intervillage courting expedition (*katuyausa*) with a couple of coconuts (as well as betel nut of course) to present to her parents. They proved that she was pretty and desirable. The girl who returned from a *katuyausa* with the most coconuts would be complimented as the prettiest of all.

Such usages have passed away. Coconuts are no longer a scarce resource but a cash crop; they no longer signify chiefly privilege. Somewhat grudgingly, Malinowski wrote, "The native customs with regard to coconuts have been seriously undermined by an extremely well-intentioned and probably beneficial ordinance of the local Assistant Resident Magistrate [Dr. Bellamy], who, about ten years before my arrival, ordered that each village should plant a few hundred palms every year."[21]

Malinowski both underestimated Bellamy's achievement and overestimated the length of time it took. Beginning in July 1912, the A.R.M. placed a "government taboo" on coconuts and warned the chiefs not to expect to be able to claim them from commoners in future. During the next two years he ordered every village to plant every mile of road and track. By mid-1914, having incarcerated a few hundred recalcitrants and converted passive resistance into competitive rivalry by the offer of prizes, he could boast that 120,694 nuts had been planted along 241 miles of track throughout the islands.[22] Within a generation, coconut production in the Trobriands increased twenty-fold.

As Linus points out, Bellamy's promulgation was "inadvertently egalitarian" in its effect; "lubwala and samaku are but a memory and do not feature in present-day harvest festivals."

⊰⊱

PLATE 32

In Kiriwina the harvest is the most joyous and picturesque stage of garden-making. The actual digging out of the roots fascinates the natives in itself; and round this technical activity there cluster a number of enlivening customs and ceremonies which, while they take even more time perhaps and require more work than the mere lifting of the tubers out of the soil, add to the joy of the season. . . . The additional activities consist in the cleaning of the taytu, in its display in the gardens, in its public and ostentatious conveyance to the storehouses and in its ceremonial stacking there. Coral Gardens, *159*

The yams have been brought into the village after being displayed in the gardens. Men carry them on their shoulders in baskets hung from poles; women, in circular baskets balanced on their heads. Although Malinowski did not choose to publish this photograph, his notes on the reverse indicate that he considered using it to illustrate Coral Gardens: "Ch. V, sec. 5. Erection of Gugula (heap) in village. Harvest. Dodige Bwema, the filling of storehouses with yams."

Linus commented, "This is possibly Kwebwaga or Yalumgwa village. One heap has just been completed by those sitting around to the right, who are probably the visiting affines. Behind the woman in the middle (with a bamboo pipe) another yam heap is being constructed. Men's carrying baskets can be seen to the left of that."[23]

THE FOLLOWING SEQUENCE of photographs was taken in Omarakana during the main harvest of June 1918. Chief Touluwa had decreed a kayasa, a competitive harvest, in which all those who contributed yams to the chief's storehouses vied with one another. Malinowski calculated that over 20,000 baskets of yams were delivered to the chief on that occasion, more than four times the usual quota.[24]

The material basis of the Omarakana chief's power is the food-wealth he is given by his wives' subclans. As a "glorified brother-in-law" to many of the villages of Kiriwina, his storehouses are filled by the main yam crops of hundreds of gardeners, who include also his many sons working on behalf of their mothers. (In 1918 about eighteen sons of Touluwa were living with him in Omarakana.)

The *urigubu* is the duty of one individual to another [typically of a man to his sister's husband], in virtue of their relationship by marriage. *Urigubu* is not a tribute, and it amounts to a tribute only in that it is integrated over a whole district through the chief's polygamy and multiplied by the assistance given by many men to the most important notables in each community. Coral Gardens, 408

PLATE 33

Malinowski's caption on the reverse: "Harvest in Omarakana. A large heap is put in front of Touluwa's bwayma. His lisiga seen in the background. Can you see the albino?"[25]

PLATE 34

The middle stage of stacking a large heap of yams. Chief Touluwa's *ligisa* is in the background. The men are probably relatives of one of his wives from another village.

A small heap is simply stacked on the ground; bigger ones have small circular framework round them. . . . [L]arge yams are placed on the outside and the smaller ones in the middle, "topping" being the accepted procedure on such occasions. Coral Gardens, *179*

The real connecting link between the fact that the chief's revenue is a personal marriage gift and at the same time is in a way a tribute consists in the fact that the chief marries a girl from the ruling family in each hamlet, so that each headman is his contributing brother-in-law; and since the headman receives substantial assistance from most of his villages, the chief draws upon the economic resources of the whole territory. Coral Gardens, *408*

PLATE 35 The completed heap from another angle. Behind it to the left is a smaller heap, cov-
ered by coconut leaves to protect the tubers from the sun. Again, the men are likely
to be the chief's affines and not residents of the village.

In Omarakana during the big competitive harvest of 1918, there were seventy-six heaps in the vil-
lage, some of which were of enormous dimensions, and the bringing in lasted about ten days. But
then it took a very long time to erect such heaps. The central place was covered with them and
crowded with men and women. Coral Gardens, *180*

꠲꠲

PLATE 36

The man in the center is clearly a chief. No one is standing taller; he carries a hafted adze and the young acolyte at his side bears his limepot in a basket. Digimrina of Okeboma (Linus's father) recognized him immediately: "It is Vanoi Kilivila of Oluvilevi [the Tabalu village adjacent to Okeboma]. He is wearing a wig of woven hair on his head and that is a wood-carver's adze (rigogu) slung over his shoulder. The boy with the chief's limepot is probably his favorite son, Tominurai or perhaps Maluwa (though he might have been rather too young then). Vanoi Kilivila is very handsome and has a splendid physique. He wore his wig only when dancing, so this is probably a milamala festival in Oluvilevi."

On 26 August 1915, Malinowski visited Oluvilevi to witness the milamala festivities. His impressions were predominantly negative: "poor dancing," "few preparations," "rather noisy, unpleasant timbre of the drums."[26] He does not seem to have fully realized until later what a poor harvest it had been.

PLATE 37

Digimrina was proved correct. Malinowski's inscription on the back of this shot identifies "Vanoi Kiriwina, without his wig."[27] Of this photograph Linus (translating for his father) commented, "The bald man is Vanoi Kilivila with his rigogu but without his wig. The man on his left holds the chief's bamboo pipe and his youngest son is on his right. This shot was probably taken at Oluvilevi, perhaps also at milamala time. Vanoi's attendants (ilomgwa) surround him, seated low, and the coconuts hanging on sticks are samaku, the chief's tribute."

In the village of Olivilevi [*sic*], the main village of Luba . . . the *milamala* (at which I was present) was very poor, there being hardly any food display at all. The chief, Vanoi Kiriwina, had a dream. He went to the beach . . . and saw a big canoe with spirits, sailing towards the beach from Tuma. They were angry, and spoke to him: "What are you doing at Olivilevi? Why don't you give us food to eat, and coconut water to drink? We send this constant rain for we are angry. Tomorrow, prepare much food; we will eat it and there will be fine weather; then you will dance." This dream was quite true. Next day anybody could see a handful of white sand on the threshold of Vanoi's *lisiga.* "Baloma," *379*

Dancing at *Milamala*

The main yam harvest is followed by *milamala,* "a time of dancing, feasting, and general rejoicing," when the ancestral spirits (*baloma*) return to the village. The inaugural ceremony of this festive period involves the "consecration" of the drums and is followed by a month of dancing which reaches its peak at the full moon. Men have "a full-dress rehearsal each afternoon, and dance ceremonially in the evening, late into the night." In some years there is an extended season, called *usigola,* which climaxes "in a orgy of feasting and dancing" lasting for several days.[1]

On his first trip to Kiriwina, Malinowski arrived in good time to witness the harvest, the ceremonies of *milamala,* and the period of dancing that followed. In 1915 the *milamala* moon was celebrated in Oluvilevi during August, in Omarakana a full month later. Malinowski's fieldnotes for this year contain many descriptions of dances, including sketches of the dancers' movements and even some clumsy attempts to record drum rhythms in musical notation. His photographic collection contains about seventy-five shots classified as "Dancing," of which Malinowski published only ten.

⊰⊱

PLATE 38 The majority of dances are circular, the drum-beaters and singers standing in the middle, while the dancers move round them in a ring. "Baloma," *373*

Plate 38 is one of a series of photographs illustrating a dance called *Rogaewa* (a *wosimwaya,* or "traditional dance"). Malinowski's legend to another one in the sequence explains, "Dancers from Omarakana instructing the villagers of Liluta in the Rogayewo, a slow dance performed by men wearing fibre skirts, and holding pandanus streamers in their hands. Most of the spectators are watching from a shady spot behind the camera."[2] Linus was pleased to recognize the decoration of the large yam house in the background as belonging to his own subclan, Kwainama.

Tabalu men of Omarakana take wives from Liluta, reason enough to enable Liluta men to "purchase" (*laga*) this dance with "a substantial payment of food and valuables."[3] Malinowski accompanied Chief Touluwa and Omarakana men on "one big visit" in late September 1915, when the dance was taught to the men of Liluta. Plate 38 can be dated accordingly.[4] Malinowski's fieldnotes indicate that the *Rogaewa* was also bought (for one stone ax blade and two pigs) by Pilibomatu, the sorcerer of Kwebwaga.

Linus commented, "According to my father, the *Rogaewa* dance comes from Iwa islanders, who first taught it to men of Okeboma. They in turn taught it to the Tabalu of Omarakana. But they were not given the complete dance, so Okeboma retained a somewhat different version."

PLATE 39

The village was identified as Omarakana by Linus and his informants, the dance the *Rogaewa*. The drummers are clustered in the center while male dancers, dressed in women's fiber skirts and waving streamers, encircle them.

The white head-dress and the brown figure seem to be transformed into a harmonious and fantastic whole, somewhat savage, but in no way grotesque, rhythmically moving against the background to a monotonous and melodious chant and the overbearing beat of the drums.
"Baloma," *373*

Men may dance in skirts in many of the *wosimwaya*, though not those which require them to hold dancing shields. Initially prejudiced (he wrote of the dancers being "disfigured"), Malinowski soon grew accustomed to the sight, "Men with petticoats make an unpleasant *Eindruck* [impression]—something effeminate and drastic. After a time, the real picturesqueness of the petticoats and of the headdress prevails."[5]

PLATE 40

When the hottest hours of the day are over, at about three to four o'clock in the afternoon, the men put on their head-dresses. These consist of a great number of white cockatoo feathers, stuck into the thick black hair, from which they protrude in all directions, like the quills of a porcupine, forming large white haloes around their heads [I]n conjunction with the cassowary tufts tipped with red feathers, and inserted into belts and armlets, the general appearance of the dancer has a fantastic charm. In the regular rhythmic movement of the dance, the dress seems to blend with the dancer, the colours of the red-tipped black tufts toning well with the brown skin. "Baloma," *373*

Malinowski's caption on the reverse: "Chaps with *kaidebu,* showing decorations and position of legs at start." The three dancers cannot be identified, though Linus is confident that the location is the *baku* of Omarakana.[6] The dance is almost certainly *Gumagabu*. In view of the number of dance shields, the occasion was instigated by Malinowski himself.

Soon after his arrival in Kiriwina, Malinowski began purchasing artifacts (his fieldnotes list "specimens" such as canoe prows, limesticks, limepots and stoppers, dancing shields, drums, and wooden dishes).[7]

DANCING AT *MILAMALA*

I had bought from various villages some twenty dancing shields (*kaidebu*); I wanted to see what the *kaidebu* dances were like. Now, in Omarakana there was only one dance in progress, the *rogaiewo,* a dance performed with *bisila* (pandanus streamers). I distributed the *kaidebu* among the *jeunesse dorée* of Omarakana, and the charm of novelty being too strong (they had not had sufficient *kaidebu* to dance with properly for the last five years at least), they at once began to dance the *gumagabu,* a dance performed with the dancing shields. This was a serious breach of the customary rules (though I did not know it at the time), for every new form of dance has to be ceremonially inaugurated [by a special feast]. The omission was very much resented by the *baloma,* hence bad weather, falling coconuts, etc. This was brought up against me several times.[8]

Inadvertently, it seems, Malinowski had almost ruined the *milamala.*

꜓꜓

PLATE 41

There are two main types of dance in Boiowa [that is, Boyowa]. The circular dances, where the orchestra (the drums and singers) stand in the middle, and the performers go round them in a circle, always in the opposite direction to the hands of a watch. These dances are again subdivided

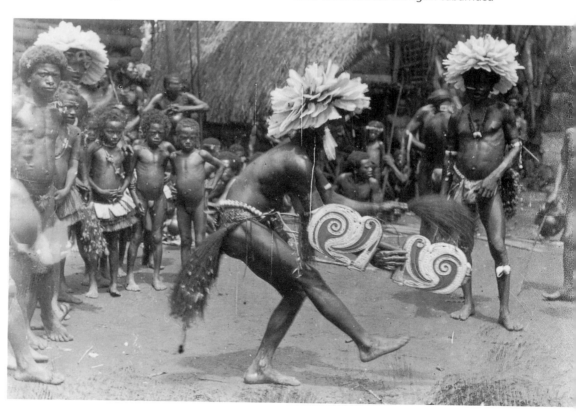

into: (1) *bisila* (pandanus streamer) dances with slow movement; (2) *kitatuva* (two bunches of leaves), with a quick movement; and (3) *kaidebu* (wooden painted shield), dances with the same quick movement. In the *bisila* dances women can take part (very exceptionally), and all the performers wear women's petticoats. The second group of dances are the *kasawaga,* where only three men dance, always in imitation of animal movements, though these are very conventionalized and unrealistic. These dances are not circular, there are no songs (as a rule) to accompany them; the orchestra consists of five *kupi* drums and one *katunenia.* "Baloma," *381*

This is clearly a *kaidebu* dance, probably *Gumagabu,* "the most popular one."

꜏꜏

THE NEXT THREE photographs form a sequence and were numbered consecutively by Malinowski. The location appears to be the "street" of Kasanai, though the three dancers are probably from Omarakana. The dance is easily identified as a *Kasawaga,* but in the absence of captions one can only guess at the bird or animal being imitated (Malinowski listed about thirty). Nevertheless, "the scheme of *kasawaga* is identical in all the villages of Kiriwina. The only difference is the movement of the hands."[9]

Linus commented, "The principal bird of Omarakana is *muluveka,* the sea eagle, which is chief of the birds. Its behavior is imitated by the dancers of the *Kasawaga* (perhaps the one shown here). In my village of Okeboma, the animal mimicked by the *Kasawaga* is the hermit crab, *ginareu* (of which there are many on our beaches). So we call the dance *Ginareu Kasawaga.*"

PLATE 42
A government-appointed village policeman can be seen behind the crouching dancers. He is wearing the regulation uniform of dark shirt and serge waist-cloth, white neckerchief; a whistle dangles from his leather belt. Note also the small boy clinging to the roof gable of the house behind.

DANCING AT *MILAMALA*

PLATE 43

PLATE 44

It took between five and ten cockatoos to provide enough feathers for a good head-dress; the birds were caught by sling-trap, or sometimes felled by throwing stones. Rafael Brudo, the enterprising Parisian trader of Sinaketa, tried to introduce peacock feathers, but "they did not take."[10]

✣

DANCING AT *MILAMALA*

PLATE 45

Malinowski's caption on the reverse: "Kasawaga—three chaps dance in imitation of animals. Number of such mimic dances form a class apart from the circular dancing." This appears to be a different occasion from that of the previous set of photographs, despite the sequential numbering and the similar appearance of the dancers. The three men clasp their neck ornaments between their teeth. They bounce forward in a characteristic position called *sitota*, literally, "sitting-standing," or balancing on the toes.[11] For Malinowski, however, "The most remarkable artistic element seems to consist in the shaking movement of the hands. It is both very difficult to do and produces a rather fine impression, as aspen leaves might shake in a violent wind."[12] The line of drummers is typical of the *Kasawaga* dance. Here it is the man in the middle who beats the small drum.

The drums of the Kiriwinians consist of: (1) the large drum . . . called *kasausa'u* or *kupi* (this latter word being an obscene synonym for the *glans penis*); and (2) the small drum, about one-third the size of the larger, called *katunenia*. All their drum-beats are a combination of the two drums, the *kupi* and the *katunenia* leading each its separate voice. "Baloma," *380*

DANCING AT *MILAMALA*

97

PLATE 46

This is another phase of the same *Kasawaga* dance. Linus suggested that the principal dancer (right) is slowly high-stepping (a movement called *pakurikweri*) toward a pair of sitting "birds." The children squatting so close to the action indicate an informal event, as do the men (who are probably singers) behind the seated dancers. That it is indeed a "rehearsal" is confirmed by another shot in the same series, in which the singer with the limepot and bamboo pipe also appears.[13] Of men with good voices (*tokegabwela*) Malinowski noted, quaintly, "Such men are said to be extremely dear to ladies."[14]

PLATE 47

Malinowski's legend to a similar photograph identifies the place and occasion, "The *Ulatile* of Kwaybwaga. More especially the singers and dancers from that village, photographed as they were about to start a *karibom* unusually early because of the foregoing festivity. They do not represent the pick of Melanesian good looks."[15] *Ulatile* (nowadays *ulatila*) is an amorous expedition undertaken by a group of youths to a neighboring village. Linus's informants also commented on the unprepossessing appearance of these dancers from Kwebwaga. Malinowski wrote about the *Karibom,* which always takes place in the evening: "After the evening meal, the village drummers, standing in the centre of the village place (*baku*), beat out a slow rhythm. Soon children, old men and women, youths and maidens, assemble in the central place and begin to walk round it. There is no special step, no complicated rhythm; only a slow, regular, monotonous walk."[16]

⁂

DANCING AT *MILAMALA* 99

PLATE 48

This is one of many anomalous photographs in the collection, and judging by the photographic style was unlikely to have been taken by Malinowski. There is no caption on the reverse. According to Linus, the dance shown is not a traditional *wosimwaya*: "Young people's line dancing is fairly modern. I suspect it might be an early version of the popular *Tapioka* or "Cricket" dances of today." *Tapioka* is the thrusting, buttock-thumping, sexually explicit dance accompanied by ribald songs that is so popular with tourists who visit the Trobriands today. It is a dance only for young unmarried people.

"Physical Types" and "Personalities"

⤙ 6 ⤚

The title of this section adopts two of Malinowski's photographic categories. In practice, however, these categories overlap, suggesting he was sometimes uncertain in which group to place a particular portrait. Occasionally he compromised by writing both "Physical types" and "Personalities" on the backs of the prints. Unfortunately, he identified very few of his subjects by name.

"Physical types" was a photographic genre used extensively by nineteenth and early twentieth century ethnologists and ethnographers, whether or not they had anthropometric predilections. In the Massim, both C. G. Seligman and Diamond Jenness had taken many photographs of such "types"—the latter from among the patients in the Samarai hospital. In the edition of *Notes and Queries on Anthropology* which Malinowski took with him to the field, A. C. Haddon and J. L. Myres instructed, "A certain number of typical individuals should always be taken as large as possible, full face and exact side view; the lens should be on a level with the face, and the eyes of the subject should be directed to a mark fixed at their own height from the ground, or to the horizon."[1]

Today we regard such images with disquiet, for they turn their posed subjects into zoological specimens. To give him his due, Malinowski generally avoided taking such photographs as he had little interest in physical anthropology and its current concern with the distribution of racial types. Only a few of his photographs conform to the above prescription. He was far more inclined to take candid portraits, which Haddon and Myres also recommended: "Besides the stiff profiles required by the

anatomist, some portraits should be taken in three-quarter view or in any position that gives a more natural and characteristic pose."[2]

To the extent that Malinowski was interested in Trobriand "physical types," it was because they illustrated the internal differentiation of Trobriand society or local standards of physical beauty. Consider the following statement from *Argonauts of the Western Pacific,* which he illustrated with six photographs: "The great variety in their physical appearance is what strikes one first in Boyowa. There are men and women of tall stature, fine bearing and delicate features, with clear-cut aquiline profile and high foreheads, well formed nose and chin, and an open, intelligent expression. And besides these, are others with prognatic [*sic*], negroid faces, broad, thick-lipped mouths, narrow foreheads, and coarse expression. The better featured have also a markedly lighter skin. Even their hair differs, varying from quite straight locks to the frizzy mop of the typical Melanesian."[3]

Almost needless to say, the former type was found predominantly in the higher ranked subclans and villages, whence Malinowski claimed to find his best informants. That he identified with the "finer" rather than with the "coarser" types is evident from his descriptive language. Plate IX of *Argonauts,* for example, presents Tokulubakiki, Towese'i, and Yobukwa'u as "Men of Rank from Kiriwina." The forthright legend reads, "All three show fine features and intelligent expressions; they were among my best informants." Contrast this with the judgement implied by the portrait of an unmarried woman (actually taken by Billy Hancock): "This shows the coarse, though fine-looking, type of commoner woman." Again, the illustration of Trobriand aesthetic judgement in two adjacent photographs in *The Sexual Life of Savages* (plate 66 features "A Melanesian Beauty" and plate 67, "A Type Not Admired by the Natives") is somewhat compromised by Malinowski's appeal to "universal" criteria of beauty ("and with this opinion the reader will not disagree").[4]

Malinowski was convinced that the higher the rank, the "finer" the features; but then, so too are the majority of Trobrianders. Indeed, they go beyond ranking people by their looks in their belief that there is a typical "face" or characteristic appearance of members of particular subclans, villages, and districts.

None of Linus's informants commented unfavorably on the possibly intrusive, exploitative, or even salacious intentions of the photographer. (These are villagers who frequently demand money from casual tourists for the right to take photographs, so they are well aware of the exploitative potential of photography.) They appear to have had no "politically correct" objections to the photographs presented in this book, and they apparently relished even the most blatantly scientistic portraits of their "ancestors."

❦

PLATE 49

Linus thought this "must be a man of rank because he's wearing a good *wakala* (shell waist belt) of many strands. His pendant (*dogadoga*) is of the old type (a genuine pig's tusk and not a shell imitation), and his *kalomwa* [Malinowski's *kaloma*] shell necklace is the kind made in Sinaketa. He could be from Vakuta. He's not a Tabalu from Omarakana or he would be wearing even more decorations." Chief Pulayasi suggested that he was a Kula trader of some repute or a man of high rank in his community; perhaps both despite his evident youth. He would, of course, have dressed up especially for the photograph.

⚏

PLATE 50

Plates 50 and 51 depict the front and side views of the same girl. Linus surmised she might be the young wife of a Tabalu notable, if not a Tabalu herself, and noted, "Her looks are those of Kwainama subclan whose women traditionally marry Tabalu men.

PLATE 51

Commoners don't wear wrist bands or such large upper arm bands (*kwasi*)." She also wears a *butia* (garland of flowers) around her head, turtleshell earrings (*paia*), and a decorative banana-leaf skirt called *takulakola*.

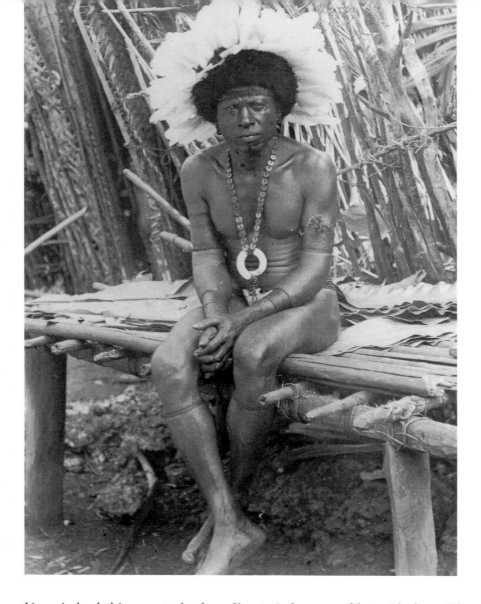

PLATE 52

Linus judged this man to be from Kavataria because of his wide face. "The wrist bands, the *kalomwa* band across his forehead (called *sedabala*), and the *doga* necklace, all indicate a man of rank, so perhaps he is a local Tabalu of the Kavataria branch. Tabalu women from Omarakana married there several generations ago, but their group is still trying to claim full Tabalu privileges. There is a saying to the effect that Kavataria Tabalu are 'an inch shorter.'"

PLATE 53

Here the same man shown in plate 52 is dressed for *wosimwaya,* complete with white cockatoo feather headdress, cassowary plumes in his armlets, a dancing skirt, and cowrie shell leg bands (*luluboda*) which can be worn only by those of *guyau* rank. He holds a pandanus leaf streamer. Many of Linus's informants admired his fine physique.

There is a staged quality about these two photographs that is foreign to Malinowski's style; they might well have been Billy Hancock's.

PLATE 54

Linus commented, "No one was able to recognize this village policeman, though most agreed with me that he and his wife are non-Trobrianders and perhaps from Fergusson Island or the Amphletts. One of his arms is shorter than the other, which makes his armlets look awkward. The woman's skirt is plain (*seyoyu,* not *doba*) and made of coconut rather than banana leaf. Her necklace is of black banana seeds, or perhaps even rubber."

PLATE 55 Linus observed, "This is a young man holding a tomahawk, a boy, and an old man with flowers on his head. They are wearing no decorations to speak of. The carved poles behind them are for making a *liku* [small yam store]. They are sitting on its platform. Depending on how you make your yam house, it is a *bwema* or a *liku*. No one I showed this picture to recognized these characters or could even suggest who they might be. But I wonder if the old man is Tomwaelakwabula, whom Malinowski called 'the seer'?" If so, the location is probably Oburaku. Malinowski must have known who the old man was, for although it was cataloged with "Physical Types" he had written "Personalities" on the back of the print.

⚏

"PHYSICAL TYPES" AND "PERSONALITIES" 109

PLATE 56

The word "Spirits" is written on the back of this print, and comparison with plate 37 in *The Sexual Life of Savages* identifies the old man as Tomwaelakwabula [Malinowski's "Tomwaya Lakwabulo the seer"] of Oburaku, complete with widower's cap, leather belt, and "the characteristic expression which heralds the approach of a trance." These are presumably Tomwaelakwabula's children (the daughter perhaps Namyobei, named after his "spirit wife" in Tuma). There is a marked family resemblance—or, as Trobrianders would put it, both son and daughter have the same face as their father.

Tomwaelakwabula was one of Malinowski's "best informants . . . a famous seer, a spiritistic medium of no mean talent and imagination (also of no small cunning) and a frequent guest of the spirit world."[5] Malinowski poked light fun at his self-contradictory beliefs concerning the egalitarian, erotic paradise of Tuma. But despite his public unmasking as a fraud, Tomwaelakwabula "enjoyed an undiminished prestige in his own community and in the Trobriands universally."[6] Writing to Elsie

about this, Malinowski likened him to a distinguished scientist of the time who was also a practicing spiritualist: "I don't know whether it is imagination, but I fancy I saw the same look about Sir Oliver Lodge's gaze."[7]

⚎

PLATE 57

Linus commented, "Two women with heads shaven for mourning, though they are unlikely to be widows. They are preparing to go to a *sagali* (perhaps related to the deaths they are mourning). The large basket on the left contains their contributions of banana leaf bundles, and their contributions of yams are in the basket on the right. The third basket on the extreme right probably contains combs, betel nut, and other things. It looks new, so it will probably be bartered for something, such as banana leaf bundles, tobacco, or calico. Who are the women? It's possible they are elderly wives of Chief Touluwa."[8]

PLATE 58

Linus remarked, "So many fine limepots! These two men have Kuboma features. The one on the left has a thin wristlet with a small cowrie shell on it, which is a sign of *guyau* rank. In Kuboma district the Tabalu village is Gumilababa. He also has a nose-shell, a limepot and ebony limestick. People agreed with me that he could also be a sorcerer. Kuboma is renowned for it. The younger man has a *dogadoga* pendant, so he is probably a man of rank too."

PLATE 59

The posed figures against a backcloth strongly suggest that this photograph was not taken by Malinowski. Linus responded, "These men are not from Kiriwina. Perhaps they are from Sanaroa, Tewara, or the Amphletts. The comb handle sticking out of the man's hair is not a Trobriand design. I've never seen anything like those pigtails with shells on the end. The man on the right also has something odd about his hair . . . that strand dangling in front of his face."

Chief Pulayasi identified the woven hairpiece of the man on the left as *sesai*, characterized by its cowrie shell decorations. "Only Muyuwa [Woodlark] and Kitava men wore *sesai*. The other man could be from Dobu."

PLATE 60

In Oburaku Navavile, the garden magician, is still the first man in the community by virtue of his office, and he exercises that office in virtue of his personality, for he inherited it from his father and not in the mother line. Coral Gardens, *291*

The man (left) in the doorway of his house is easily identified as Navavile, the *towosi* of Oburaku.[9] In late March 1918 Malinowski witnessed a performance of *vilamalia* ("the magic of health, wealth and prosperity") in this house.[10] Although Navavile was one of Malinowski's most indefatigable and reliable informants, things did not always go smoothly between them: "irritated by the impudence of Navavile and the Wawela fellows (they had eaten too much betel nut)."[11]

PLATES 61 AND 62 BELONG to a group of five photographs (all of them poorly focused) cataloged under "Contact." All three men possessed cameras, so the occasion was something of a photographic expedition. The location of the beach is uncertain, but it is probably on one of the smaller islands. Malinowski's full beard dates these photographs to his 1915–16 field trip.

PLATE 61

Malinowski with Cyril Cameron, a trader whose store and small coconut plantation was on the island of Kitava. Malinowski recorded one of his earliest accounts of *mila-mala* from Cameron, as well as anecdotes relating to Trobriand procreation beliefs and sexual behavior.[12]

Linus, who recently visited Kitava on a Kula expedition from Okeboma, commented, "Cameron liked women very much. One story goes that when men came to buy tobacco from him, he would lower it on a string to them from his verandah. (His house was built into a hillside.) But if women wanted tobacco, he insisted that they climb up to get it. He married one or more local women and he has several grandchildren in Kitava."

PLATE 62 Malinowski with Billy Hancock, "a trader of exceptional intelligence and one of the finest men I have known."[13]

"I always keep in mind Bill's basic problem: his marriage with Marianna; his love for their children. He treats Marianna as a native, stressing her bronze complexion. Today I thought that this was perhaps very clever on his part, that he expected the worst."[14]

But racial stereotyping cuts both ways, and Billy's physical appearance would not have impressed Trobrianders. "Europeans, the natives frankly say, are not good-looking. The straight hair 'coming round the heads of women like threads of *im*'

(coarse pandanus fibre used for making strings); the nose, 'sharp like an axe blade'; the thin lips; the big eyes, 'like water puddles'; the white skin with spots on it like those of an albino—all these the natives say (and no doubt feel) are ugly."[15]

"More polite than truthful," they diplomatically made a "meritorious exception" of Malinowski, telling him he "looked much more like a Melanesian than like an ordinary white man." They credited him with "thick lips, small eyes, absence of any sharp outline in the nose" though they were "discreet and honest enough" not to compliment him on his forehead and hair.[16]

⊣⊢

"Magic"

Malinowski's fascination with magic (and to a lesser extent with religion) dates from his earliest writings. His theoretical contribution to its understanding, culminating in his two-volume monograph on the role of magic in Trobriand horticulture, cannot be overestimated.[1] Despite his profound interest in magic, however, only thirteen photographs are to be found under this rubric in the collection. Many more, of course, were placed under headings such as "Sagali," "Pregnancy," "Kula," "Gardening," etc. Most of those categorized under "Magic" appear to constitute a residual group: the magic of war, rain, beauty, and sorcery. Succinctly, in the Trobriands,

Magic consists of spells and rites performed by a man who is entitled by the fulfilment of several conditions to perform them. Magical power resides primarily in the words of the formula, and the function of the rite, which is as a rule very simple, is mainly to convey the magician's breath, charged with the power of the words, to the object or person to be affected. All magical spells are believed to have descended unchanged from time immemorial. . . . This last point has its sociological corollary; several systems of magic are hereditary, each in a special sub-clan . . . since the time it came out from underground. It can only be performed by a member, and is, of course, one of the valued attributes and possessions of the sub-clan itself. It is handed on in the female line, though usually, as with other forms of power and possession, it is exercised by men alone. But in a few cases such hereditary magic can also be practised by women.[2]

PLATE 63

"A sorcerer is always also able to effect a cure. The curative spell must be uttered loudly and publicly over the healing substance, so as to allay all suspicion. The sorcerer is here seen with a [coconut shell] water bottle in his hand and he chants the spell into the opening, using a leaf as a screen so as to prevent his voice straying away."[3] Linus suspected a chance encounter at either Losuia or Gusaweta during which Malinowski persuaded the three men to enact a rite for the camera. The man on the right appears to be Yobukwau, son of Chief Touluwa.

PLATE 64
Malinowski's inscription on the back of this print is unusually informative. In addition to identifying Navavile of Oburaku "preparing for *Isunapulo*," he notes that this photograph was "squeezed out of Ch. X." In that chapter of *Coral Gardens*, Malinowski wrote, "The garden magician, Navavile, collects two big bundles of leaves in the morning; one gathered from the *menoni*, a fruit tree, the other from a tree called *kekewa'i*. These two bunches are laid on the platform before the magician's house and he seats himself beside them."[4] There is a canvas chair at left in the picture, presumably Malinowski's.

PLATE 65 This ramshackle village is Tukwaukwa.[5] The old woman seated on the log platform is preparing for a first pregnancy rite by cutting up the inner leaves of a creamy white lily called *morobau*.[6] Chief Kwewaya of Tukwaukwa identified her as Ibomri, the wife of Toguguwa the sorcerer. She was presumably the Ibo'umli who taught Malinowski several incantations of beauty magic.[7]

"MAGIC"

PLATE 66

The two men on the "stage" appear to be enacting a macabre dance, but the inscription on the reverse gives the clue to the meaning of their performance: "War magic." The location is therefore Kwebwaga [Malinowski's Kwaibwaga], less than a mile from Omarakana. Although he published very little of it, Malinowski collected a great deal of information in 1915 on Trobriand warfare and its magic, *boma*.[8] His chief informant was Kanukubusi of Kwaibwaga, "the last office holder of the long succession of war magicians to the chiefs of Omarakana." He is the man on the right with an oval war-shield behind him. Malinowski also photographed him in a simulated act of charming the shield.[9]

Chief Pulayasi of Omarakana was intrigued by this photograph. "Although each village has its own spells for fighting, Kwebwaga is the 'root' of war magic. The most powerful war magicians came from Kwebwaga and the Omarakana chiefs used to hire them. The young man with Kanukubusi is perhaps his son. The war magic of Kwebwaga is owned by Kanukubusi's *dala*, but it was transmitted to his sons who took it to Obulabula from Kwebagatola [different hamlets within Kwebwaga village]. It was only in recent times that the magic was returned to its original owners, the *dala* of Kanukubusi."

Kanukubusi is an old man, with a big head, a broad, high forehead, a stumpy nose, and no chin, the meekest and most docile of my informants, with a permanently puzzled and frightened expression on his honest countenance. I found this mild old man very trustworthy and accurate, an excellent informant indeed, within the narrow sphere of his speciality, which he and his predecessors had used to make "anger flare up in the *nanola* [mind]" of Omarakana men, to make the enemy fly in terror, pursued and slaughtered by the victorious warriors.[10] *Argonauts, 409*

PLATE 67

PLATE 68

Plates 67 and 68 belong to a series of six in the collection. "Rain Magic" is written on the reverse of one of them, the only clue to their interpretation and possible location. Linus commented, "They show a man with shaved head, presumably the rain magician, surrounded by tombstone-like slabs of dead coral. If it is rain magic then it has to do with Tabalu chiefs, but neither Chief Pulayasi nor anyone else could tell me where it might be. They agreed it looked like a 'sacred site,' if not a 'place of [ancestral] emergence' of a *dala*. Chief Pulayasi said such stones could be found in Kitava, Vakuta, Luwebila, and Omarakana itself, but he couldn't identify this particular spot."

❧

"MAGIC"

PLATE 69

One of nine photographs classified under "Mythology." Some of Linus's informants suggested that the place was Okinai in Vakuta.[11] Malinowski spent ten days in Vakuta in mid-April 1918, and although he certainly visited Okinai he mentioned taking photographs only in Kaulaka, "a poetic village in a long hollow amid palm trees, a kind of sacred grove."[12]

Malinowski's caption to a similar plate in *The Sexual Life of Savages* explains the mythological stone: "Ancestral emergence spot in a small village on the island of Vakuta." According to Trobriand myths of origin, human beings led a subterranean existence before emerging from the ground in different localities. "The spot of their emergence is usually marked by a grotto, a large boulder, a pool, the head of a tidal creek, or merely a large stone in the village centre or street. In this way they established the traditional claim to ownership of the "hole" [or large stone] and its surroundings; that is, to the village site, which often lies immediately round the hole, of the adjoining lands, and of the economic privileges and pursuits associated with the locality."[13]

PLATE 70

PLATE 71

These two photographs belong to a sequence of eight labeled "Fishing Magic." Linus identified the location as Labai, on the northwest coast of Kiriwina. "People are dark there, with plump faces, like these men." The islet is called Sia. The men are about to fish on the fringing reef for mullet (*kalala*) using nets of the triangular *kiluva* type.

Malinowski described the magic of *kalala* fishing in Labai, which was decreed by the mythical hero Tudava:

When full moon approaches and the natives expect the fish to arrive soon, the magician [having already observed a number of taboos] sweeps his house and its surroundings, muttering a spell in which he invokes the names of certain ancestors. This is done so as to "keep the way clear for the *kalala.*" The next day, early in the morning, all the men follow the magician to the beach. A few yards away at a definite spot, the magician puts an uprooted *libu* plant across the path and recites a spell over it. From this moment the beach is taboo to all strangers, and the fishing period begins. The villagers camp on the beach, ready to cast their nets, and some even spend the night there. . . . On the day following the ceremonial march to the beach more magic formulae are said over the fishing nets and over certain herbs which are supposed to attract the fish.[14]

Such magic confirmed his theoretical view that magic in general served to "ritualize man's optimism" in that it is deployed only where some element of risk is involved and reasonable doubt as to the success of an enterprise. In the calm lagoon, where abundant yields could be virtually guaranteed the year round, there is very little fishing magic. On the northern coast, where there is uncertainty of outcome (shoals of *kalala* appear only on a few days in each seasonal moon) fishing is "absolutely governed by magic."[15]

PLATE 72

This photograph (the only one to be found in an anomalous category labeled "Spirits —Chief Touluwa") conveys a remarkable amount of information about Omarakana. It was studied intently by Chief Pulayasi. Linus noted, "Chief Touluwa and his youngest son Dipapa are right of center, the chief standing in his characteristic pose, left arm clasped behind his back.[16] The men beneath the spirits' *milamala* platform are (left to right) Tokulubakiki, Touvesei, and Yobukwau."[17]

Concerning tall platforms such as this one, Malinowski wrote, "[I]n villages belonging to chiefs, special rather high, though small, platforms . . . are erected for the *baloma* [ancestral spirits] of the *guya'u* (chiefs). The chief is always supposed to be in a physically higher position than the commoners. Why the platforms for the spirit *guya'u* are so very high (they measure some 5 to 7 metres in height) I could not ascertain."[18]

Malinowski's footnote to this passage from *"Baloma"* (written soon after his 1915–16 field trip) helps to date the photograph. No such platform was built in Omarakana during the *milamala* celebration he observed in 1915. This platform must therefore have been erected for the harvest festival of 1918.

According to Chief Pulayasi, such platforms are built by men of Kaulagu village, who are repaid with yams and pork. Its height is a reflection of the Tabalu chief's superior rank, and food for Tabalu ancestral spirits is placed on top.

Malinowski's tent can be seen behind Yobukwau, and Bagidou's hut to the left of that (additional confirmation that this is 1918, for Bagidou did not have a house on that particular site in 1915). The roof of the larger building to the right belongs to Touluwa's *ligisa*.

The mound of dead coral (*tuwaga*) directly behind Touluwa is called Lugwalaguva. Malinowski does not name it, making only passing reference to "a tabooed heap of stone which no one must tread on nor even approach" and "the sacred clump of aromatic and decorative bushes."[19] Despite its close proximity to his tent, the magical significance of this "heap of stone" seems to have escaped him (quite possibly, its secrets were deliberately withheld by his Tabalu informants).

Linus quoted Chief Pulayasi, "The Lugwalaguva harbors the magic of *vilamalia*. The Tabalu chief and his close kinsmen are the owners of this magic. When it is performed on this spot a mysterious woman appears. If the magic is done to bring *malia* (abundance), she carries a basket full of food on her head and walks toward the south. If the magic is done to bring *molu* (hunger or famine), she carries an empty basket and walks northward."

8 Fishing and Canoes of the Lagoon

Malinowski lived for three months in Oburaku, one of several lagoon villages which depend upon fishing for their subsistence. "Here, in water almost constantly calm, fishing can be done all the year round, and it has developed into a regular trade, as the villagers are often requested by an inland community to provide fish in exchange for yams."[1]

As a frequent visitor to Billy's place at Gusaweta, Malinowski also observed lagoon fishing by the men of Tukwaukwa and Teyava. He visited Labai, too, where he photographed fishing magic. It was only when he moved to Oburaku, however, that he participated in fishing expeditions. He found the experience exhilarating. "At 10.30 [on 20 December 1917] they decided to go for a *poulo* and I set out with them. *Megwa* [magic] in the house of Yosala Gawa. I felt again the joy of being with real *Naturmenschen*. Rode in a boat. Many observations. I learn a great deal. General *Stimmung* [atmosphere], style, in which I observe tabu. Technology of the hunt, which would have required weeks of research. Opened-up horizons filled me with joy. We made a *cruise around this part of the lagoon*—as far as Kiribi, and then to Boymapo'u. Extraordinary sight of fishes darting through the air, jumping into nets. I rowed with them."[2]

PLATE 73

A *kewou,* the smaller of the two types of fishing canoes built by lagoon dwellers. The man is holding a punting pole for propelling his vessel. This is at Tukwaukwa, facing the inlet.

PLATE 74

Fishing canoes of the second, more seaworthy type, called *kalipoula* (Malinowski's *kalipoulo*).[3] Both of these canoes have carved prowboards, *tabuya* (Malinowski's *tabuyo*) and *lagim*. The place is Tukwaukwa, identified by the creek between the two canoes. It leads to the "village waterhole," called Mkikiya, mentioned in the pregnancy spell Malinowski cited in *The Sexual Life of Savages*.[4] Although Linus's informants understandably assumed that the men are about to embark on a fishing expedition, the legend of plate 60 in *Sexual Life* indicates that they are off on another kind of expedition called *ulatila*—the quest for amorous adventure.

At harvest and during the dancing season . . . groups of young men, more or less dressed up, can be met with on the road or seen paddling along in large fishing canoes. As a matter of fact, the love-making expeditions from the lagoon villages of the west coast would also be made by water. Sexual Life, *227*

PLATE 75

Linus commented, "According to Giyomatala of Teyava, these photos show men (probably of Teyava or Oyuveyova) using nets called *kiluva*. He says that the men who use this method must be physically strong, as they have to manage two nets at once: large rectangular seine nets (which cannot be seen under water) and the smaller triangular *kiluva*."

Whether they are standing in the shallows or sitting in the canoes, the men wielding the *kiluva* must face those in the water who are driving the shoal. As the fish approach the submerged seine nets, many of them leap out of the water and are caught in the upraised triangular nets. Giyomatala also pointed out that a net basket, called *kabila*, is attached to the base of the triangular *kiluva* net. When the leaping fish hit the triangular net they tumble securely into the basket. *Kiluva* nets are no longer to be found in Kiriwina today.

Malinowski described this method of fishing for mullet in Labai, on the northwest coast of the island, so it is possible that the first photograph was taken there and not in the lagoon as Giyomatala believes.[5] Fishing by this method from canoes is illustrated in plate 4 of *Coral Gardens,* which could well have been photographed on the same occasion, though Malinowski refers in his caption to "southern lagoon

PLATE 76 villages" (and therefore not to Teyava or Oyuveyova). This unusually large *kalipoula* is carrying eight men.

An exciting punting-along, everyone on the alert for jumping mullet. The shoal sighted, two large nets sunk so as to encircle the fish, terrible row of beating, screaming and splashing to drive the fish out and suddenly the air seems to bubble with silvery and bluish bodies and the niggers move about like [men] possessed with their large triangular nets. I never knew that on the lagoon also the bulk of fish is caught in the air! We sank our nets about a dozen times with varying results but the total yield was fairly good, every man (there were some 25 present) getting about 5 fish, quite large. *Malinowski to Masson, 23 December 1917 from Oburaku, in Wayne,* The Story, *85*

PLATE 77

Fishermen of Teyava. Their catch is a "subsistence" fish called *ketakeluva*—although tasty, they are very bony. Malinowski used a similar photograph of these men to illustrate "types of commoners."[6] According to Linus, Giyomatala refused to accept that these men came from his village: "Some are very ugly. There must be some inlanders among the Teyava men."

PLATE 78

Malinowski's legend to a similar photograph states, "Fish caught in large quantities will be smoked and then distributed to be eaten with yams. . . . Fish thus smoked will last for a day or two before it goes bad."[7] Linus remarked, "Smoking fish is called *kevala*. Almost any kind can be smoked, including bony fish, *ketakeluva*. This youth looks like a Kapwapu man, from inland of Teyava. They don't fish much there but do grow good taro. The wood for the platform over the fire has to be green otherwise it would burn. It only takes about an hour to smoke the fish, though he must turn them over once."

PLATE 79

Malinowski labeled another version of this photograph "The Beach at Teyava."[8] Giyomatala was more specific and named the spot as Waseva, which lies in the direction of Gusaweta and Tukwaukwa. Today it is overgrown and no longer a major landing place.

Malinowski did not mention *wasi* in his caption, but Linus reads this photograph in these terms. "This is a typical scene of *wasi* exchange. The fishermen have returned and are arranging their catch for their inland partners, who would have brought their yams or taro on a previous day."

PLATE 80

This photograph was cataloged under "Wasi" along with a dozen others. Linus's first observation was that what is being pictured is not *wasi* but *vava*; his second was that only one string of fish is visible ("sweet lip," similar to bream), though many bundles of taro are in evidence.

Although both *wasi* and *vava* involve the exchange of fish (provided by lagoon dwellers) for vegetable staples (provided by inland people), the distinction is important. *Wasi* is a delayed exchange between established partners; *vava* is a direct or simultaneous exchange between bartering parties. Malinowski illustrated the contrast in *Argonauts* by juxtaposing two plates (XXXVI and XXXVII, the latter Billy Hancock's taken at Tukwaukwa). Understandably, he paid greater attention to *wasi* on account of its rule-bound, ceremonial nature.[9] His legend to Hancock's photograph showing *vava* makes this very point: "Direct Barter of Vegetables for Fish: In the picture the inland natives exchange bundles of taro directly for fish, without observing the rites and ceremonies obligatory in a *wasi*."

But the discussion provoked among Linus's Teyava informants suggests that the distinction between *wasi* and *vava* cannot be based simply on the presence or

absence of trade partnerships. After close study of plate 80, Giyomatala was convinced that the scene of the event was none of the regularly used bartering beaches. This led him to suspect that the fishermen had been intercepted by the men with the taro in one of the tidal inlets of Luba district. This, he claimed, is an irregular, even unethical practice, for each fishing village has its own traditional exchange partners (*kidodina*) from inland villages, and such opportunistic, clandestine trade (as Giyomatala surmised this to be) can lead to indignant recrimination by the true partners who have been denied their right to exchange.

Linus elaborated, "At each *kawalawa* [beach or landing place] a similar ethic is observed. Every single canoe has its own particular landing place, where its crew will be met by their inland partners. Baskets of yams or bundles of taro are then directly exchanged for the fish. This is the essence of *vava*. But if a canoe does not have enough fish to match the amount of yams or taro brought by their waiting partners, the latter cannot simply move to another canoe to barter their remaining yams. They will carry them to the front porch of their partners' houses and leave them there. A day or two later the fishermen will take out their canoe and catch the necessary amount of fish to reciprocate the yams."

PLATE 81

Probably Teyava men, landing their catch of bony *ketakeluva,* which they have strung through the gills. Such fish are too inferior for ceremonial *wasi* exchange, so this must be *vava.*[10] Tabalu people cannot eat *ketakeluva* lest their rank be compromised and they lose privileges.

PLATE 82

Wasi at Oburaku. The island of Bwemapo is on the horizon, left. There are two *kalipoula* canoes and one *kewou*. The taro being heaped into the crate (*liku*) is typical of *wasi*, but never done in *vava*. Malinowski's legend to the companion photograph in *Argonauts* explains the scene, "The inland party have brought their yams by boat to the village of Oburaku, which is practically inaccessible by land. They are putting up the vegetables into square, wooden crates in order to carry them ceremonially and to place each before the partner's house."[11] Linus added that each crate will be given to the *toliwaga,* the canoe owner and exchange partner of the taro donor, who will distribute the tubers among his crew. This occurs some days before the canoes go fishing for the reciprocal gift.

Figure 1, a sample page from Malinowski's fieldnotes, illustrates a number of things about his manner of note taking. It is typical of his last period of fieldwork, when he had virtually dispensed with the regular 8″ × 5″ notebooks that had served him on his first two trips. On his return to Kiriwina in December 1917 he began to use 12″ × 8″ sketchpads, which required him to write across the page (echoing his preference for horizontally framed photographs). On all of the many hundreds of sheets, he left a wide margin in which he jotted miscellaneous notes, mostly subsequent to the main text. For example, at the bottom left of this page are three definitions, the first of which is "Wasi—to offer food in village for subsequent repayment with fish"; the numbers IV B.7. are in colored pencil and were added later to cross-refer to another set of notes in a different folder or file.

The sample page shows the extent to which Malinowski took down notes in an almost seamless blend of English and Kiriwinan (with the odd word or phrase of Pol-

FIGURE 1

ish, French, or German thrown in). It shows too how he jumbled topics of investigation on the same page, and how he checked and rechecked his information.

He begins the sheet with a dubious list of villages that were said to observe "kabikabi custom," literally "weeding gardens," here probably referring to the orgiastic practice of *yausa* in which groups of women sexually assault lone men who stray into their vicinity while the women are weeding.[12] Next is a note on the remarriage of the widows of a deceased chief, Mtabalu of Kasanai. This is followed by a note on small *solava* seen in Tukwaukwa and a technical note on Kula procedure; as the margin note opposite it indicates, however, this information was "contradicted by Namwana Guyau."

The notes which follow return to the subject of the remarriage of Mtabalu's wives. Malinowski had apparently checked information received from Tokolibeba (described in *Sexual Life* as "once a famous Don Juan, now a peppery old conservative and stickler for proprieties"[13]) and found it unreliable. Moliasi (a man of Toliwaga rank from Kabwaku) contradicted him, saying that the dead chief's henchmen (*ilomgwa*) would seize the widows by force (*biu, ilebusi*) and distribute them among other chiefs. They would join the first wives of these men and mourn their dead husband "for a relatively short time."

The last topic to be dealt with on this page is "fish exchange." Here Malinowski checks information previously obtained on the complexities of *wasi* and *vava*. Most of it is "confirmed," though he does not in this instance give the names of his informants. His diary entry for the date given here, 2 January 1918, records that he and Billy went to Teyava and took six rolls of film, presumably of the *wasi*, though this is not mentioned in the diary.[14] The notes on this sheet conclude, "On the 2.1.18 in Teyava, all the canoes came together, there was a mêlée (which I was unable to observe as I was busy with the camera) & then the bulk returned with their fish. One man with a bundle of taro & another one with bananas got no fish; they left it in Teyava as Wasi."

⊶⊷

PLATE 83

A *kalipoula* fishing canoe with fairly old but well-carved *lagim* and *tabuya*. The inlet can be recognized as that of Tukwaukwa, and judging by the mangroves it is high tide. Linus added, "My informants were full of admiration for the carver of these prowboards. They are obviously the work of a once-famous *tokabitam* [master carver]."

PLATE 84

Linus surmised that this might be Sinaketa, where people still build their houses among the coconut palms fringing the beach. It is a *kewou* canoe drawn up, and the youth is wearing a cloth cap on his head (neither a wig nor dyed white hair). One suspects that Malinowski snapped this image of a cozy world cocooned by wood entirely for its tactile appeal.

PLATE 85 This photograph of juxtaposed logs and sticks of varying bulk and texture (coconut trunks, a discarded outrigger, the hull and platform of an upturned fishing canoe) is further testimony to Malinowski's occasional surrender to an aesthetic impulse. It conveys little ethnographic information, though the inscription on the reverse dutifully appeals to realism: "Fishing—Canoes."

"Village Scenes"

9

Malinowski's category "Village Scenes" contains more than sixty prints, very few of which bear any identifying inscriptions. The photographs cover a range of subjects and places. There are many unpeopled scenes in nameless villages, many anonymous figures simply sitting or standing around, many others engaged in more or less comprehensible activities. I considered calling this section (using Malinowski's own portentous phrase) "imponderabilia of actual life," but that would have suggested a methodological purpose it could not sustain.[1]

What so many of these photographs seem to convey, rather, is the unfocused interest on the part of the ethnographer, his mind disengaged, snapping away in the often vain attempt (if only because so many of his shots are as unfocused as his attention) to capture a pervasive village mood of *ennui*, of waiting for something to happen. To enliven the mood I have included some images from other categories, images which attract the eye by the sense of purpose of their active human subjects.

PLATE 86

The seafront of Tukwaukwa. Linus counted eight fishing canoes in the photograph, most of them of the *kalipoula* type. Only one canoe (center left) carries a crew, embarked on some activity. The log jutting from the water in front of it serves as a springboard for bathers; there is one in the same place today.

These villages—an attractive palm grove with here and there a house showing among the trees and a few canoes drawn up on the beach, or being paddled into the offing, do not gain by near inspection. The beach itself is very often littered with rubbish, shells, fish-bones and, nowadays, tins and cotton rags. Coral Gardens, *24*

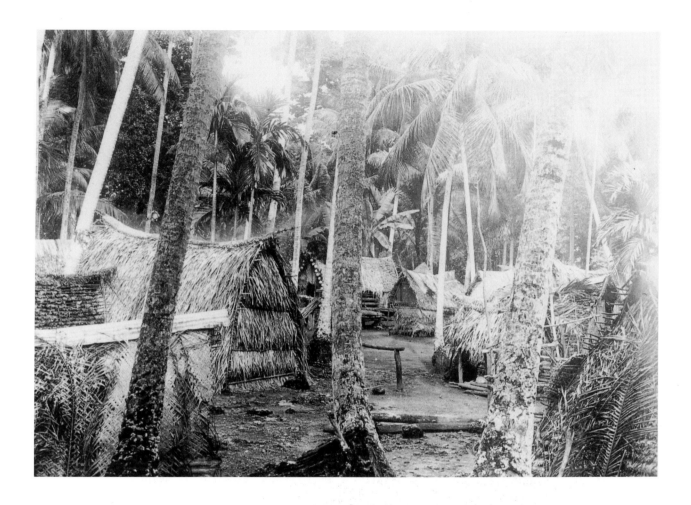

PLATE 87
Linus refused even to guess the location of this shot, but some of his informants thought it might be Tukwaukwa.

PLATE 88 Street in a small hamlet, perhaps in Oburaku.

The coastal settlements also appear at first sight chaotic, with huts irregularly placed and storehouses scattered among the palms without much system. Coral Gardens, *24*

PLATE 89 Inundated village following a deluge of rain. The location is Bwoytalu (today Bwe-
talu), the "pariah" village of superb craftsmen which Malinowski visited for a few
days at the beginning of January 1916.[2]

PLATE 90

This is probably Kasanai village, which adjoins Omarakana. Both men are smoking bamboo pipes (*bobau* or *dum*). All houses are of the older style, with roofs reaching to the ground and lacking platforms. A boy's tiny yam hut can be seen between two houses on the left, a domestic yam hut on the extreme right.

The village in plate 91 was identified (largely by the faces) as Ketuvi (Malinowski's Kayturi) in Luba district. Although an inland village, it has access to an inlet, enabling men to fish in the lagoon. Linus commented, "The betel palm on the left is under taboo, as can be seen by the coconut leaf wrapped round the trunk. On the roof of the covered platform to the right are coils of tough *weiugwa* vine, used as lashings for canoes. The woman in the shelter is scraping on a flat polished board a

PLATE 91 *wakaya* banana leaf for a bundle (*nununiga*). Ketuvi is locally famous for its bananas. You can see suckers ready for planting in the shelter. A large banana bunch droops over the roof of the old house in the center. This is a traditional type of house with woven, coconut-leaf front wall and a pandanus-leaf roof. The house on the left is the newer, postcontact design, raised slightly above the ground and with an awning over a "porch" in front of the doorway. The roof is made of sago leaves which would have come from Wawela, the only local source of sago."

For health reasons, the colonial government encouraged people to build houses raised off the ground. Wary of sorcerers, Trobriand builders compromised by making the house floor too low to crawl beneath, but sufficiently raised to allow air to circulate and eliminate dampness.[3] Malinowski does not seem to have commented on these modifications to traditional house design, though they had already begun to change the appearance of Trobriand villages before his arrival.

PLATE 92

House building in Teyava. This is probably the occasion Malinowski refers to in his diary entry for 11 May 1918: "took pictures of a house . . . and studied the construction of a new house."[4] We can be certain it is Teyava because the girl who features in so many of the photographs of children's games in Teyava is seated in the center of this photograph, her tell-tale necklace dangling to the right of her head. (Surprisingly, in view of their confidence in making other identifications, Linus's Teyava informants did not claim to recognize any of these faces.)

The two girls are shown from a different angle in a published photograph entitled "Technique of Thatching a Roof." To adopt Malinowski's legend, "The broad end of a lalang wisp, or of a palm leaf, is pulled through the interstice between two frame rods. It is then folded back and pulled through the next interstice below."[5] The poles in the middle of the house are merely temporary supports and would have been removed before the house was completed.

PLATE 93 This photograph was cataloged under "Cooking." None of Linus's informants could guess the location, though some agreed that the people might be from Liluta. There is no visual evidence of cooking, and, other than the children sitting in front, little indication of eating. Linus speculated that the party is resting on the outskirts of a village, having just carried harvest yams to its chief.

PLATE 94

"Firemaking" is Malinowski's inscription on the reverse of this print (cataloged under "Cooking"). The young men could belong to Mtawa or Oburaku. The taro leaf is being used as a wind screen, not as a fan. The fireplough is rubbed vigorously in the groove of a small log, both of which are hardwoods (*usari* is preferred). The sexual mimicry of the act is acknowledged in the term for the fireplough: *kekwila*, literally "that penis."

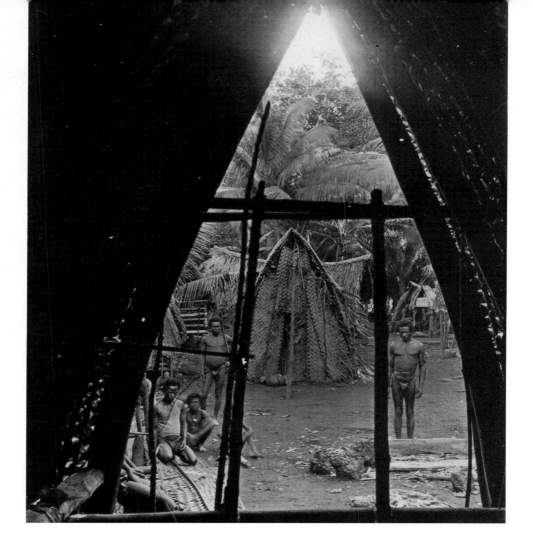

PLATE 95

Although the reverse of this print has "Housebuilding," it was cataloged under "Village scenes." It is taken from the inside of a dwelling house, obviously a new one as the space between the gables has not yet been filled in. The photograph is a rare example of vertical framing, obviously dictated by the high pitch of the roof. Linus observed, "This house shows finer craftsmanship than is usual nowadays. The gables are well-shaped. The house is perhaps on the edge of the *baku* in Oburaku. If so, Malinowski's tent would have been to the right. The traditional house directly opposite is unusually small, perhaps belonging to a widow or widower."

PLATE 96

This photograph of the interior of a house is one of a unique pair. The seated woman is absent in the other one, to which Malinowski gave this legend, "Two bunks run across the back wall. Besides a Chinese trade trunk and a piece of calico there are water bottles, folded mats and a basket on the lower bunk. On the top bunk note the lime pot stuck into the round basket and a few coils of pandanus leaf."[6] In addition, Linus noted firewood stacked under the platform, an aluminum pot on the back shelf (left), and carved pieces of canoe prowboards, hanging to the left. The presence of the large limepot caused Linus to wonder if the woman was the wife of a chief.

PLATE 97

These two photographs make up the category "Ropemaking." Their sequential numbering in the collection is misleading, for they are of different men (with different armbands) in different locations. Both men are making lashings for a canoe ("Canoe-making" is written on the back of one of the prints). The man in plate 97 is rolling fibers into a string on his thigh, seated on what appears to be the upper edge of a beach. The man in plate 98 (whose rugged features resemble those of Namwanaguyau or Tokulubakiki) is twisting plant fibers into a rope (*yuwayoula*), using a stake to provide tension. Behind him is the *baku* of Omarakana.

PLATE 98

⊰ 10 ⊱ Women's Domain

In the predominantly matrilineal Massim, women are highly valued for their role in the reproduction of descent groups and the transmission of social identity. Additionally, Trobriand women control the ritual processes surrounding birth and death through the production and exchange of wealth in the forms of banana leaf bundles and skirts. In *Argonauts of the Western Pacific*, Malinowski detailed these and other facets of the women's social position:

[Women] do not as a rule join the councils of men, but in many matters they have their own way, and control several aspects of tribal life. Thus, some of the garden work is their business; and this is considered a privilege as well as a duty. They also look after certain stages in the big, ceremonial divisions of food, associated with the very complete and elaborate mortuary ritual of the Boyowans. Certain forms of magic—that performed over a first-born baby, beauty-magic made at tribal ceremonies, some classes of sorcery—are also the monopoly of women. Women of rank share the privileges incidental to it, and men of low caste will bend before them and observe all the necessary formalities and taboos due to a chief. A woman of chief's rank, married to a commoner, retains her status, even with regard to her husband, and has to be treated accordingly.[1]

The "friendly familiarity" of Trobriand women both delighted and disconcerted Malinowski. By the standards of his day they were sexually liberated—shockingly so. No prude himself, Malinowski's personal diaries document an agonizing moral struggle with powerful sexual urges. He was both attracted to and repelled by young Trobriand women: "I met women at the spring, watched how they drew water. One

of them very attractive, aroused me sensually. I thought how easily I could have a *connection* with her. Regret that this incompatibility can exist: physical attraction and personal aversion."[2] Ultimately, his fear of sexual (and spiritual) pollution outweighed his lust. While he occasionally surrendered to the temptation to "paw" them (for which he severely castigated himself), he seems never to have indulged in anything more than a furtive caress.

Malinowski's photographs of women convey no hint of any such salacious interest. As always, he kept his distance from his subjects, and there is not a single shot of what might be read as a flirtatious glance or an erotic pose. Even the photographs he categorized under the blunt rubric of "Sex" display female "Physical Types" in an asexual manner, despite his inscription "Melanesian beauties" on the reverse of a few of the prints. There are only seventeen photographs in the category "Sex," most of them of groups of pubescent girls or young women, some of which he published in *The Sexual Life of Savages*. In the same category are three photographs of *pwatai* structures containing marriage gifts, so it is clear that (as in his monograph) "Sex" included marriage. It did not include pregnancy, however, for which he reserved another category. "Dress" is yet another category comprising photographs almost entirely of women, most of them engaged in various stages of skirt making. By contrast, more than half of the twenty-nine photographs classified under "Cooking" feature men.

PLATE 99 The women are mashing cooked taro for rolling into flat dumplings or pancakes. Thereafter the men take over. They will boil the dumplings in large clay pots of coconut cream to make *mona*. Linus added, "*Mona* is also made with yams. Only *kui* [greater yam] is cooked raw in the coconut. *Tetu* [lesser yam] is grated and cooked first in an earth oven to make a cake. This is then cut into cubes with a thin piece of twine and thrown into the boiling coconut cream. The women's anvils are made of a hardwood called *meku* (more generally known as *kwila*). The women on the left and in the center have the Tabalu look, so this is perhaps Omarakana at the time of *milamala*." Some of Linus's informants guessed that they might be from the nearby village of Wagaluma.[3]

꘡

WOMEN'S DOMAIN

PLATE 100

A different group of women mashing cooked taro. The location is not Omarakana. Malinowski's caption is "Domestic cooking," but Linus suspects they are preparing for a mortuary *sagali*. Linus commented, "This is specifically women's work. The men are probably scraping coconuts for the *mona* at this very moment. The four coconut shells in the center are water bottles (*lukwava*) for the cooked taro, which is very sticky and needs to be moistened. The beaters are called *ketutu*. The wooden platters are *kabomwaya* (literally, 'old plates'). The baskets probably contain cooked taro ready for mashing."

PLATE 101

Men preparing to cook *mona* in an undetermined village. They are seating the pot on a triangle of coral cooking stones (*kelagila*). The woman on the left is probably cutting baked yam cakes or mashing taro for the *mona*.

PLATE 102 Men cooking *mona*. Malinowski wrote of a very similar occasion, "Large claypots, imported from the Amphletts, are used for the purpose; in these coconut oil [that is, cream] is brought to a boil, pieces of pounded taro being thrown in afterwards, while a man stirs the contents with a long, decorated wooden ladle."[4]

Linus remarked, "I suspect this is being done for a *sagali* exchange, perhaps on the day before *lisaladabu,* the women's mortuary exchange to release female mourners from their taboos."

PLATE 103 Women with woven carrying pads (*tugebi*), which cushion the weight of food baskets. The mourning necklace (*sewega*) worn by the woman in the center was formerly a *doba* ("proper") skirt, perhaps that of a dead daughter. It is covered in cowrie shells, beads, and betel nuts. Malinowski published an almost identical photograph in which the second woman from the left has her breasts covered.[5] In this "rejected" image, her left breast seems unduly large and is possibly infected. Malinowski's inscription on the back is "Ladies of the road," which has rather offensive connotations today.

PLATE 104

A group of women at Gusaweta, looking south toward the island of Bwemapo. Linus speculated that "the women are perhaps passing through Gusaweta on their way to a mortuary feast or *sagali*. The baskets of banana leaf bundles (*nununiga*) suggests a *lisaladabu* event. The woman on the right carries germinating yams in her basket. The little girl in the center carries a folded rain mat on her head."

The neat fence on the right would have enclosed Billy Hancock's property; today it is the site of the Catholic Mission.

PLATE 105

Linus suggested that these four women were from Tukwaukwa: "a grandmother, perhaps, with her daughter and two granddaughters."

✤

PLATE 106 With the likely exception of the girl on the far right, these nubile girls will have left "the children's republic" and entered the sexually active stage. Even so, Malinowski classified this print under "Physical types" rather than under "Sex." Linus commented, "These are perhaps young unmarried girls of Omarakana posing for a shot. The location could be between Kasanai and Omarakana."

Plates 107 and 108 are sequential and were obviously intended to illustrate women's dress ("petticoats," as Malinowski frequently referred to women's skirts). His caption for both, however, is "Melanesian beauties." The six young women in plate 107 are in their underskirts (*sekuya*). In plate 108, the same girls plus a seventh are shown wearing their *dobatola* skirts. This photograph prompted Chief Pulayasi and his daughter Elsie to comment that, traditionally, *dobatola* designs were identified with certain *dala* and ranked accordingly. Linus explained, "Each subclan has its own skirt design which is displayed during the *tubotubo* phase of a *sagali*. Such designs are therefore part of *dala* identity, having been inherited matrilineally."

Linus guessed the location of these shots to be Teyava. Judging by the massive beams of the yam house, however, Chief Pulayasi thought that it might be Kaulik-

PLATE 107

WOMEN'S DOMAIN

PLATE 108

wau village in northwest Kiriwina. There they grow big fat prickly yams called *tomwaguba*, which are appropriately housed in stout-beamed yam huts.

Among the Southern Massim, [the] fibre skirt is long, reaching to the knees or below, whereas in the Trobriands it is much shorter and fuller, consisting of several layers standing out round the body like a ruff. . . . The highly ornamental effect of that dress is enhanced by the elaborate decorations made in three colours on the several layers forming the top skirt. On the whole, it is very becoming to fine young women, and gives to small slender girls a graceful, elfish appearance. Argonauts, *53*

PLATE 109

The three young women are scraping off the fleshy outer skin of *wakaya* banana leaves to make fibers which will be dried and made into *doba* skirts. Alternatively, they will be tied into bundles and stored with *doba* skirts as "women's wealth."[6]

After the fleshy substance has been scraped off from the top of the [wakaya] leaf, this latter is scratched over with plain geometrical designs. This is done on an oval-shaped, smooth board (*Kaidawaga*) with a small shell (*Kidonatu*). After that, the pieces of leaf are bound into bundles (*Nununiga*) and in this form play an important part in the mortuary distributions (*Sagali*).[7]

Linus observed that the women are sitting on one of the shelving coral beaches, which are only found on the east coast of Kiriwina. He deduced that since the two women on the right are "clearly Tabalu," and that there are only two Tabalu-dominated villages on that coast, this must be Mweuya beach of Oluvilevi. It is unlikely to be the beach of Omarakana, for that is too far from the village for women to visit for the purpose of skirt making. *Wakaya* bananas, he noted, are also a speciality of Luba district, of which Oluvilevi is the "capital."

PLATE 110 Women drying dyed banana leaf fibers (*noku*) in the sun. They are spread on mats of woven coconut leaves. The woman on the right appears to be laughing at the girl drawing from a bamboo pipe. Linus suspected this was taken in Teyava.

One of Linus's older Okeboma informants was reminded of a ribald ditty which used to accompany the sharing of a bamboo pipe: "Tobacco was scarce and men would take turns to inhale from the *dum* pipe. Before 'dragging' on it, however, each man would have to recite, *'Lutu, lutu kasesa . . . , uwesala, kwalabolu . . . '* [Power, power of clitoris . . . , its inner part, ram it in . . .]."

PLATE 111 The bunches of frayed banana leaves are hung in the sun after being stained with crimson and purple.
Sexual Life, part of legend to plate 10 (a more distant shot of the same event)

Another way of drying *noku* is to hang them on shrubs growing in the village *baku*. The red dye was made by mixing juice extracted from the roots of the *noku* plant with burnt lime made from dead coral; the purple dye was obtained by boiling *noku* leaves with the bark of a certain tree. Nowadays, commercial dyes of different colors are used, though red is still the dominant color.

These are Teyava women. Linus noted that the houses in the background are of the "modern" type.

PLATE 112

This young woman is probably on the same Oluvilevi beach as those photographed scraping banana leaves (plate 109). She is at the final stage of skirt making. The string looped around her toe forms the belt, to which she is attaching dyed bundles of fiber. Beside her on the banana leaf mat are plain bundles for the underside of the skirt. Linus added, "She is wearing a necklace of black banana seeds with shells attached. It is called *sikwekula* (literally, 'fingernails'), and these shells might well contain the nails or teeth of her dead father. A married or unmarried woman may still carry them nowadays to honor her father's memory. She will wear them until her father's *dala* make a feast for her, though she might prefer to wear them forever. There is also the key to a wooden chest on this woman's necklace."

PLATE 113

On several grounds this photograph must be denied Malinowski's authorship. It was certainly not his practice to write captions on negatives, nor did he come in so close to his subjects. There is also a postcard posture about the young woman, a "candidness" betrayed by the intensity of her concentration. "Don't look at the camera," Billy Hancock had probably warned her, waiting until she seemed to be absorbed in her task before snapping the shutter.

Linus's informants could not identify her. Linus himself noted, "The house has sago walls, so the village is perhaps Oburaku, where sago is fairly plentiful being so close to Wawela. The woman is wearing the same kind of 'fingernails' necklace as the girl on the beach. She is also in the finishing stages of making a *doba* skirt. The string for the waistband is tied to the house post instead of to her toe. Her tight long armlets (*kwasi*) could mean that she is newly married or has recently given birth (though the appearance of her breasts suggests otherwise). It might be that she has simply dressed up for the approach of *milamala*. The bundles (*vana*) in her armlets are scented leaves called *sulumweya* [Malinowski's *sulumwoya,* which he referred to as 'mint.']"

PLATE 114

"The finished article" is written on the back of this print. Both of these skirts (a woman's and a child's) are of the highest grade, *dobatola,* and therefore valuables in their own right. They are fit to be exchanged at *lisaladabu,* the final stage of women's *sagali.* They would have been colored red and purple; the broad strips of white trimming are of bleached pandanus leaf.

Malinowski listed five different *doba* designs, which people "classified according to the manner in which the decorative layers are placed, one on top of the other."[8] He did not say that these designs were ranked, however, as claimed by Chief Pulayasi, nor that they belonged to particular *dala.*

PLATE 115

Women make another kind of skirt for mourning called *sepwana*. These are much longer and somewhat fuller than *doba,* and usually undyed. They can be woven from banana-leaf fibers or from fibers of the *seulolu* plant. The reverse of this print has "Mortuary—technology."

Linus commented, "A group of Teyava or Oburaku women. They are weaving *sepwana* skirts for the *lisaladabu* phase of the mortuary ceremonies. The women who wear these skirts will contribute the most *nununiga* [leaf bundles]."

In Oburaku on Monday, 24 December 1917, Malinowski had a bad day: "Got up at 7, walked around the village . . . [everyone had gone fishing]. This annoyed me a little. *Kilesi Imkuba ivita vatusi Saipwana* [this should be *ilesi Lukuba iutuvatusi sepwana,* meaning 'women of Lukuba clan weaving/tying mourning skirt']. I decided to take pictures. I blundered with the camera, at about 10—spoiled something, spoiled one roll of film. Rage and mortification."[9]

PLATE 116

On the reverse of this print: "Two young women in pregnancy cloaks." The location appears to be the beach of Tukwaukwa. Linus disregarded the girls' evidently tender years, though he agreed that the only clue to their condition is the *sekeula* cloaks (Malinowski's *saykeulo*). The garlands around their foreheads are white sweet-smelling *butia* flowers. The girl on the left has a gaping wound on her knee.

Malinowski devoted a chapter to pregnancy and childbirth in *The Sexual Life of Savages*. He illustrated it with ten photographs, at least four of which had been taken by Billy Hancock.[10] First pregnancy rites are particularly important in the Trobriands. Malinowski explained, "Native embryology teaches that four moons after the appearance of the *baloma* in the [woman's] dream the abdomen begins to swell; and when this stage in a first pregnancy is reached, the relatives of the mother-to-be take steps to provide her with certain ceremonial garments prescribed by custom; a plain white fibre petticoat, and a long cloak (*saykeulo*) of the same material. These will be given to her in about the fifth moon of her pregnancy with a great deal of ceremony, and she will wear them on that occasion for a month or two and also after she has given birth to the child."[11]

PLATE 117

"The way into the water." One of several photographs that Malinowski took of a pregnant woman's "ritual bathing" on 26 May 1918.[12] He wrote in his diary, "[H]alf the day spent taking pictures of *nasusuma* [pregnant woman] in Tukwa'ukwa. . . . In the evening, somewhat depressed and sluggish; we developed pictures. Almost all of Billy's unusable; I failed to expose three of them."[13]

The woman in plate 117 would have been carried to the beach by her *tabula*, father's sisters and other female paternal relatives: "Arrived at the water's edge, the women arrange themselves in two rows, facing each other, and join hands with their opposite partners crosswise. . . . Over this living bridge the pregnant woman walks, holding on by the women's heads, and as she advances, the rear couple move to the front, constantly extending the bridge. . . . At a certain point she is allowed to jump into the water."[14]

After washing her thoroughly, the *tabula* carry her back to the village where they anoint and dress her and perform beauty magic "to make her skin smooth, clear, and soft, and her appearance generally beautiful."[15] Following this, the woman is ritually invested with the long pregnancy robe and finally carried to her father's house and seated on a special platform. There she remains, under taboo, for the rest of the day. Meanwhile the maternal kinsmen of the woman hold a food distribution to repay her *tabula* for playing their part in the pregnancy ceremonies.

Linus added, "If the pregnancy rites are carried out successfully and seem to produce the desired physical effects in the woman (that is, a light skin, glowing with youth and beauty), then the *tabula* will be praised and congratulated for having publicly demonstrated the efficacy of their pregnancy magic, *kepwakova*."

PLATE 118

This Tukwaukwa woman features in several of Billy Hancock's photographs, taken to illustrate the sequence of pregnancy rites. She maintains her grim expression in all of the shots.[16] This one is probably the first in the series, taken after she has ritually bathed but before she has been invested with her pregnancy cloak. Malinowski's legend for a similar photograph reads, "Note the mat on which the woman is standing, the basket with magic herbs at her feet and the crown of hibiscus flowers; also the remarkably clear colour of her skin in contrast to her black hair."[17]

Linus commented, "The basket appears to contain her decorations (not only 'magic herbs'). What is still missing is her facial decoration (made of betel paste) and her *yaulai*. This is a specially-made string wound around a pregnant woman's thorax, placed immediately above her breasts."[18]

In an undated letter to Malinowski which probably refers to these photographs, Hancock tells him they were taken between 6:30 and 7:30 A.M. with a one second exposure at f8, and developed with 5 grams of "good old Bromide." He was obviously pleased with the results. Tongue in cheek, Billy attributed the lightening of pregnant women's skin to their vigorous washing in the sea: "they had never in their lives been scrubbed so hard before."[19]

⚞⚟

PLATE 119

Another photograph in Billy Hancock's characteristic portrait style. Linus observed, "A first-time mother (*igavau*) with her baby at her breast. She is fully adorned with all the necessary accoutrements of a young mother, including her birth-cloak (the second *sekeula*), the maternity cap on her head (*tugebi*), the tight string (*yaulai*) above her breasts."

PLATE 120

At center is the same woman as pictured in plate 119. (A third photograph in the sequence was published by Malinowski, though he did not attribute it to Billy Hancock.[20]) After the birth, which usually takes place in her parent's house, the mother remains in seclusion with her child for a month. More beauty magic is then performed on her by her father's sisters, and she now wears a plain fiber skirt and the second *sekeula* mantle they have made for her.

Linus identified this photograph as, "Women of Teyava posing with the woman who has recently given birth." He commented, "She can now be referred to as *igabogwa*. The woman on the right is pregnant, but it seems not for the first time. These women all have a Teyava appearance. It hasn't changed. We sometimes laugh at the old photographs in *The Sexual Life of Savages* because so many of the people in them resemble people in the same villages today!"

PLATE 121

Malinowski's legend on the back of this print is unusually informative in general terms: "Woman, a few months after childbirth. Woman wears a kind of headdress, consisting simply of a grass petticoat (*doba*) put on the head. They also wear another *doba* on the shoulders."

Linus noted, "The youngsters look as if they might be from Kalieuna or Kitava. It's Kitava custom to pile the *sekeula* cloak on the head like this young woman has done. Her child must be close to one year old, but she is still wearing her *sekeula*."

Asked the reasons Trobrianders give for wearing the *sekeula* cloak, Linus listed several: "To restore the mother's youth. Every day she sews fresh aromatic leaves into it. To protect her milk for the baby. To protect the baby from witchcraft and sorcery. To protect her skin from the sun and keep it white. The dew at night can harm the baby, so the cloak keeps mother and child warm like a blanket."

⌘

⊰ 11 ⊱ "The Children's Republic"

Malinowski took many photographs of children, at least fifty of which he never published. Children feature prominently in *The Sexual Life of Savages,* which is an integrated ethnography of Trobriand reproduction—the begetting, bearing, and raising of children—and not simply a discursive account of the sexual behavior of youths and adults. Plate 16 of of *Sexual Life,* captioned, "The Children's Republic," shows a group of ten-year-olds on the beach at Teyava. The legend reads, "Sometimes in the course of an ethnographic demonstration a general discussion breaks out, which is easier to 'snap' than to take down in notes."

In describing this "children's republic," Malinowski notes,

Children in the Trobriand Islands enjoy considerable freedom and independence. They soon become emancipated from a parental tutelage which has never been very strict. . . . Such freedom gives scope for the formation of the children's own little community, an independent group, into which they drop naturally from the age of four or five and continue until puberty. As the mood prompts them, they remain with their parents during the day, or else join their playmates for a time in their small republic. And this community within a community acts very much as its own members determine, standing often in a sort of collective opposition to its elders. . . . In my ethnographic work I was able and was indeed forced to collect my information about children and their concerns directly from them. Their spiritual ownership in games and childish activities was acknowledged, and they were also quite capable of instructing me and explaining the intricacies of their play or enterprise.[1]

He then refers to plate 15, which shows him crouching by a group of children and bears the caption, "Children showing a game to the Ethnographer." It was probably taken in Teyava by Billy Hancock in May 1918.

The virtue of discussions with the Trobriand children was clear to Malinowski from the start. Following his first field trip to Kiriwina he had written,

I have had most valuable information on several points from boys and even girls of seven to twelve years of age. Very often, on my long afternoon walks, I was accompanied by the children of the village [Omarakana] and then, without the constraint of being obliged to sit and be attentive, they would talk and explain things with a surprising lucidity and knowledge of tribal matters. In fact, I was often able to unravel sociological difficulties with the help of children, which old men could not explain to me. The mental volubility, lack of the slightest suspicion and sophistication, and, possibly, a certain amount of training received in the Mission School, made of them incomparable informants in many matters.[2]

Malinowski crouched over his snapshot camera at low tide on the mangrove-fringed shore of Oburaku. The boy on the left is holding his helmet. The photographer, probably Billy Hancock, is facing south in the direction of Sinaketa.

PLATE 123

Two little boys holding a simple fish trap. It is possible that this was one of the photographs Malinowski took on the occasion Billy "snapped" him. This photograph was among those Malinowski presented to the National Museum in Melbourne in 1920. It bore the legend, "Many of the children's amusements are in imitation of their elders' occupations. Here two boys are seen playing with miniature nets on the shallow waters of the lagoon."

Linus explained the technique, "This kind of fish trap is called *be'uya* on the lagoon side of Kiriwina (*Wadom*), and *sobwara* on the coral-reef-platform side (*Waluma*). The miniature, conical, upside-down net is attached to a string with a loop that encircles the rim of the net. A coconut leaf, along with bait consisting of food crumbs or tiny insects, is inserted vertically into the net. After the net has been lowered into deeper water the boy stands and watches the coconut leaf. When it shakes vigorously he quickly jerks at the string, thereby closing the loop and trapping the fish."

PLATE 124 Silhouetted youths and children bringing short fishnets (*sukwalu*) to shore.

PLATE 125 Boys sailing toy canoes (*keluilui*), mimicking the *tasasoria* competitions of adults. The place can be identified as a tidal inlet called Ubuwa near Ketuvi village.

PLATE 126

"Village scenes" is Malinowski's classification. A group of children sitting in a village street, possibly Omarakana, in which case the houses to the left belong to wives of the chief (see plate 57). Maize seed hangs from the house on the extreme left. Maize had been introduced into the Trobriands by Bellamy only recently, but did not rate a mention in *Coral Gardens*.

PLATE 127

"Brother and sister" is Malinowski's caption to this photograph. It was taken in Tuk-waukwa, doubtless on the same occasion that Malinowski and Hancock took reflex-ive pictures of one another taking photographs. It is at exactly the same spot, and the same children appear in the background to the right.

❖

MOST OF THE FOLLOWING photographs have "Games" or "Children's games" writ-ten on the prints. Malinowski would have taken them in Teyava during the days in May 1918 that he devoted to recording games (*mwasawa*) and bawdy folktales (*kuk-wanebu*). He was staying at Gusaweta with Billy at the time. On 8 May his diary is explicit about his intentions: "[P]repared campaign: *children's plays* [*sic*] *and games.* Went to the village with Teapot [presumably one of Billy's assistants, but unlikely to have been a Trobriander]. Some difficulty in picking an informant. Tried to master my impatience and anger. Finally one or two good informants emerged. I worked on *games,* sitting under a tree."[3]

That night he developed photos with Billy, and on the following afternoon, hav-ing loaded his camera, "went to Teyava and again busied [himself] with games, get-ting fairly good results," noting, "I should make a list of games as I go along and try to see them all and take pictures of them."[4]

Although it was the luckless day he broke his false teeth, Malinowski devoted the whole of Saturday, 11 May, to photography: "At 10 I went to Teyava, where I took pictures of a house, a group of girls, and the *wasi,* and studied construction of a new house."[5]

As he points out in *The Sexual Life of Savages,* all his photographs of games had to be taken in the daytime. "The actual performances take place always after nightfall, and could not be photographed. The difference consists mainly in the presence of spectators, who are not to be seen in these illustrations."[6]

PLATE 128 Girls of Teyava. Linus commented, "Malinowski's little friends. A shot of gratitude, perhaps, for the *kasesuya* performances they put on for him. Although none of them can be identified with certainty, my informants pointed out distinctive physical features and guessed at a few names." Note the scowling girl wearing a long necklace. Thanks to this necklace she can be identified in many of the photographs Malinowski took during this period. She appears in the photograph of house building, plate 92.

PLATE 129

These small, recently constructed *pwatai* are probably intended for a marriage exchange (*katuvila*). The extended scaffolding on them is for ease of carrying. The children appear to be holding them simply for the sake of the photograph. The location is almost certainly Teyava village on one of the days Malinowski spent photographing games. The girl with the long necklace stands just to the right of the central frame.

❧

ON 16 MAY, just before taking to his bed with a bout of sickness, Malinowski made another excursion with Billy Hancock to Teyava to photograph children playing. After recovering his health, he again visited Teyava on 23 May "to do *games*," and yet again the following evening when he "observed" games.[7] He described these games in *Sexual Life*: "In the ordinary course of tribal life, as the moon waxes, the children, who always play in the evening, sit up later and band together to amuse themselves on the central place of the village. Soon the young boys and girls join

"THE CHILDREN'S REPUBLIC"

them, and, as the moon grows fuller, the maturer youth, male and female, is drawn into the circle of players. Gradually the smaller children are squeezed out; and the round games and competitive sports are carried on by youths and grown-ups. . . . The games which are played on moonlit evenings . . . usually begin with a round game of 'ring-a-ring-a-roses' type, called *Kasaysuya* [today, *kasesuya*]."[8]

According to Kwewaya, the present chief of Tukwaukwa, *kasesuya* games were imported from Muyuwa and Gawa by an immigrant subclan named Kabata (of Lukulabuta clan). Linus explained, "Among other landfalls, they settled on the beach front of Kokowa, a prominent point between Gusaweta and Teyava. Every night the Kabata people would joyfully dance their *kasesuya*, much to the amusement of the local villagers. Eventually, Teyava people invited the immigrants to live with them in their village so that they could teach them their *kasesuya* games. Thereafter *kasesuya* spread from Teyava to other villages in Kiriwina."

PLATE 130

Kasesuya in Teyava. Malinowski took several photographs of this particular game, which he described but did not name.[9]

Boys and girls join hands and sing, while they move first slowly and then, with the quickening rhythm of the chant, spin around faster and faster, until, tired out and giddy, they stop, rest, and begin again in the reverse direction. As the game progresses, and one ditty follows another, the excitement grows. The first ditty is one which begins with the words, *"kasaysuya, saysuya,"* referring to a bush after which the game is named. Each time they start on a new round, a new ditty is chanted. The rhythm in song and step is at first slow, grows rapidly quicker, and ends in a swift staccato repetition of the last syllables as the players whirl round and round. Towards the end of the game usually the rhymes became rather ribald.[10]

Malinowski gives five examples of *kasesuya* ditties (*vinavina*) with "sexual allusions." It was probably one such bawdy *vinavina* that Malinowski sang in Teyava on the evening of 24 May: "To encourage them to play (there was no one on the *baku*), I began to *kasaysuya* myself. I needed exercise, moreover I could learn more by taking part personally. . . . Here at least there is movement, rhythm, and moonlight; also emulation, *playing of parts,* skill. I like naked human bodies in motion, and at moments, they also excited me."[11]

Linus offered his own interpretation of the *kasesuya* in plate 130:

It looks like the *kasesuya* of Kabwaku [magpie] and Taumudurere ["chief of the witches," whose home is Mt. Bwebweso on Normanby Island]. The ditty refers to *seyakwa,* a black paint made from bark of the *kadikokwa* tree which was traded from Dobu or Muyuwa [Woodlark]. The children make a circle and sing:

Sesuye-e, Kabwakwe-e	*Kadikokwa, kadikokwa*
Black berries-e, Magpie-e	Black paint tree, black paint tree
Itopera, itoraga okesiri	*Ivaruru karawata*
Skips across, lands on a dead branch	Conceives white child
Taumudure-e-re!	*Ivaderi tubuyasapi*
Taumudurere!	Reared by honey bees
Seyakwa, seyakwa	*Dento, dento, dento, dento . . .*
Black paint, black paint	Untranslatable, repeated several times

With the last line, everyone in the circle begins to move sideways, rapidly gaining speed until hands break their grip and the circle falls into disarray.

꙰

PLATE 131

Another *kasesuya*, called *Karaga* (Parrot). Malinowski's fieldnotes for 1915 contain a description of *Karaga,* "the most complicated and perhaps finest of all *kasaysuya* games":

Boys stand in a ring, usual clasp of hands (above wrist). One boy *isinetoto* [that is, *isinetota,* to "sit-stand"] in the middle. The ring turns around him and sings. . . . To which he answers "A-A," in imitation of croaking. . . . The *karaga* man gets up and tries to push asunder the hands of the men—to see if they are strong. Then he runs against the hands of several couples, one after the other and tries to break them through. (If successful he does not run away.) Then he sits down on the arms of a couple, who run across the ring and put him on the arms of the opposite couple. . . . Then the *karaga* stands in the middle and the men sing a ditty [not translated, about shitting in a tree]. After which they clap hands on their mouths and chase the *karaga* man who runs away.[12]

Unaware of Malinowski's description, Linus offered a detailed comment from the Teyava people who studied the photograph:

This *kasesuya* is called *Deirekasi.* It is about *Karaga* (parrot) who steals food from the gardens. The circle of children clasp wrists and move around as they sing in chorus, "*Kaita-a-na, nesika-a-ka, deri, deride-eri / Deirekasi, deirekasi, deireka-a-s. . . .*" They gain speed until one of the children breaks the circle. He becomes the "parrot" and is pushed into the middle of the reformed circle. The children then chant the following questions, to which the "parrot" replies:

Karaa, avaka buku koma, ke?
Parrot, what do you want to eat?
Ahh, a-a-a!
Kena magim usi, uri o kena, maisi?
Do you want to eat bananas, taro or corn?

Ahh, a-a-a!
Ama mkedaga bukumwa?
Where is your way to it, then?
Taga besa ke!
Here it is!

At this, the "parrot" lunges at a point in the circle, trying to break out of it (as pictured here). If he manages to escape, the game begins again with another "parrot."

�

PLATE 132

Linus's informants offered two likely names for the "star-form" *kasesuya* in this plate: *Bulari* or *Kwaieru*. The ditty for *Bulari* begins, "*Keulo tegam, nenaya / Tai tala tatu—tu!* [Stand your ears, enlarged / Imitation of drum beats]." In the *Kwaieru* version, each child has a partner. One of them sits with legs stretched into the center of the circle, the other stands behind clasping the partner's hands. The circle revolves to the chant:

Kwaieru, o kwaierisaga
Destroy heaps, strewn in abundance
Mwali, mwaligeriga
Armshells, most beautiful
Kwaierisu, kwaieru!
Strewn and destroyed!

❧

"THE CHILDREN'S REPUBLIC"

PLATE 133

PLATE 134

PLATE 135

This sequence of photographs illustrates a *kasesuya* still played in Teyava. Linus explained, "This is the *kasesuya* of *Pwasisikwa,* a small bird like a robin or wren. He's the tiniest and craftiest of Kiriwina birds, and in this game he is punished for shitting on the footpath. He is cornered and captured, and then, as shown in the first photograph, he is questioned by his captors. In the second photograph they are bending down to pick him up. In the third they are about to carry him away. I do not know what happens next!"

The girl with the long necklace is prominent in every shot.

PLATE 136

Helped by his Teyava informants, Linus explained,

Nowadays, this *kasesuya* is called *Kabuboia,* and it seems to be what Malinowski referred to as "The fishing of Kuboya."[13] In some other villages it is called *Bubuneroro,* which is a kind of tug-of-war. The modern version in Okeboma goes as follows: Two persons face one another with their arms resting on each other's shoulders to form a gate or garden stile. They each choose a food or crop, with which they identify. One usually nominates a local food, such as yam or fish; the other nominates a trade store food, such as corned beef or biscuit. The other children form a line, each resting his or her hands on the shoulders of the one in front. They then pass through the "gate" while singing a ditty, "*Bubuno-o, bubuneroro-o / Mama, dita, dita, di'ita.*" The last one is trapped by the gatekeepers and questioned by them:

Avaka magim bukukwam?
What do you want to eat?
Paskeda, kui, iniya, miti, bunukwa, pwarawa?
Biscuit, yam, fish, corned beef, pork, bread?
Paskeda!
Biscuit!
O, kuma otubologu
All right, get behind me (says one of the gatekeepers).

The children file through the gate again and again until they have all have been "caught" and lined up behind their respective gatekeepers. A tug-of-war then begins until a winner is declared.

⸙

PLATE 137

Linus offered two different readings of this sequence: "Some people suggested that this *kasesuya* dramatizes sugarcane and banana toppling over. Others thought it was *Tutu tubelela,* a Trobriand version of 'Hide-and-seek.' In this game some of the children kneel down with their eyes covered while the ditty is sung."

But when plate 136 is juxtaposed with plates 137 and 138, and all three are compared with plate 55 of *The Sexual Life of Savages,* it is difficult to resist the conclusion that what Malinowski photographed here was the *kasesuya* he called "The Fishing of Kuboya."[14] According to this interpretation, these three photographs form a sequence. Children ("fish") pass in single file under an arch ("net") formed by the upraised arms of two players (plate 136). They raise and lower the arch to the rhythm of a ditty, periodically "catching" one of the moving children, who then sits or crouches on the ground like a netted fish (plates 137 and 138). The *kuboia* (or, *kuboya*) fish is quite small; the type of net used to catch it (*kaileta*) is held in both hands.

Malinowski recorded a ditty for this *kasesuya:*

PLATE 138

Kuboia kuboia kau kau
Blind kuboia
Leiwo mamasi tau
Bulging sinew/veins of a man's hands
"M'm," "M'm"
(Answering hum)

Malinowski attempted a free translation: "Kuboia, O blind Kuboia, Go there, the hands of the fisherman are tense" (presumably from holding a net).[15]

Note the cat in two of the pictures—a very recent addition to Trobriand domestic fauna.

PLATE 139

One of the photographs Malinowski presented to the the National Museum in Melbourne. His caption reads, "A children's game. There are many pantomimic games in the Trobriands: a group of children recite aloud a shanty, accompanying it by the appropriate action. This picture represents a game about the morning star."

Unaware of this caption, Linus plausibly suggested that the children are imitating a white man looking though binoculars (more fancifully, Malinowski looking through his camera lens). Ironically, the photographer's shadow looms bottom right.

PLATE 140

Linus commented, "This *kasesuya* is called *Gebila,* which means to carry something above one's head. The game begins with each child scooping dirt into a small mound. Using the tips of their elbows they make mini-craters, into which they pee. The urine mixed with the dirt forms a pliable mud which they each shape into an imitation clay pot, designated 'the chief's pot.' The children then form a close circle (as shown in the photograph) while holding their toy pots above their heads, and they sing the following ditty.

Gebila, gebila, gebila	*Asulu asewa wabariga*
Carry, carry, carry	I cooked, left it on the hut's upper shelf
Taya, taya, taya	*Ewa kaukwa ekatui!*
Put down, put down, put down	Along came a dog and smashed it!
Mitakata, kala kuria	*O kweya! kweya! kweya!*
Chief Mitakata, his pot	O fuck it! fuck it! fuck it!

At the end of it they all burst into laughter and smash their mud pots."

PLATE 141

Two lines of youths ready to throw darts at targets. The game is called *Kwenuta*. Fishing nets are drying to the right. The location is probably Teyava. Linus explained, "This was once a very common boys' game. The targets are made from taro stalks cut into various lengths, each representing a certain social position. Thus, the shortest is referred to as *guyau* ('the chief'), others are *ilomgwa* ('henchmen' or 'guards'), and still others his 'basket carriers' etc. The darts are simply coconut leaf midribs of the type normally tied together to make brooms, and therefore of unlimited number. The boys form two opposing lines, as shown in the photograph, and try to outdo each other by spearing as many targets as possible. The boy who spears 'the chief' is the champion of his own side."

ONE IMPORTANT competitive game which, curiously enough, Malinowski did not photograph, was cricket (*kiliketa*). This neglect simply reflects his prejudice, for he referred to a game in progress during a visit to Teyava.[16] Despite the enthusiasm with which Trobrianders adopted it (reinventing it in the process), Malinowski was scathing about this "newly introduced boon of civilization and Christianity": "Cricket, which to an Englishman has become a synonym for honour and sportsmanlike behaviour, is, to a Kiriwinian, a cause for violent quarrelling and strong passion, as well as a newly invented system of gambling; while to another type of savage, a Pole, it remains pointless—a tedious manner of time-wasting."[17]

⊰ 12 ⊱ Mortuary Rites and Exchanges

Of all the major institutions of Trobriand society that Malinowski systematically described, he gave least attention to the practices surrounding death.[1] His coverage of mortuary observances "in their barest outline only" was not due to any lack of material; he claimed that a "complete account of them would easily fill a volume" the size of *The Sexual Life of Savages*.[2] In fact, Malinowski described the mortuary ritual as "perhaps the most difficult and bewildering aspect of Trobriand culture for the investigating sociologist. In the overgrowth of ceremonial, in the inextricable maze of obligations and counter-obligations, stretching out into a long series of ritual acts, there is to be found a whole world of conceptions—social, moral, and mythological—the majority of which struck [him] as quite unexpected and difficult to reconcile with the generally accepted views of the human attitude towards death and mourning."[3]

No less bewildering were the incessant mortuary exchanges and food distributions (*sagali*): "This intricate series of distributions stretches out into years, and it entails a veritable tangle of obligations and duties; for the members of the deceased's sub-clan must provide food and give it to the chief organizer, the headman of the sub-clan, who collects it and then distributes it to the proper beneficiaries. These, in their turn, partially at least, re-distribute it. And each gift in this enormous complex trails its own wake of counter-gifts and obligations to be fulfilled at a future date."[4]

Malinowski's photographic collection provides two large, adjacent categories for

"Mortuary" and "Sagali" (reason enough for bringing them together in this section). The former contains more than fifty photographs, the latter—a capacious category like "Canoes" and "Gardening"—contains almost seventy.

⬥⬥⬥

PLATE 142

First the corpse is washed, anointed, and covered with ornaments, then the bodily apertures are filled with coconut husk fibre, the legs tied together, and the arms bound to the sides. Thus prepared, it is placed on the knees of a row of women who sit on the floor of the hut, with the widow or widower at one end holding the head. They fondle the corpse, stroke the skin with caressing hands, press valuable objects against chest and abdomen, move the limbs slightly and agitate the

head. The body is thus made to move and twist with slow and ghastly gestures to the rhythm of the incessant wailing. Sexual Life, *130–31*

Significantly, Malinowski chose another photograph of the same decorated corpse to appear as the final plate in *Argonauts*. It has the visual impact of a pietà.[5] His caption applies equally here: "A great number of valuables, including large axe blades, with which this man was covered at dying, have been already withdrawn. Only personal possessions are left on the corpse, and they will be removed immediately before the interment."[6]

Malinowski truthfully noted that the scene was "reconstructed outside the hut for purposes of photography," and that dead man's son (right) replaced the widow.[7]

Linus commented, "He is very shriveled and must have died of a wasting disease. This is perhaps a couple of days after death. Chiefs were laid out like this for as long as a week (like Mitakata when he died during the 1950s). Mourners should not show any signs of disgust at the smell of putrefaction by spitting or covering their nostrils. They say that formerly the dead chief's brothers and sisters' sons would stand behind the mourners ready to cut off their heads if they showed any revulsion. In this picture the three women in the middle, who have already shaved their heads, are probably the deceased's daughters. The women on the left and right of them would be his sisters. The 'sister' on the right had shaved her head earlier, perhaps for another death."

Neither the people nor their village were named by Malinowski, and Linus's informants made no suggestions. It is possible, however, that this is the death in Kwaibwaga that Malinowski referred to in a letter to Elsie Masson: "I photographed the decorated corpse today and in the evening I'll go to the vigil (*vawali*)."[8]

᪥

PLATE 143

Oburaku women performing a mortuary or mourning dance (*vesali* or *keyelu*) follow-ing the death of Inekoya. "This is a slow movement done to the rhythm of wailing, some of the dancers clasping each other, some holding an object, which is or repre-sents a relic of the dead."[9] It could well be her mother at the end of the line (right), holding a basket containing her daughter's possessions.[10]

Malinowski's diary gives a precise date for this mourning dance. Inekoya died during the night of Friday, 25 January 1918, and the women danced their *vesali* on the village *baku* the following day.[11] Inekoya was the wife of Malinowski's best Obu-raku informant. "Toyodala, the nicest man I knew in Oburaku, was for weeks anx-iously watching his wife's illness and hoping for her recovery. When she died, he behaved at first like a madman, and then, during his mourning confinement, in which I often visited him, he wept so bitterly that his eyesight suffered."[12]

Inekoya's death affected Malinowski, too, probably more than any other he wit-nessed in Kiriwina. This was partly because he was a very close neighbor (his tent was next to their house), and partly because Inekoya was so young and attractive. Worse, her terminal illness was a remorseful reminder of his betrayal of Nina Stirling who was ailing in distant Adelaide.[13] "During the night Ineykoya died. Got up at 3:30 and went there. Deep impression. *I lose my nerve.* All my despair, after all those killed in the war, hangs over this miserable Melanesian hut."[14]

PLATE 144

According to Malinowski's helpful legend on the reverse of the print, "[t]he man has just been put into the grave—which is not filled with earth. Platform put over grave. The same day at sundown he was taken out and the marks for *bwagau*—the evil spell cast on him—were searched [*sic*]." Linus was surprised by all the women around the grave, and not a single man present. Chief Pulayasi thought it might be in Omarakana and rightly suspected that the photograph showed preparations to exhume the corpse for divination. (He was unaware of what Malinowski had said in his caption.)

Although we cannot be absolutely certain, plate 144 and a few of the following photographs were probably taken in early July 1915, when Malinowski attended his first Trobriand burial and observed his first mortuary sequence. The occasion was the death of a young man called Kima'i (Kimai) of the village of Wakayluwa (now Wakeluwa). On Tuesday, 6 July 1915, provoked by the public exposure of his incestuous relationship with a maternal cousin, Kimai climbed a coconut tree and leapt to his death. Malinowski was led to believe the youth had fallen accidentally, and only three years later did he learn that it was suicide.[15]

If the scene in plate 144 is indeed the burial of Kimai, it would help explain the prominence of female mourners, though none of them would be his maternal kin. At sunset men tried to get Malinowski away from the grave, warning him about the imminent arrival of *mulukwausi*, witches from Iwa, Gawa, and Murua. He suspected they wanted to exhume the body for divination, which they would not do in his presence.[16]

MORTUARY RITES AND EXCHANGES 215

On the following evening [after burial] the body is exhumed, and inspected for signs of sorcery. . . . Before daybreak after the first exhumation, the body is taken out of the grave [again], and some of the bones are removed from it [for relics]. . . . This practice has been strictly forbidden by the Government—another instance of the sacrifice of most sacred religious custom to the prejudice and moral susceptibilities of the "civilized" white. Sexual Life, *132*

PLATE 145 In the mortuary distributions of food and wealth, based on the idea that the members of a deceased's sub-clan give payment to the other relatives for their share in the mourning, women play a conspicuous role and conduct some of the ceremonial distributions themselves. Sexual Life, *32*

A moment in the first mortuary distribution, called *sigiliyawali,* which takes place on the same day or the day after the burial. Kinswomen of the deceased distribute

banana-leaf bundles to all the women who attended the death and assisted in the burial.

After only a few weeks in Kiriwina and still communicating through pidgin English, Malinowski's notes concerning this event are understandably deficient, but their raw, graphic immediacy complements his photographs:

The *yawali* [or *yawari,* a wake] of 7 VII. Made by Malasi clan [to which Kimai belonged]. The food and the raw materials . . . are brought to the village by all the clans. 1st distribution of raw materials of petticoats [banana-leaf bundles]. Women of the Malasi clan first receive the *dobes.* Then the Malasi women distribute the *ramis* [skirts]. This took place in the *baku,* and the proceedings were of a somewhat disorderly nature. (I was busy with the camera too.) The Malasi women stood up. The other women squatted down. With the words *"Kam yolova ke,"* a woman gives her batch of *dobes* to another woman. This took place in the *baku*, on which the *taitu* heaps had been previously laid. After that the men made *sagali.* Tomonuwa [a Malasi man] called out the names.[17]

❧

PLATE 146

Although Malinowski did not mention pigs at this point in his notes, it is likely that some pork would have been distributed with the vegetable food. Linus commented,

"This is also the *yawari* stage. The men are overseeing a distribution of yams and pork at the end of the first day of mourning. Place and people cannot be recognized."

There are surprisingly few photographs of pigs in the collection. On pig killing in the Trobriands, Malinowski wrote, "When a pig is to be killed, which is a great culinary and festive event, it will be first carried about, and shown perhaps in one or two villages; then roasted alive, the whole village and neighbours enjoying the spectacle and the squeals of the animal. It is then ceremonially, and with a definite ritual, cut into pieces and distributed."[18]

PLATE 147

PLATE 148

While the kinswomen of the deceased are distributing women's wealth to the female workers, kinsmen are distributing pots and other valuables to the men who assisted in the work of burial (nowadays cash is given too). This is called *sigiliveguwa*. Malinowski's caption on the reverse of plate 147 is unspecific: "Sagali of Kuria (pots). The display." His notes, however, are explicit enough to permit identification of the event depicted here: "The last act of the feast consisted of giving of wealth or *vaigua*. The wealth consisted of 12–14 clay pots, 2 *soulava*, 2 *kaloma* belts (*wekala*), 1 *mwali*, 4 *beku*."[19]

Thirteen pots can be counted in plate 147. Three axes (*beku*) can be seen in plate 148, and two *kalomwa* shell belts. Linus noted that the axes with handles (*utukema* and *vala*) are "very important and very rare nowadays."

※

PLATE 149

Letter from Oburaku, 14th December 1917: "On Friday afternoon [Oburaku] had a big ceremonial cooking of *mona* (taro pudding). It is a big affair: the big clay pots put up in the village, lots of scraping, beating, coconut cream prepared, big wooden ladels [*sic*] to mix the mess. . . . The whole thing somewhat in the style of the Polish X-mas Eve meal: two days of preparing, then 10 minutes of cooking, then the stuff is gulped down in a few minutes and the whole fun is over. The main point is in the preparation of course. I don't remember whether you saw any of my photographs taken during such a ceremonial cooking in Wakaise near Omarakana?"[20]

Linus's informants guessed that these men were from Wakesa or Wakaluwa villages [Malinowski's Wakaise or Waykayse and Wakayluwa]. If the photograph was taken in Wakaluwa, however, the mortuary event might have been the death of Kimai.

Malinowski's fieldnotes record a death at Wakaise on 8 October 1915. He had placed a stick of tobacco on the dead man's stomach (presumably alongside the other valuables) and subsequently observed the exhumation of the body.[21]

The four men seen here are carrying cooked *mona* by means of dried banana leaves slung beneath the pot, which would be hot as well as heavy.

PLATE 150

Men butchering a pig for distribution, probably on the day of burial. Malinowski's caption on the reverse ("Pig-eating during *sagali* in Oburaku") is anticipatory. The death was probably that of Inekoya, in which case this photograph can be dated to 26 January 1918.

Linus remarked, "*Yawari* also refers to all food given to mourners on the day of burial. The *dala* of the deceased contribute the pig for the mourners and workers."

PLATE 151

A distribution of yams at *yawari* at yet another burial. Malinowski's caption on the back of one of the prints (a sepia copy) is unusually informative, as if the photograph had been selected to illustrate a public lecture: "No. 1. Scene at a Sagali (mourning feast or rather distribution of food) in M'tava village, Kiriwina, Trobriand Islands. The heap of *taitu* in the central place of the village (*baku*) are brought by the neighbouring villages. The people of the dead man's clan distribute them subsequently. Each village represented at the Sagali receives one heap. The photo represents the men of the distributing clan as they go along, discuss [who] has to receive given heaps, upon which the man in the centre sings out loudly the name of the place."

On the back of a second sepia copy another caption reads, "Sagali—the names are called out. To the right an albino in a *rami* [waist-cloth]. Unfortunately the colour of his skin is not different in this picture from the others. He was absolutely white."

PLATE 152 The same group of men allocating yams at *yawari*. They are now facing the camera and the albino and the giggling girls have disappeared. Malinowski's caption on the reverse confirms: "Represents the same scene as No. 1. The man is seen just singing out."

⟨⟩

PLATE 153

Linus commented on this photograph, "It looks like the *litutilasepwana* stage, a part of *lisaladabu* [women's mortuary exchange] for a death that probably occurred about six months before. The woman in the center in the white dress would be deciding on the day when the mourners (those with shaven heads) can be released from their taboos. The women of the *dala* of the deceased weave a long grass skirt (*sepwana*) for the widow, which they 'distribute,' not literally but symbolically, allocating various roles and tasks to different women."[22]

Attempting to identify the occasion in plate 153, we find in Malinowski's Oburaku diary for 8 March 1918, "Got up at 8. Fine weather, the rippled surface of the water green, transparent. . . . *Round the village*. Marianna's *saipwana*. . . . Breakfasted late. I decide to take a few decent pictures. Loaded both cameras and discovered probable cause of fogginess in 1/4 *plate camera*. Took picture of *saipwana;* then of a small sailboat."[23]

Marianna (Marion) was Mrs. Billy Hancock, whose mother was Ilumedova of Oburaku. It is plausible, therefore, that she would be conducting a *lisaladabu* ceremony in her natal village, and also—given her status as wife of a white man—that she would be wearing a white dress. (The other woman in a similar dress standing on the right could be the wife of a local missionary teacher.)

PLATE 154

Malinowski took no fewer than six photographs of this skull cave. The light was probably poor, and this one is the sharpest of the images. None of the prints bear captions. Linus guessed immediately that it was a Tabalu subclan cave in the coral cliffs of the *rebwaga* (Malinowski's *rayboag*), but not being a Tabalu himself he had

never seen it. Tabalu, he believed, used to keep a record of which skull belonged to whom, "like a genealogy."

"All such burial caves are called *bulagwau.* Most are located in the *rebwaga* no more than 50 meters from the beach, and most that I know of face the sea to the east. Only one long bone is visible here. There are no jaw bones, of course, as they were always kept as mourning relics. There were burial caves near my village [Oke-boma], and as children we would peep into them out of curiosity, throw stones into them, then run away screaming with fear."

Chief Pulayasi identified this cave as Lubabelu, which once had great religious significance for Tabalu. He told Linus, "It does look something like this from below, but today it is no longer regarded with much reverence as the contents have been disturbed. The last Tabalu bones to be placed there were those of Chief Numakala of Oluvilevi, who died young. His skull was dutifully prepared by a *tabula* [father's sister's daughter] of Mwauri subclan who died as recently as 1994."

⟨⟩

13 *Masawa* Canoes and the Kula Quest

The main subject of *Argonauts of the Western Pacific,* Malinowski's most famous and influential work, is Kula, the inter-island ceremonial exchange of shell valuables. Yet the draft synopses of his abandoned *Kiriwina* monograph show that he originally intended to devote only one chapter to Kula.[1] While still in Australia in late 1919, however, he wrote "a short preliminary account" of the essentials of Kula for the journal *Man,* and from this evolved the extraordinary book that was to become *Argonauts of the Western Pacific: Native Enterprise and Adventure in the Archipelagos of Melanesian New Guinea.*[2]

As intimated by his title, the romance of Kula was for Malinowski inseparable from the romance of sailing. In an early letter to Elsie he wrote, "It is beautiful always to sail in a native canoe—it gives you the impression of being on a raft, quite on the surface of the water, floating as if by a miracle."[3]

He genuinely admired the technical skill which went into the construction of *masawa,* the stout sea-going canoes ("undoubtedly the greatest achievement of craftsmanship of these natives"[4]). A somewhat nervous sailor himself, he also admired the seamanship with which Trobriand sailors made their hazardous voyages.

Malinowski's fieldnotes clearly demonstrate that he studied Kula and canoe building most intensively during his first trip to the Trobriands. Living then mostly in Omarakana, he had a privileged view of Kula, for Chief Touluwa's network of partnerships was far more extensive than anyone else's, and he dominated local Kula in a way impossible for those of lesser rank. In 1918, however, Malinowski took

pains to broaden his perspective on overseas Kula by visiting Vakuta, the Amphletts, and Sinaketa.

It will be obvious from the absence of women in these photographs that Kula and canoe sailing in the Trobriands is strictly a male activity. Traditionally, Kula was the preserve of leaders and men of rank, commoners being virtually denied access (though this was no longer the case in Malinowski's day). Personal fame (*butura*) was—and still is—created in Kula by the circulation of one's name, which becomes attached to the most valued shells as they are won, kept and displayed for a time, and then surrendered to one's partners, eventually to continue their endless progression around the ring of islands: necklaces in a clockwise direction, armshells, counterclockwise.

Most of the photographs reproduced here were selected from among the forty or so classified under "Kula" and the one hundred classified under "Canoes." (The collection has a separate category for "Argonauts," comprising the seventy photographs Malinowski published in his book.)

Those presented here can be placed in chronological sequence with a fair degree of confidence, and with one or two exceptions I have done so. They can be grouped into three periods:

October–November 1915. The display of armshells from Kitava and the presentation of necklaces to Touluwa by his sons in Omarakana.

February 1916. The refitting of Chief Touluwa's canoe in Omarakana followed by its launch and ceremonial racing.

March–April 1918. Malinowski's visit to the Amphletts followed by the Dobuan fleet's visit to Sinaketa, a major Kula-making community on the lagoon of Kiriwina.

PLATE 155

"Armshells brought from Kitava. The personal share of Touluwa from the haul of armshells brought to Omarakana in October, 1915."[5] Twenty-two armshells were won from Kitava on this occasion. The two men standing are sons of the chief: his favorite, Namwanaguyau (a month or two before his banishment from Omarakana), and Yobukwau. Behind them is the coral mound of Lugwalaguva, which contains the Tabalu's *vilamalia* magic. The spot on which the unidentified men are squatting is where the *milamala* platform will be erected in July 1918. The fly sheet of Malinowski's tent is visible on the extreme right.

❧

PLATE 156

Chief Touluwa faces four of his sons and three other Omarakana men as they cere-
monially present him with a magnificent *solava*. From right to left, Chief Touluwa,
Namwanaguyau bearing the *solava*, Yobukwau blowing a conch shell, Kalogusa with
the chief's limepot, and an empty-handed Dipapa. Chief Pulayasi recalled, "Dipapa
came to be admired for his powerful muscles, his great strength in lifting and carry-
ing things. People recall his exploits in catching the chief's huge pigs (*bunukwa
yayosa*), then breaking their legs with his bare hands."

Taken in November 1915, this photograph is almost identical to the frontispiece
of *Argonauts,* which Malinowski titled "A ceremonial act of the kula." These two
belong to the same sequence as plates LXI and LXII, though they form a separate pair;
they show a different ordering of men in the procession—suggesting that at least
one pair of photographs depicts a re-enactment for the camera.

PLATE 157

In the same series, Namwanaguyau poses alone. "[O]ne or two more domestic Kula acts were performed, a son of Touluwa offering him a necklace and receiving a pair of armshells afterwards."[6] Linus observed, "The decorations at the end of the necklace are attached to the edge of a conch shell. Nowadays, such necklace decorations are attached instead to a mother-of-pearl shell (*kaeki*), called *gineuba* in this context."

PLATE 158

Malinowski published several photographs of *mwali* and *solava,* the principal Kula valuables.[7] But he published none specifically to illustrate other Kula valuables, such as circular boar's tusk pendants (*dogadoga*), shell waist belts (*wakala*), polished greenstone ax heads (*beku*), or whalebone lime spatulas (*bosu*).

This photograph riveted the attention of Linus and Chief Pulayasi. It shows a *wakala* made of *kalomwa* shells (Malinowski's *kaloma*), and was probably made in Sinaketa.[8] In the past the role of *wakala* in Kula was to "move" more important valuables; it no longer features in today's exchanges however. Linus commented further, "This is a rare and extraordinary *wakala* made of seven layers of threaded shells on a bast backing, with two additional strings hanging below them and seven short dangling strings. The *kalomwa* shell decoration hanging to the left is actually a headband (*sedabala*). To the right of this are two fine *Spondylus* shell necklaces, called *kuwekuwa* in Kiriwina and *samakupa* in Dobu. *Sedabala* headbands (usually the prerogative of rank) are no longer worn and have become extremely rare. Chief Pulayasi thought that the *wakala* itself could even be worn as a headband if shortened."

[THE] MOST IMPORTANT canoe [in Kiriwina] is, of course, that owned by the chief of Omarakana. This canoe always leads the fleet; that is to say, on big ceremonial Kula sailings, called *uvalaku,* it has the privileged position. It lives in a big shed on the beach of Kaulukuba, distant about one mile from the village. . . .The present canoe is called Nigada Bu'a—"begging for an areca nut."[9]

A better translation, perhaps, would be "soliciting for betel nut." The phrase is a modest euphemism for the quest for Kula valuables. In preparation for an overseas Kula expedition (*uvalaku*), new canoes have to be built and old ones renovated. In 1915–16 *Nigada Buwa* was among the latter; it had to be relashed and repainted and a new, larger sail sewn for it.[10] Malinowski took about a dozen photographs of various stages of sail making, though he published only one.[11] They are all of the same event in Omarakana, which can be dated precisely to 31 January 1916, on which day Malinowski made detailed fieldnotes.[12]

Sail-making is done on another day [that is, after painting the canoe], usually in the village, by communal labour, and, with a number of people helping, the tedious and complicated work is performed in a relatively short time. The triangular outline of the sail is first pegged out on the ground, as a rule the old sail being used as a pattern. After this is done, tapes of dried pandanus leaf are stretched on the ground and first fixed along the borders of the sail. Then, starting at the apex of the triangle, the sail-makers put tapes radiating towards the base, sewing them together with awls of flying fox bone, and using as thread narrow strips of specially toughened pandanus leaf. Two layers of tapes are sewn one on top of the other to make a solid fabric.[13]

PLATE 159

"The triangular outline of the sail is first pegged out on the ground . . . "

Malinowski mentioned that the old sail, used as a pattern, had been too small. This is evident from the photograph.[14]

꧁꧂

PLATE 160

" . . . tapes of dried pandanus leaf are stretched on the ground and first fixed along the borders of the sail."

In his caption to the published plate of sail making, Malinowski mentions the albino among the workers, though he is less prominent there than he is in this image. The camera has also caught, at the extreme left, a European wearing a hat and shoes seated languidly in a chair. His identity is unknown, but it is not Billy Hancock.

PLATE 161

"Then, starting at the apex of the triangle, the sail-makers put tapes radiating towards the base."

The man with what appears to be a white wig is Mwedeli (Malinowski's Mwaydayli), a ginger-haired son of Touluwa. According to Chief Pulayasi, "Mwedieli was renowned for his fearlessness and his skill in dodging spears and other missiles during fighting." Here he seems to be in charge of the sail making.

PLATE 162 Mwedeli directs the activity. In the background, Malinowski's tent and Touluwa's personal house (*ligisa*).

PLATE 163

The man left center is carving a rudder for a *masawa* canoe; the man in the foreground is using his adze to put the finishing touches to a paddle. The village is probably Omarakana, though Chief Pulayasi suspected that the men were Kitavans. (His guess probably was correct; Malinowski stated that it was a master-builder from Kitava whom Chief Touluwa summoned to renovate *Nigada Buwa*.[15])

MALINOWSKI TOOK a series of photographs of the *tasasoria* festivities (ceremonial launching and trial run) of *Nigada Buwa* at Kaulukuba beach in February 1916. The shots were apparently taken in bright sunlight:

By about nine o'clock, everybody was ready on the beach. It was fully exposed to the Eastern sun, but this was not yet sufficiently high to drop its light right from above, and thus to produce that deadly effect of tropical mid-day, where the shadows instead of modelling out the details, blur every vertical surface and make everything dull and formless. The beach appeared bright and gaudy, and the lively brown bodies looked well against the background of green foliage and white sand. The natives were anointed with coconut oil, and decorated with flowers and facial paint. Large red hibiscus blossoms were stuck into their hair, and wreaths of the white, wonderfully scented *butia* flowers crowned the dense black mops.[16]

Concerning its exotic appeal: "It was a fine sight from the spectacular point of view. A superficial onlooker could hardly have perceived any sign of white man's influence or interference. I was the only white man present, and besides myself only some two or three native missionary teachers were dressed in white cotton."[17]

Nigada Buwa was launched in the morning, with an accompanying magical rite which ought to have been performed by Touluwa. "As he, however, is quite incapable of remembering magical spells . . . the rite was performed on this occasion by one of his kinsmen" (perhaps Namwanaguyau, who is prominent in the photographs).[18] The launching was followed by a ceremonial food distribution among the several villages represented at the *tasasoria*. (Malinowski estimated that about a thousand people were present). All eight canoes of the Kiriwina district had by this time arrived and were soon to be displayed and "raced" at this regatta.

After the *sagali* [food distribution] was over, the canoes were all brought up to one spot, and the natives began to prepare them for the race. The masts were stepped, the fastenings trimmed, the sails made ready. Argonauts, *153*

PLATE 164

Preparing *Nigada Buwa* for the *tasasoria* on the beach of Kaulukuba. The mast has just been stepped. The fresh lime paint on the outrigger shows that the canoe cannot have been raced yet. Chief Touluwa is standing to the left of the mast. A companion photograph in *Argonauts* shows several other canoes in the near vicinity being rigged at the same time.[19] Judging by the disposition of men on and around *Nigada Buwa,* Malinowski must have taken these two photographs within moments of each other.[20]

PLATE 165

Aboard *Nigada Buwa* leaving Kaulukuba beach. Touluwa (partly decapitated by the frame) is leaning against the mast. It appears to be his son Dipapa seated to his right. In 1917 Malinowski wrote to Elsie of Dipapa, "a really good-looking boy (ab. 16 years old) and quite a gentleman, so far in manners and in his conduct quite my favourite in Kiriwina (besides Tokulubakiki)."[21]

PLATE 166

Nigada Buwa in full sail. The chief is seated, right center, and appears to be reaching out—perhaps for a betel nut—offered by Namwanaguyau. Dipapa is seated third from the left. Plate XXIII of *Argonauts* shows the same *masawa* canoe carrying the same eighteen men as viewed from the outrigger side.

The trial run of *tasasoria* is a regatta, a display of several new and renovated canoes. It is not really a competitive race as the chief's canoe must always be seen to sail the fastest and to "win."

Chief Pulayasi told Linus a story (which now has the status of legend) about Touluwa and his beloved canoe.

He was returning from one of his Kula expeditions with his sons. They were approaching Kaulukuba beach when a sudden squall hit them, creating huge waves. *Nigada Buwa* was in danger of breaking up on the reef. Namwanaguyau said they should abandon the canoe to save their lives. Touluwa said, "Yes, life is more important than the canoe." His sons leapt overboard and struggled ashore. Touluwa waited until *Nigada Buwa* was almost upon the reef before he too jumped overboard. But

he clung to the outrigger, trying to guide his canoe over the reef. During this struggle he broke a large hole in the coral with his right foot. His leg sank up to his knee, and using this as an anchor he steadied the boat. Seeing this from the shore, his sons swam back to help him, and together they guided *Nigada Buwa* to safety. The hole in the reef is still there today, and fishes have made it their home.

PLATE 167 *Nigada Buwa* photographed after the trial run; note that the paint has been washed from the outrigger. In front is Namwanaguyau, his bother Kalogusa at the extreme left.[22]

PLATE 168

None of the men are recognizable in this photograph, and the bird decoration on the prow of this *masawa* (not evident in any of the photographs of *Nigada Buwa*) suggests that it is a different canoe altogether. It could be the new one built by Chief Ibena of Kasanai, mentioned by Malinowski as having been launched at Kaulukuba on the same day as the renovated *Nigada Buwa*.[23]

PLATE 169

The chief's canoe shed (*bunatolu*) on Kaulukuba beach. Men and women are pushing *Nigada Buwa* along log rollers into its hanger. The bundle to the right is the folded sail.

The boat shed of Omarakana, round which the chief, his family and the other villagers were grouped, was the centre of all the proceedings. Argonauts, *152; see plate XXII for a similar photograph*

❊

ON 13 MARCH 1918, Malinowski boarded the ketch *Kayona* and sailed south from Kiriwina to the D'Entrecasteaux Islands, known to Trobrianders as the Koya. Among other things, he took his two cameras, "12 rolls [of film], 3 dozen plates, and equipment for developing film."[24] Almost losing her mast after being hit by a squall, *Kayona* made a forced landfall on Sanaroa Island, north of Dobu, where Malinowski spent a few days observing and photographing sago preparation before sailing again

for the Amphletts. Here he camped for three weeks on the island of Gumawana (Gumasila to Trobrianders) and at Nuagasi, the main village on Nabwageta.[25]

The precipitous, spectacular Amphletts are clustered just to the northeast of Fergusson Island: "Scattered under the lee of Koyatabu [Fergusson's highest mountain] are the numerous smaller and bigger islands of the Amphlett Archipelago—steep, rocky hills, shaped into pyramids, sphynxes and cupolas, the whole a strange and picturesque assemblage of characteristic forms."[26]

The main island of Gumawana is "a tall steep mountain with arched lines and great cliffs, suggesting vaguely some huge Gothic monument"; to the east of it "the heavy pyramid" of Domdom.[27]

PLATE 170 The main village of Gumawana at the southeast end of the island. Linus, who has often visited this village, observed that it is low tide.[28]

Built on a narrow strip of foreshore, open to the breakers, and squeezed down to the water's edge by an almost precipitously rising jungle at its back, the village has been made sea-proof by walls of stone surrounding the houses with several bulwarks, and by stone dykes forming small artificial harbours along the sea front. The shabby and unornamented huts, built on piles, look very picturesque in these surroundings. Argonauts, *46*

PLATE 171 Gumawana with its artificial seawall. The men are loading clay pots which they cover with coconut leaf mats. Sugar cane, a fish net, and a rolled sleeping mat are also visible.[29] The date is probably 25 March 1918, when Malinowski "took a few pictures" of the loading of pottery, sago, and coconuts.[30]

PLATE 172

It seems almost a miracle to see how, in a relatively short time, out of this after all brittle material, and with no implements whatever, a woman will shape a practically faultless hemisphere, often up to a metre in diameter. Argonauts, *285*

Fourteen photographs appear in Malinowski's collection under the heading "Pottery"; they form a series showing the same Amphlett woman in various stages of pot-making. Most of the images are blurred.[31] Linus commented, "The woman is applying additional clay to the base of the almost completed pot. In the language of Kiriwina this is a *walata* pot, for everyday use. Nearby is a coconut shell water container and a bailer shell, used by the potter to moisten the clay."

A *masawa* under full sail in the Amphletts. It is almost certainly a Dobuan canoe, of which the *lagim* (carved washboard) design is characteristic. The island on the right is Yabwaya; the island to which the canoe is heading, Nabwageta.

Plate XL of *Argonauts* ("A Waga Sailing on a Kula Expedition") was taken a few moments after this photograph. It bears the legend, "A canoe fully loaded with a crew of twelve men, just about to furl sail arriving in the Amphletts. Note the cargo at the *gebobo* [main compartment] and each man's personal bundle of folded mat on top of it."

Malinowski's text refers to plate XL in connection with the composition and positioning of the crew during an overseas voyage: "[T]he *toliwaga* [owner or master of the canoe] usually sits near the mast. . . .With him perhaps is one of his sons or young relatives, while another boy remains in the bows, near the conch shell ready to sound it, whenever the occasion arises. . . .The *usagelu* or members of the crew, some four or five strong, are each at his post, with perhaps one supernumerary to assist at any emergency. . . . On the platform are lounging some of the *silasila,* the

youths not yet employed in any work, and not participating in the Kula, but there for their pleasure, and to learn how to manage a boat."[32]

This is perhaps the canoe whose arrival at Nagwageta Malinowski noted in his diary on Sunday, 31 March: "In the afternoon, the *mina*-Dobu [people from Dobu] arrived; I took pictures of the boat and talked with the policeman from Sanaroa."[33]

❀❀

THE DOBUAN FLEET of some sixty canoes passed through the Amphletts on their way to Vakuta and Sinaketa. None of those who called at Nabwageta were willing to take Malinowski along, nor were any of the dozen Amphlett canoes which immediately preceded or followed the main Dobuan fleet: "I was left in the village [Nuagasi on Nabwageta] with a few cripples, the women, and one or two men who had remained perhaps to look after the village, perhaps specially to keep watch over me and see that I did no mischief. Not one of them was a good informant."[34]

Fortunately, the *Ithaca* happened to call, and the marooned ethnographer reached Kiriwina just as the *uvalaku* fleet left Vakuta for Sinaketa on 5 April. He was thus able to photograph the Dobuans' arrival and the great concourse of visitors that gathered on the beach of Sinaketa over a period of four days.[35]

These were days of intensive photographic activity; as he told Elsie, "I did a great deal of photography (which I hate above all other things)."[36]

On Friday, 5 April: "[Dobu men arrived and] I hurried out (and in my hurry didn't take *extra* rolls of film!). Impressions from *kula* (once again a feeling of ethnographic joy!). Sitting in Tovasana's boat I looked at the *kula* ceremonies. Raffael [Brudo] watched from the shore. Sinaketa almost like a summer resort with all these *guma-numa* [foreign] people. I was engrossed—as an ethnographer—in all the goings-on."[37]

PLATE 174

When, on a trading expedition or as a visiting party, a fleet of native canoes appears in the offing, with their triangular sails like butterfly wings scattered over the water, with the harmonious calls of conch shells blown in unison, the effect is unforgettable. Argonauts, *108*

The Dobuan and Amphlett fleet approaching Sinaketa: " . . . there could be seen, far away, like small petals floating in the horizon, the sails of the advancing fleet."[38]

Among the prominent Kula traders who came to Sinaketa were Tovasana of the Amphletts and Kouyaporu of Dobu. Malinowski referred frequently to both.

PLATE 175

Kouyaporu (left) and Tovasana (center) sitting together on a house platform, probably that of Koutauya, the second chief of Sinaketa, who was Kouyaporu's main Kula partner.[39] The identity of the man on the right is unknown. Kouyaporu was a headman (not strictly speaking a chief) of Tu'utauna in Bwayowa (or, Bwaiowa) on southeast Fergusson Island. Tovasana was from Nuagasi village on Gumawana. Malinowski made the latter's acquaintance when he visited the Amphletts, of which Tovasana was "the most important headman": "[W]ith his big, roughly carved features, with his large aquiline nose sticking out from under an enormous turban-like wig, [he] looked like an old gnome."[40]

To Elsie he wrote that Tovasana's profile reminded him "irresistibly . . . of a distinguished F.R.S. of Adelaide."[41] He was referring to his erstwhile host, Sir Edward Stirling, whose daughter Malinowski had briefly courted.

PLATE 176

The beach at Sinaketa looking north, probably taken on the day the Dobuan fleet arrived. Chief Pulayasi commented, "This stage of kula is known as *vatai* [to argue or harangue]. It occurs only between Trobrianders and Dobuans, or other people of the Koya. It usually occurs in the morning of the day after the arrival of the Koya fleet, when the visitors are receiving their partners on the beach or formally marching up to their huts in order to present their *pari* [Malinowski's 'solicitory gifts']."

Malinowski's comprehensive caption to an almost identical photograph published in *Argonauts* reads, "A Kula gathering on the beach at Sinaketa. Along about half a mile's length of shore, over eighty canoes are beached or moored, and in the village, on the beach, and in the surrounding country there are assembled some two thousand natives from several districts, ranging from Kitava to Dobu. This illustrates the manner in which the Kula brings together large numbers of people belonging to different cultures; in this case, that of Kitava, Boyowa, the Amphletts and Dobu."[42]

The two photographs were taken within minutes of one another, for many of the men are in the same position. What is striking is that the published one does not show the man in a white shirt seated to the left of the large coconut trunk. Malinowski had moved his camera slightly so that this man was hidden by the tree. He then chose to publish this image, though both are equally good. Was it to preserve the exotic illusion that his "natives" did not dress in European clothes? Note too the presence of shirts and waist-cloths in the group of men on the left, a group which had partly dispersed (or not yet gathered) at the moment Malinowski took the photograph he eventually published.

A few hundred yards from this scene was the house of the pearl-trader Rafael Brudo, where Malinowski dined in style during this first week of April.[43]

PLATE 177

The Dobuans, during their stay in Sinaketa, lived on the beach or in their canoes (see pls. LIV and XX). Skilfully rigged up with canopies of golden mats covering parts of the craft, their painted hulls glowing in the sun against the green water, some of the canoes presented the spectacle of some gorgeously fantastic pleasure boat (see pl. LV). The natives waded about amongst them, making the Lagoon lively with movement, talk and laughter. Groups camped on the sea shore, boiling food in the large clay pots, smoking and chewing betel-nut. Big parties of Trobrianders walked among them, discreetly but curiously watching them. Women were not very conspicuous in the whole proceedings, nor did I hear any scandal about intrigues, although such may have taken place.
Argonauts, *390–91*

Dobuan canoes moored on the shallow lagoon at Sinaketa, their cargoes protected by pandanus rain mats.[44] During their four days in Sinaketa the Dobuans received a total of 304 pairs of armshells from their local partners. Sinaketa men had visited Omarakana a few days earlier to bag their own haul of 154 pairs; these were among the 213 pairs that Touluwa had got in Kitava the week before.[45]

PLATE 178 Another group of Dobuan canoes at Sinaketa. On 6 April, Malinowski "went to take pictures, and lounged among [the visitors]." That day he scribbled a note to Billy in Gusaweta, "There's a packet of Rafael's & my letters, will you be kind enough & send it along to B[urns] P[hilp]s by the *kaione*? Geo[rge] A[uerbach] left today in a small launch; I just missed him by 10 minutes. If you have developed the films already (though I hardly think you had time to do so) just tell me how they are or send them along because I'll be able to get a number of canoe photos (full sail etc.) if the Amphlett ones are no good."[46]

PLATE 179

Dobuans and their canoes at Sinaketa. On 7 April: "Again worked with camera; by sunset I was simply exhausted. . . . Photographed a few boats—and in this way passed the time until 12. . . .Then lunch. Around 4 again took pictures on the shore and a few from a boat. . . . In the evening I was so tired I almost fainted."[47]

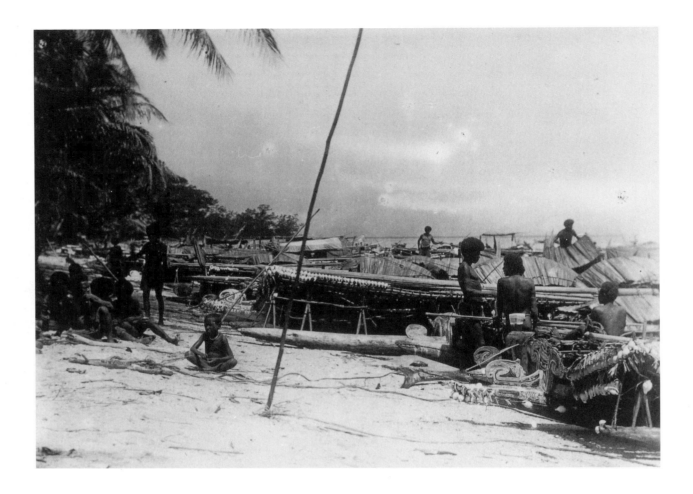

PLATE 180

Linus observed, "This looks like a casual meeting of Kula partners, Dobuan and Sinaketa men discussing trade."[48]

PLATE 181 Linus noted, "That must be a Sinaketa fishing canoe in the foreground, and behind are the visitors' *masawa* canoes. Children love to hang around when overseas visitors call, and they would learn a lot about the conduct of Kula by just watching and listening."

PLATE 182

Linus commented, "Two old men cooking their supper on Sinaketa beach. They are probably from Dobu. The style of their cooking vessel, however, is that of Wari or Panaeati, not Amphletts."

The man with the cloth around his head is covered in scaly ringworm (*sipuma*), a fairly common affliction in these islands.

⌗⌗

PLATE 183

Visitors at Sinaketa cooking their evening meal on the beach.

A FEW DAYS AFTER this event, Malinowski was back at Billy's place in Gusaweta. On 10 April he wrote in his diary, "I began to develop films, felt energetic and wanted to work. . . . 24 plates in the evening. At night, storm; two plates broken; then three ruined by insects. Unhappy about this."[49]

The next day he wrote to Elsie, "I came here yesterday to develop 24 films and 24 plates taken during the *kula* in Sinaketa. 3/4 of the films and 1/2 of the plates are a success, which number I consider satisfactory."[50]

Indeed, he had probably taken more photographs on this occasion than at any other time during his fieldwork.

"Black and White"

Malinowski's plan for his monograph on Kiriwina included a lengthy appendix on culture contact which he entitled "Black and White." His draft synopses and notes for this appendix grouped topics under the same seven headings as his main text (social structure, village community, tribal life, economics, magico-religious ideas and practices, knowledge, and language). He proposed to document the effects of European contact in each one of these domains of Trobriand life, and also presumably to illustrate them with some of the photographs in his collection classified under "Contact."[1]

Yet at the end of *Coral Gardens and Their Magic,* Malinowski chided himself for having had a "false" attitude toward the observable facts of contact and change which were transforming Trobriand society and culture before his very eyes. "The Trobriander as he was, even two or three generations ago, has become by now a thing of the past, to be reconstructed, not to be observed. And the scientific way to reach even a careful reconstruction is through the observation of what actually exists."[2]

Although he had observed and noted them well enough, it was "perhaps the most serious shortcoming" of his field research that he did not realize that "the real subject-matter" of fieldwork should be the changing Melanesian as "a citizen of the world," whose "reality consists in the fact that he lives under the sway of more than one culture."[3]

Summarizing some of the changes effected by colonial rule, he focused on the "eclipse of the chief's power":

The paramount chief and his peers in other districts are no longer the only people or even the main people who wield power and of whom one has to be afraid. There is a resident magistrate who can put you in gaol, fine you, or even—as has happened once or twice—hang you. His law has to be obeyed. There are the missionaries who moralize, pester and shame you into doing this or abstaining from that. There are the traders who exercise a different but not less powerful influence by giving or withholding things which have become almost a necessity. All this has affected the chief's tribute, especially in an indirect manner through the limitation of polygamy.[4]

PLATE 184

Although these men do not look like Trobrianders, Malinowski presumably lined
them up to illustrate changes in what he called the "appearances of tribal life." Two
of them wear calico waist-cloths, and two wear leather belts; one holds a large steel
ax. Linus commented, "All my informants agreed that these four well-dressed men
are not Trobrianders, but could not say for sure where they might be from. They
look Dobuan to me."

⚎

PLATE 185

Judging by appearance, dress, and setting, this can only be a missionary family. In 1915 there were four South Sea Island mission teachers (three from Fiji and one from Rotuma) in the Trobriand Islands. In addition, there were fifteen Kiriwinan mission teachers in charge of different village schools—at which attendance, according to A. R. M. Bellamy, "seeing that it is not compulsory, is very good."[5] The Reverend John Wheen toured Kiriwina in 1912 and visited Tukwaukwa, where he observed a school conducted by Miss Margaret Jamieson: "It was a motley crowd of children that mustered in the shade of the trees to be instructed. From 90 to 100 of them, every one as sharp as a needle and as restless as a mosquito. But with the help of a native teacher and the cooperation of the village policeman the teacher succeeded in reducing the hive of buzzing little mortals to order, and took them through exercises in reading, singing, writing and arithmetic."[6]

Malinowski made only passing mention of such village schools, and he refers only once to the surprising fact that there was a Fijian missionary teacher in Omarakana.[7] The man in the photograph might be he, though to Linus he looks Rotuman rather than Fijian. If not Omarakana, the location is possibly Oiabia (Malinowski's Oyabiya), the Wesleyan Methodist Mission headquarters near Losuia. During Malinowski's time Oiabia was staffed by white missionaries and their families, though there was also a Fijian "native minister" named Livinai.

PLATE 186

Although this photograph is cataloged under "Sex" (referring rather to marriage), it is also inscribed "Black and White." This unusually tall and stoutly constructed *pwatai* needs extra scaffolding, and Linus speculated that it is a communal gift for the marriage of a person of high rank.[8] The location is a mission station, easily identified as such by the imported wooden slit drum (*bela,* that is, "bell") on the left.

Every Christmas Day the missionaries sponsored "native sports" at Oiabia, which also appeared to include European-style athletic contests. In 1917 Malinowski was in the near vicinity, staying at Gusaweta for Christmas, though he did not accompany Billy who went to watch the sports, thereby missing an opportunity to shoot "Black and White" pictures.[9]

PLATE 187

Billy Hancock appears to be inspecting a pearl in the palm of his hand. Most of the men surrounding him are Malinowski's friends from Omarakana. Linus grew quite excited about this photograph: "Billy is outside his store at Gusaweta. He must be trading *veguwa* (valuables) for pearls from a local diver. That's Kalogusa with necklaces on the left, then Tokulubakiki with a string of four armshells. Billy Hancock is examining pearls, and that might be Mitakata looking on, and his brother Touvesei standing behind with a whalebone spatulae. Next to Billy is Namwanaguyau with a comb tucked into his hair and holding a stone adze. The man holding out the waist belt of threaded shells is perhaps the vendor of the pearls. Traders like Billy would be able to fetch items like these from anywhere in the Massim and bring them to Kiriwina to exchange for pearls."

Malinowski explained, "Under European influence a new industry has blossomed. By the wise legislation of the Papuan government, European traders are

allowed only to purchase pearls from the natives and must not carry out or organize any diving on their own account. To five communities—Kavataria, Teyava, Tukwa'ukwa, Oburaku and Sinaketa—this has, for the last quarter of a century or so, provided what to the natives seems an incredibly large source of income. In many ways it has produced a revolution in native economics."[10]

In a letter to Elsie, Malinowski mentions that he had witnessed Billy's purchase of a large pearl, "for which Billi himself will receive some 60–70 pounds and its value at a jeweller would be probably the double of this." Its Trobriand owner "was simply drunk with excitement: his eyes had a moist gleam, he could hardly stand and swayed about in an unsteady manner as if in a trance and there was a group of his *veyola* [kin] and friends about who did most of the haggling for him. There was not much of it, however. Billi gave him a six-row belt (of red *sapisapi*) two *beku* (large stone blades) and he haggled another small belt and still another baby-one and then he got calico, tobacco, betel nut etc. into the bargain—some 10–15 pounds worth altogether."[11]

Despite such evident exploitation, "[t]he Trobriander . . . shows and expresses as readily his contempt for the European's childish acquisitiveness in pearls as a duchess or Parisian cocotte would show for a necklace made of red shell-disks."[12]

꙼

PLATE 188

The caption on the reverse identifies this as the house of Mick George ("that truly homeric Greek") at Kiribi plantation just south of Oburaku. Mick had married a woman of Oburaku named Ilumedova, and it was their daughter Marion (or, Marianna) who was married to Billy Hancock. Malinowski stayed in this house for a few days in December 1917, just before setting up his tent in Oburaku. Although he found it hard to sleep "because of the endless chatter," he liked Mick's "congeniality" and Greek ways: "'Mediterranean' when he sits crouching like Achilles in a drawing by Wyspiański. Greek-Turkish cuisine . . . Mick helps me in my ethnographic studies. *'Kayasa all same bloody market.'*"[13]

Thanks to his marriage to Ilumedova, Mick ran Oburaku as "a kind of feudal dependency": "[T]hey sell him all the pearls they get and perform anything he orders them. . . . Mick promised them to finance [a *sagali*] if they work well for his pearling."[14]

On 12 December Malinowski went to Oburaku to watch Mick's *sagali,* a munificent distribution of pigs and yams, of which he took "a dozen films, all underexposed."[15] That evening over supper Mick boasted that "Kiriwina had never seen such a *sagali.*"[16]

Linus pondered over the photograph. "There is a figure in white on the verandah to the left, sitting forward in a deck chair. Could it be Ilumedova, or perhaps her daughter Marion, Billy's wife? If it's a man in a white suit, why is he sitting with all these women? The pig fence around the bottom of house doesn't look very effective. Oburaku people told me that the name of the site of the house is Olakum. Kiribi referred to Mick's coconut plantation."

Not too fancifully, the man in the white suit could be Malinowski. As he noted in his diary on 11 December, "In the afternoon I wrote down the story of Marianna on the verandah."[17]

⌖

PLATE 189

Women, probably from Oburaku, seated on the verandah of Mick's house. The caption on the back of the print ("Black and White") is uninformative, but we may be sure this photograph was taken while Malinowski was staying here in mid-December 1917.

The women are scraping banana leaves for bundles. None of them are likely to be Mick's wife, Ilumedova, though Linus legitimately wondered whether the young woman in the dress was Marion Hancock. Her shaven head and "fingernail" necklace indicate that she is in mourning, though not for a husband. Despite the clue of the dress, however, would not Marion have been discouraged by Billy from wearing such conspicuous shell earrings (for which the pierced earlobes have to be considerably enlarged during childhood)? Moreover, can we imagine that this startled-looking young woman speaks "perfectly correct English, learnt in one of the white settlements of New Guinea, where she had been brought up in the house of a leading missionary"?[18]

PLATE 190

A mysterious woman in white (Ilumedova or Marion?) stands on the jetty in front of Mick's house at Kiribi.

Arrival; house surrounded by palms; the deep cavernous shadows between the trunks designate clearings in the mangrove forest. Near the house a *bwayma;* then a tin *shithouse.* A jumble; I wanted to take pictures of it. Ilumedoi [*sic*] ignored me. Diary, *145–46*

On 16 September 1918, the day before Malinowski sailed from Kiriwina for Samarai on the first leg of his long journey to Melbourne, marriage, and ultimate fame:

"I and Billi started early in the morning for Kiribi. There the last meal I had with Billi and Mick and a last talk. I was sitting there in Mick's store and I suddenly looked on all the quaint mixture of Greek and Melanesian barbarism with Anglo-Saxon trade culture as one looks at a memory—it was receding fast into the realm of remembrances. . . ."[19]

Appendix 1:
Malinowski's Photographic Equipment

In late May 1914 Malinowski began shopping in London for stores and supplies to ship to New Guinea. He planned to spend about a year in the field, so he equipped himself accordingly. Staś Witkiewicz had joined Malinowski in London and accompanied him on most of his shopping expeditions.

Charles Seligman had already lent Malinowski a camera of an unspecified type, though it was probably a "snapshot" camera. On 6 June, two days before departure, Malinowski took delivery of a quarter-plate Model II Klimax camera, complete with a Beck Mutar lens and two slides. It was a standard folding camera, first manufactured in 1910, with a double extension to enable close focusing (a facility Malinowski does not appear to have used very often).

The invoice (from Charles Baker of High Holborn, "Optical and Scientific Instrument Maker") listed thirty other items. These included ten extra slides for the camera, a leather case, filters, two darkroom lamps, a tripod and case, a half-gross of Paget self-toning paper, a half-gross of Seltona glossy paper, two boxes of tropical lights, two gross of Imperial S.R. backed plates, one gross of Imperial S.R.O. backed plates, a ten-pound tin of acid hypo fixing, a three-pound tin of alum, seven assorted developing dishes, three printing frames, a gallon of Hypona, two developing tanks, a Wynnes meter, two glass measures, and three packing cases. The total cost of this equipment was £18.11.1, of which the biggest expense was £5.15.0 for the camera.[1]

Malinowski would have been advised on these purchases by Witkiewicz, who

probably planned to use them too. It is clear that Malinowski intended to set up a dark room in the field, though in the event he did not need to, using Saville's facilities on Mailu Island and later Hancock's on Kiriwina. After returning to Australia in early 1916, Malinowski continued to purchase and dispatch photographic supplies to Billy.

In late August 1917, Malinowski approached the Australian Government for the loan of another camera, and through the offices of Atlee Hunt, Secretary of the Department of External Affairs, he was able to borrow a state-of-the-art, 3A Graflex "snapshot" camera, fitted with a Zeiss Kodak Anastigmat F.6.5 lens. Hunt also arranged for Malinowski to purchase photographic supplies from Kodak at a discount (costing £12.14.5 in all), and for the printing of 212 of Malinowski's plates at Departmental expense.[2]

Malinowski's commitment to photography can be judged by the amount of money he was prepared to spend on it. From surviving orders, invoices, and receipts (including those mentioned above), I calculate that it cost him approximately £50 over the course of his two years of fieldwork, that is, an average of £25 a year. Since his gross income was about £250 per annum[3] during 1914–18, his expenditure on photography was about 10 percent of his total budget. It was a significant amount by any standards, far greater than he spent on any other single item of field equipment. Indeed, as a recurrent expense, photography came second only to twist (or trade) tobacco. Tobacco was the common currency in Papua at the time, and Malinowski used it to pay for most goods and services (including payments to translators and informants). I estimate that his annual expenditure on trade tobacco was about £50, or twenty percent of his total fieldwork expenditure for each year.

Appendix 2:
The Numbering of the Collection

There exists no master list of Malinowski's photographs, and I have found his system of numbering them impossible to decode. The compound number given to each photograph (written on the back of the print or, if only a negative is present, on its envelope) consists of a small number and a larger one separated by a slash. Usually the latter precedes the former (50/1), though sometimes they are reversed (1/50).

It is easy to deduce that the smaller number represents a place within a series or sequence as defined by the category according to which a group of photographs is classified (for example, "Samarai," "Wasi," or "Canoes"). It is plausible, too, that the larger number represents a particular ethnographic subject or topic. In the absence of a code, however, it is difficult to guess its significance, and the logic of particular juxtapositions and sequences of numbers is baffling.

For example, under the category "I. Amphletts" there are 34 photographs numbered 1 to 34, but the larger numbers with which each one is paired begin at 317 and leap erratically (with a few short consecutive sequences) to 925. The next category "II. Samarai" consists of 15 photographs which can also be arranged in a 1–15 sequence; but in this case the larger numbers run (with a few omissions) from 509 to 527. Seeking numbers which complement or continue this notional "500 series" elsewhere in the collection we find some suggestively present in "XXV. Contact" (extending from 512 to 595). But other numbers in the 500–599 range identify pho-

tographs in a bewildering variety of unrelated categories: for example, "IV. Canoes," "VIII. Pregnancy," "IX. Magic," "XII. Dress," "XVI. Games," "XXIV. Personalities," and "XXXI. Harvest and Gardening." Again, category "III. Wasi" also contains 15 photographs, but the larger numbers make enormous leaps from 160 to 718. Photographs under "IV. Canoes" begin at 1/147 and end at 78/919.

Thus, there are marked numerical discontinuities in almost every category (or topical group) of photographs. To put it another way, the classification by labeled category is not commensurate with particular series of numbers, except in short sequences (sail making in Omarakana, for instance, or children's games at Teyava).

I have considered and rejected various hypotheses to account for the larger numbers. Unless there is a mediate code, they cannot correspond to the page numbers of Malinowski's Trobriand field notebooks (which run consecutively from 700 to 2000). Nor can they be linked to dates, whether of days, months, or years, nor yet to locations—unless there was an improbably complex code according to which a particular number signified a particular place.

The only clue to his system of numbering that I have been able to find in Malinowski's papers occurs in a letter he wrote in 1931 to James Sinclair, Photographic Suppliers of Whitehall, London. Malinowski sent him some one hundred negatives of which he wanted prints made. He added, "It is very important for me that the negatives should be kept in the order in which they are now arranged in the [negative] books and that each print should bear a number corresponding to its negative.... I have them numbered in accordance with ethnological descriptions in my fieldnotes and it would entail considerable labour on my part if they had to be gone through and classified again."[1]

Despite the information that his photographs are "numbered in accordance with ethnological descriptions" in his fieldnotes, the logic of the system remains elusive. Fortunately, an understanding and appreciation of Malinowski's photography does not rest upon a comprehension of his system of reference numbering.

THE CODE FOR matching plate numbers in this book with Malinowski's numbering of the same photographs is given below. On some of his prints the numbers are reversed, but for the sake of consistency I have placed the larger number first throughout the list.

Plate	Malinowski's Ref. No.	Plate	Malinowski's Ref. No.
1	517/7	30	414/27
2	516/4	31	426/38
3	511/3	32	484/90
4	525/13	33	100/32
5	510/2	34	BXXXI7
6	519/8	35	BXXXI4
7	518/9	36	49/2
8	BXXV3	37	417/30
9	32/1	38	224/5
10	595/12	39	914/19
11	BXVIII	40	233/13
12	795/11	41	746/2
13	341/6	42	244/21
14	BXVIII1	43	245/22
15	655/89	44	248/25
16	113/3	45	250/27
17	808/8	46	251/28
18	809/10	47	596/43
19	55/3	48	BVII1
20	348/18	49	714/5
21	350/8	50	713/4
22	Glass plate	51	734/10
23	79/10	52	B11
24	94/26	53	B12
25	589/102	54	738/14
26	389/80	55	873/28
27	360/76	56	755/9
28	492/40	57	584/8
29	411/25	58	863/25

Plate	Malinowski's Ref. No.	Plate	Malinowski's Ref. No.
59	817/23	95	804/40
60	853/11	96	906/11
61	529/5	97	268/1
62	530/6	98	269/2
63	289/3	99	BXIV1
64	792/109	100	705/28
65	854/11	101	50/1
66	111/2	102	61/6
67	559/6	103	860/10
68	563/10	104	326/5
69	754/7	105	765/17
70	134/5	106	398/8
71	135/6	107	14/1
72	59/1	108	25/2
73	919/78	109	264/2
74	148/2	110	506/8
75	140/5	111	566/10
76	275/10	112	265/3
77	364/24	113	709/14
78	362/18	114	721/15
79	280/15	115	288/5
80	718/15	116	861/15
81	278/13	117	557/13
82	321/12	118	BVIII2
83	851/72	119	B15
84	855/73	120	581/14
85	794/66	121	335/7
86	13/8	122	BXVIII3
87	800/39	123	72/4
88	766/33	124	876/43
89	819/43	125	BXVII1
90	165/15	126	890/55
91	739/25	127	590/32
92	866/8	128	801/41
93	69/13	129	334/11
94	262/15	130	483/25

Plate	Malinowski's Ref. No.	Plate	Malinowski's Ref. No.
131	283/10	161	195/37
132	369/14	162	184/31
133	371/16	163	266/39
134	373/17	164	159/11
135	375/18	165	183/18
136	378/20	166	351/47
137	377/19	167	592/60
138	381/21	168	159/19
139	385/24	169	177/21
140	726/38	170	323/3
141	384/23	171	382/7
142	832/28	172	475/12
143	405/14	173	442/25
144	214/3	174	434/26
145	304/18	175	791/31
146	419/32	176	431/18
147	206/6	177	869/76
148	846/56	178	435/21
149	64/14	179	763/63
150	330/22	180	783/64
151	302/17	181	436/22
152	211/11	182	925/34
153	163/4	183	848/38
154	849/36	184	B18
155	204/8	185	46/1
156	202/6	186	719/11
157	197/5	187	BXXV4
158	727/33	188	538/10
159	193/34	189	BXXV2
160	196/38	190	539/11

Glossary of Trobriand Terms

Variant spellings appear in parentheses.

baku. Open, central place of village.

baloma. Spirit(s) of the dead.

beku. Polished greenstone ax head.

bisila. Decorative pandanus leaf streamer.

boma. System of war magic.

bosu. Whalebone lime spatula.

bukumatula. Bachelors' house.

butia (bweta). Garland of scented flowers.

bwagau (bwa'ga'u). Sorcerer; sorcery.

bwema (bwayma, bwaima). Yam house; yam store.

dala. Matrilineal subclan.

doba (dobe). Banana leaf fiber skirt.

dobatola. Finest banana leaf skirt.

doga. Animal tusk; shell pendant imitation of boar's tusk.

dogadoga. Boar's tusk pendant.

dum. Decorated bamboo pipe.

Gumagabu. Type of dance using dancing shields.

guyau (guya'u). Noble rank; chief.

ilomgwa. Attendents or henchmen of a chief.

isunapula (isunapulo). Early harvest of taro.

kaidebu. Carved dance shield.

kalala. Mullet.

kalipoula (*kalipoulo*). Large fishing canoe.

kalomwa (*kaloma*). Shell discs of *Chama* sp. made for necklaces and belts.

kamkokola. Magical structure of poles erected in new gardens.

Kasawaga. Type of dance which mimics animals.

kasesuya (*kasaysuya*). Popular type of game involving song and dance.

kawalawa. Named beach or landing place for canoes.

kayasa. Competitive display of food or other wealth.

ketakeluva. Type of bony fish caught in the lagoon.

kevala. Technique of smoking fish; platform on which fish is smoked.

kewou. Small fishing canoe.

kiluva. Triangular fishnet.

kuboia (*kuboya*). A small fish; a children's game.

kukwanebu. Bawdy folktale.

Kula. Ceremonial exchange of shell valuables; literally, "to gain."

kui (*kuvi*). The greater yam, *Dioscorea alata.*

kwasi. Arm band.

lagim. Carved washboard of canoe.

liku. Small yam hut; food crate.

lisaladabu. Women's mortuary exchange to "wash off the dirt of mourning."

lisiga (*ligisa*). Chief's personal hut.

malia. Prosperity; time of plenty.

masawa. Large, sea-going outrigger canoe.

milamala. Period of harvest festival; dancing season.

mona. Mashed taro or yam pudding cooked in coconut cream.

mulukwausi. Flying witches.

mwali. Armshell made of *Conus* sp.

mwasawa. Games; play; playfulness.

nasusuma. Pregnant woman.

noku. Plant used for making red and purple dyes; dyed banana leaf fibers.

nununiga. Banana leaf bundle.

pwatai (*pwaita'i*). Prismatic food containers for display.

rebwaga (*rayboag, raiboag*). The rugged coral ridge of eastern Kiriwina.

Rogaewa (*Rogayewo, Rogaiewo*). Type of traditional dance.

sagali. Food distribution, especially at mortuary events.

sekeula (*saykeulo*). Fiber pregnancy cloak or mantle.

sepwana (*saipwana*). Long mourning skirt.

sigiliveguwa. Distribution of valuables following a death.

sikwekula. Literally, fingernails; mourning necklace worn by women.

solava (*soulava*). Necklace of shell discs of *Spondylus* sp.

sulumweya (*sulumwoya*). Scented leaves resembling mint.

tabula. Father's female kin, notably, father's sister(s) and father's sister's daughter(s).

tabuya (*tabuyo*). Carved transverse prowboard of canoe.

Tapioka. A sexually explicit, nontraditional dance.

tasasoria. Ceremonial launching and regatta of new canoes.

tetu (*taytu, taitu*). The staple food *Dioscorea esculenta,* the lesser yam.

toliwaga. Owner or master of a canoe.

towosi. Garden magician; literally, "singer."

ulatila (*ulatile*). Youths' courting expedition.

urigubu. Harvest gift of yams or taro, typically of a man to his sister's husband; literally, "taro garden."

uvalaku. Overseas Kula expedition; Kula competition.

vakavaylau (*vakavayla'u*). Inaugural rite of burning the garden.

vava. Direct exchange of fish for vegetable produce.

veguwa (*vaigua*). Valuables; wealth.

vesali. Women's mourning dance performed immediately after a death.

vilamalia. Magic of village prosperity.

vinavina. Ditty or rhyme sung in a game.

wakala. Waist belt.

wakaya. Type of banana; leaves used for making women's skirts.

wasi. Delayed ceremonial exchange of fish for vegetable produce.

wosimwaya. Traditional dance.

yawari (*yawali*). Wake following a death; first mortuary feast.

Notes

INTRODUCTION

1. Annette Weiner, *Women of Value, Men of Renown* (St. Lucia: University of Queensland Press, 1977), xv.

2. Paul Theroux, *The Happy Isles of Oceania* (London: Hamish Hamilton, 1992), 97. "Islands of Love," however, was not Malinowski's coinage.

3. The phrase was Haddon's. See George W. Stocking, Jr., *After Tylor: British Social Anthropology 1888–1951* (Madison: University of Wisconsin Press, 1995), 115. See also Michael W. Young, "The Intensive Study of a Restricted Area, or, Why Did Malinowski Go to the Trobriand Islands?" *Oceania* 55, no. 1 (1984): 6.

4. Michael W. Young, "A Myth Exposed," *Asia-Pacific Magazine* 1, no. 3 (1996): 44–48.

5. Stocking, *After Tylor,* chapter 6.

6. Edmund Leach, introduction to *Coral Gardens and Their Magic,* by Bronislaw Malinowski (London: Allen and Unwin, 1935; reprint, Bloomington: Indiana University Press, 1965), vii. All page citations refer to volume 1 of the reprint edition.

7. Bronislaw Malinowski, *Argonauts of the Western Pacific: An Account of Native Enterprise and Adventure in the Archipelagoes of Melanesian New Guinea* (London: G. Routledge and Sons; E. P. Dutton, 1922), 25.

8. Namely, *Argonauts of the Western Pacific: An Account of Native Enterprise and Adventure in the Archipelagoes of Melanesian New Guinea* (1922), *Crime and Custom in Savage Society* (1926), *Sex and Repression in Savage Society* (1927), *The Sexual Life of Savages in North-western Melanesia: An Ethnographic Account of Courtship, Marriage, and Family Life among the Natives of the Trobriand Islands, British New Guinea* (1929), and *Coral Gardens and Their Magic* (1935).

9. A dripping stalactite pierced Bolutukwa's hymen, enabling her to conceive Tudava. Bronislaw Malinowski, *The Sexual Life of Savages,* 3d ed. (London: G. Routledge & Sons, 1932), 155–56.

10. Helena Wayne, ed., *The Story of a Marriage: The Letters of Bronislaw Malinowski and Elsie Masson,* vol. 1, 1916–20 (London: Routledge, 1995), 124.

11. Christopher Pinney, "The Parallel Histories of Anthropology and Photography," in *Anthropology and Photography,* ed. Elizabeth Edwards (New Haven: Yale University Press, 1992): 74–95.

12. Everard im Thurn, "Anthropological Uses of the Camera," *Journal of the Anthropological Institute* 22 (1893): 184; Donald Tayler, "'Very loveable human beings': The Photography of Everard im Thurn," in *Anthropology and Photography,* ed. Edwards, 187–92.

13. Terence Wright, "The Fieldwork Photographs of Jenness and Malinowski and the Beginnings of Modern Anthropology," *Journal of the Anthropological Society of Oxford* 22, no. 1 (1991): 41; Elizabeth Edwards, "Performing Science: Still Photography and the Torres Strait Expedition," in *Cambridge and the Torres Strait: Centenary Essays on the 1898 Anthropological Expedition,* ed. Anita Herle and Sandra Rouse (Cambridge: Cambridge University Press, 1998): 106–36.

14. British Association for the Advancement of Science (BAAS), *Notes and Queries on Anthropology,* 4th ed. (London: Royal Anthropological Institute, 1912). The short article on photography was revised by John Myres for this edition, but the substance remains Haddon's.

15. Wright, "Fieldwork Photographs," 41–58; Elizabeth Edwards, "Jenness and Malinowski: Fieldwork and Photographs," *Journal of the Anthropological Society of Oxford* 23, no. 1 (1992): 89–93; Jeremy Coote, "Malinowski the Photographer," *Journal of the Anthropological Society of Oxford* 24, no. 1 (1993): 66–69; Terence Wright, "Malinowski and the Imponderabilia of Art and Photography," *Journal of the Anthropological Society of Oxford* 24, no. 2 (1993): 164–65; Terence Wright, "The Anthropologist as Artist: Malinowski's Trobriand Photographs," in *European Imagery and Colonial History in the Pacific: Nijmegen Studies in Development and Cultural Change* 19 (1994): 116–30; Étienne Samain, "Bronislaw Malinowski et la photographie anthropologique," *L'Ethnographie* 91, no. 2 (1995): 107–30.

16. Wright, "Anthropologist as Artist," 127. This probably overstates the case. While Malinowski's methods of participant observation and direct eyewitnessing certainly influenced those members of Mass Observation who attended his LSE seminar, there is no evidence that Malinowski's fieldwork photography was ever a subject of discussion.

17. Samain, "Bronislaw Malinowski."

18. Bronislaw Malinowski, *A Diary in the Strict Sense of the Term,* trans. Norbert Guterman (London: Routledge, 1967), 73.

19. *Diary,* 22, 65, 173, 176; 69 (21 January 1915); 163 (24 December 1917). The Guterman translation indicates Malinowski's use of foreign languages by "printing in the original language in italics all passages not in Polish (including passages in English), with translations supplied in brackets where this seemed necessary." *Diary,* xxi.

20. Malinowski to Seligman, 24 November 1914. C. G. Seligman Papers, British Library of Political and Economic Science, LSE.

21. Seligman to Malinowski, 4 February 1915, Seligman Papers.

22. Malinowski to Seligman, 19 October 1915, Seligman Papers.

23. Seligman to Malinowski, 15 August 1916, Malinowski Papers, series I: 565, Stirling Library, Yale University.

24. See Edwards, "Jenness and Malinowski," 91. Malinowski's interest in photography waned in later years. He does not appear to have taken any photographs during his four-month visit to Africa in 1934, and during two summer field trips to Mexico in 1940 and 1941 he delegated photography to his second wife, Valetta Swann (an artist), and to his research assistant, Julio de la Fuente. Despite the technical advances that had been made in photography since his years in the Trobriands, he seemed quite uninterested in pursuing them himself.

25. Roslyn Poignant, "Surveying the Field of View: The Making of the R.A.I. Photographic Collection," in *Anthropology and Photography,* ed. Edwards, 65.

26. *Coral Gardens,* 461–62.

27. "Loose Fieldnotes X," folder no. 124, Malinowski Papers, LSE.

28. While on Mailu, Malinowski referred in his diary to being haunted by the image of Tośka as captured in one of these photographs. *Diary,* 43.

29. See Pinney, "Parallel Histories," 84–85, for a brief characterization of Seligman's photography among the Veddas of Ceylon during 1907–8.

30. See Michael W. Young, editor's introduction to *Malinowski among the Magi: "The Natives of Mailu"* (London: Routledge, 1988), 67–68.

31. Jim Specht and John Fields, *Frank Hurley in Papua: Photographs of the 1920–1923 Expeditions* (Bathurst, NSW: Robert Brown, 1984); Malinowski, foreword to *In Unknown New Guinea,* by W. J. V. Saville (London: Seeley, Service, 1926), 8.

32. See Wayne, *The Story,* 141–43.

33. Howard Morphy and Marcus Banks have recently made the anachronistic claim that Spencer and Gillen's photography was "motivated" by "the documentary ethos of participant observation," thus putting them "well within" the later tradition most famously represented by Malinowski. Morphy and Banks, eds., introduction to *Rethinking Visual Anthropology* (New Haven: Yale University Press, 1997), 8–9.

34. J. Mulvaney and G. Walker, *The Aboriginal Photographs of Baldwin Spencer* (South Yarra: John Currey O'Neil, 1982).

35. Malinowski, "*Baloma*: The Spirits of the Dead in the Trobriand Islands," *Journal of the Royal Anthropological Society* 46 (1916): 354–430. Reprinted in R. Redfield, ed., *Magic, Science, and Religion and Other Essays* (New York: Doubleday, 1954).

36. Anna Micińska, *Witkacy: Life and Works* (Warsaw: Interpress Publishers, 1990); Daniel Gerould, *The Witkiewicz Reader* (Evanston: Northwestern University Press, 1992).

37. Eva Franczak and Stefan Okołowicz, *Przeciw Nicości (Against Nothingness)* (Cracow: Wydawnictwo Literackie, 1986).

38. Gerould, *Witkiewicz Reader,* 82.

39 .Gerould, *Witkiewicz Reader,* 83; 93 (5 August 1914).

40. Malinowski to G. A. Mokrzycki, 6 January 1941. (Letter in the possession of Helena Wayne.)

41. Coote, "Malinowski the Photographer"; Wright, "Malinowski and the Imponderabilia."

42. Wright, "Malinowski and the Imponderabilia," 164.

43. Coote, "Malinowski the Photographer," 68.

44. *Diary,* 175.

45. Gerould, *Witkiewicz Reader,* 7. Elizabeth Edwards offers an extrapolation of this interpretation concerning Malinowski's abhorrence of "fragmenting themes." She writes, "Maybe Malinowski's dissatisfaction with photography was ultimately that, ontologically, the photograph is incapable of producing the depth of coherence that he sought. . . . The tensions produced by the photograph as expressive fragment always lurk within it perhaps." Personal communication to author, 28 September 1997.

46. *Diary,* 31–32, 52, 117.

47. Johns to Malinowski, 20 December 1915, verso page in "Language," folder no. 1, box 1, Malinowski Papers, LSE.

48. *Diary,* 221, 246, 281.

49. Hancock to Malinowski, verso of page 376 in "Loose Fieldnotes V," folder no. 286; verso of page in "Loose Fieldnotes VIII," folder no. 287, Malinowski Papers, LSE.

50. Perhaps on 26 June 1918—see *Diary,* 292.

51. Hancock to Malinowski, verso of page in "Loose Fieldnotes VI," folder no. 128, Malinowski Papers, LSE.

52. Pinney, "Parallel Histories."

53. *Diary,* 148 (12 December 1917).

54. Wright, "Anthropologist as Artist," 119.

55. *Coral Gardens,* 461–62.

56. In a personal communication, Elizabeth Edwards suggests that there may have been technical reasons for preferring the horizontal format; although handheld, the Graflex snapshot camera possibly handled better in that mode. I am not convinced. Billy Hancock readily overcame any such difficulty.

57. See Malinowski, "The Problem of Meaning in Primitive Languages," in *The Meaning of Meaning,* by C. K. Ogden and I. A. Richards (London: Routledge and Kegan Paul, 1923), 296–336. Malinowski judged it more fruitful to view language pragmatically as a "mode of action" rather than cognitively as a "countersign of thought."

58. Plate 13 of *Coral Gardens* offers another photograph of the same subject from a different angle but from the same distance.

59. Of course, Malinowski was not alone in this. Baldwin Spencer and Diamond Jenness, to mention but two precursors, also captured social context in their photographs of material culture.

60. I am indebted to Elizabeth Edwards for a valuable commentary on the preceding paragraphs: "I think one has to link these ideas to realist and positivist ideas of photographic inscription and its role in the presentation of anthropological information. This again is linked to expectations of how photographs (as opposed to text) 'perform' their information. While the inevitable reductions of ethnographic writing are considered normal, to manipulate a photograph, even in simple ways like cropping, is viewed almost as falsifying the evidence! The uncropped, unmanipulated image is part of the 'truth' discourse of record photography; it is also an anti-aesthetic which speaks to the idea of unmediated, direct inscription on the negative which is then disseminated in full—'you see what I saw.' It creates 'virtual witness,' to use Latour's phrase." Personal communication to author, 28 September 1997.

61. *Coral Gardens*, 462.

62. *Sexual Life*, xlviii.

63. *Diary*, 292.

64. John Collier, Jr., and Malcolm Collier, *Visual Anthropology: Photography as a Research Method* (Albuquerque: University of New Mexico, 1986), chapter 8.

65. In the Malinowskian tradition, Linus did eighteen months' fieldwork among Basima people of northeast Fergusson Island. Basima have a language and culture geographically related to, but quite distinct from, those of his native Trobriands. L. S. Digim'Rina, *Gardens of Basima: Land Tenure and Mortuary Feasting in a Matrilineal Society* (Ph.D. diss., The Australian National University, 1995).

66. For example, on 13 July 1918, with the end of his fieldwork clearly in sight, he wrote, "There are several chapters (war, all parts of sociology, decorative art, spirits) where I shall make no new inquiries." A month later he told Elsie that he had written "two long letters to America . . . *re* publication of my Kiriwinian book." Wayne, *The Story*, 167, 171.

67. Edmund Leach, "The Epistemological Background to Malinowski's Empiricism," in *Man and Culture: An Evaluation of the Work of Bronislaw Malinowski*, ed. Raymond Firth (London: Routledge and Kegan Paul, 1957), 124.

ONE

1. Colonel Kenneth Mackay, *Across Papua* (London: Witherby, 1909), 47.

2. Nigel Oram, *Encyclopaedia of Papua New Guinea* (Melbourne: Melbourne University Press, 1972), s.v. "Samarai."

3. *Diary*, 44–45.

4. Malinowski to Masson, 14 November 1917, in Wayne, *The Story*, 52.

5. *Papua Annual Report*, 1914–15 (Melbourne: Government Printer, Commonwealth of Australia), 32. The European population of Samarai in that year was 247.

6. *Diary*, 45 (ca. 30 November 1914).

7. Jenness to R. Marett, 16 December 1911, as cited by Wright, "Fieldwork Photographs," 45.

8. *Diary*, 47, 123, 133; 113.

9. Malinowski to Masson, 10 November 1917, in Wayne, *The Story*, 48.

TWO

1. *Argonauts,* 4.

2. *Argonauts,* 6.

3. *Papua Annual Report,* 1914–15, 38.

4. Young, "Intensive Study," 16.

5. *Diary,* 167 (27 December 1917). The portion in square brackets appears in the original but was omitted from the published version.

6. George W. Stocking, Jr., "The Camera Eye as I Witness: Sceptical Reflections on the 'Hidden Messages' of *Anthropology and Photography, 1860–1920*," *Visual Anthropology* 6 (1993): 211. The photograph was first published by Stocking in "The Ethnographer's Magic: Fieldwork in British Anthropology from Tylor to Malinowski," in *History of Anthropology* 1 (1983): 101. More recently it was reproduced by Helena Wayne in *The Story of a Marriage*, 93.

7. Malinowski to Masson, in Wayne, *The Story*, 151–53.

8. *Diary,* 140 (30 November 1917). On the reverse of this print is "Intro. methods."

9. Malinowski to Masson, 11 April 1918, in Wayne, *The Story*, 125.

10. *Diary,* 171. The flaw in this supposition is the absence of any explicit mention of Tukwaukwa, where most of the photographs in this series were taken. Malinowski's fieldnotes only refer to the fact that he photographed "fish exchange" in Teyava that day (see photo-essay 8, fig. 1).

11. On the reverse: "Introduction. Methods," and on another print of the same photograph, "Black and White." Toguguwa, the sorcerer in a wig, appears with Malinowski in plate 68 of *Sexual Life,* which clearly belongs to the same Tukwaukwa sequence.

12. On reverse is "Frontispiece."

13. On reverse is "Sex and Marriage: Bukumatula." See *Sexual Life,* 59–64. A companion image of Malinowski inspecting the Kasanai chief's yam-house appears as plate XXXII in *Argonauts.*

14. *Sexual Life,* 61.

THREE

1. See, for examples, *Sexual Life,* 385, and *Coral Gardens,* 277.

2. See Martha Macintyre's cogent revaluation of Malinowski's ideological construction of Trobriand chieftainship, "Too many chiefs? Leadership in the Massim in the Colonial Era," in *Transformations of Hierarchy: Structure, History, and Horizon in the Austronesian World,* ed. Margaret Jolly and Mark Mosko, special issue of *History and Anthropology* 7, nos. 1–4 (1994): 241–62.

3. *Diary,* 153.

4. Wayne, *The Story,* 80–81.

5. Malinowski described it twice, in *Crime and Custom in Savage Society* (London: Routledge & Kegan Paul, 1926), 101–5, and in *Sexual Life,* 10–13.

6. *Crime and Custom,* 104.

7. Fieldnotes, Malinowski Papers, LSE, 1717.

8. *Sexual Life,* 12–13.

9. See plate 27, *Coral Gardens,* for what appears to be a wider shot of the same event.

10. See *Coral Gardens,* 245–46 and plate 88.

11. Compare to plate 2, *Sexual Life,* also taken at the same time.

12. See *Sexual Life,* 175 and plate 40.

13. *Papua Annual Report,* 1910–11, 120–21.

14. Plate 72 in *Coral Gardens.*

15. *Sexual Life,* 377.

16. Malinowski to Masson, 7 June 1918, in Wayne, *The Story,* 153.

17. The three photographs of Mitakata that Malinowski published all predate December 1915. Plate 3 in *Sexual Life* shows Namwanaguyau with Mitakata "before their quarrel." Plate 25 in *Sexual Life* shows Mitakata being deloused by his wife Orayayse, obviously before their divorce (though in view of what appears to be a backcloth, it is unlikely that Malinowski took this photograph). Plate 35 in *Coral Gardens* shows Mitakata ritually burning the garden, an event that can be dated to October 1915.

18. *Sexual Life,* 96.

FOUR

1. Malinowski to Seligman, 30 July 1915, Seligman Papers.

2. *Coral Gardens,* xx.

3. *Argonauts,* 58–59; also *Coral Gardens,* 8.

4. Compare to plate 34, *Coral Gardens.*

5. *Coral Gardens*, 111.

6. See *Coral Gardens*, 112–13.

7. Compare to plate 100, *Coral Gardens*, showing Bwaideda performing the same rite in an unposed shot.

8. *Coral Gardens*, 128–29.

9. See plates 101 and 102, *Coral Gardens*.

10. For a full account of the complex magical sequence performed by Nasibowai, see *Coral Gardens*, 278–89.

11. Compare to plate 104, *Coral Gardens*, taken a moment earlier.

12. *Coral Gardens*, 60.

13. *Coral Gardens*, 99; compare to plate 31, a more distant shot of the same boys.

14. *Coral Gardens*, 166.

15. Plate 49, *Coral Gardens*.

16. See plate 85 of *Coral Gardens*, which shows Malinowski seated on the platform of this *bwema*.

17. *Diary*, 281; Fr. B. Baldwin, "Traditional and Cultural Aspects of Trobriand Island Chiefs," *Canberra Anthropology* 14, no. 1 (1991): 72.

18. *Diary*, 217. The frontispiece (plate 1) of *Coral Gardens* belongs to this sequence of photographs, and although Malinowski's caption is unspecific as to time and place, it does refer to "mortuary commemorative feasts."

19. See "Chart of Time-Reckoning," *Coral Gardens*, 50–51.

20. *Sexual Life*, plate 84.

21. *Coral Gardens*, 310.

22. *Papua Annual Report*, 1913–14, 46–54.

23. Compare to plate 62, *Coral Gardens*, which is clearly a shot of the heap in the background, taken from a spot near the woman with the pipe. Malinowski's caption: "Construction of small heap in front of the new owner's storehouse."

24. *Coral Gardens*, 392.

25. Compare plate v in *Crime and Custom*, in which the albino is more obvious. The caption to that plate reads, "A conical heap of yams is put up in front of a chief's storehouse by his wife's relatives." (It should perhaps be "the relatives of one of his wives.")

26. Fieldnotes, 1050.

27. Although cataloged under "Sagali," the back of the print also offers "Village scenes."

FIVE

1. *Sexual Life*, 211–13; *Coral Gardens*, plate 9.

2. Plate 58, *Sexual Life*.

3. *Argonauts,* 186.

4. *"Baloma,"* 375; Fieldnotes, 1228 (ca. 26 September 1915).

5. *"Baloma,"* 373; Fieldnotes, 1056, concerning observations made in Oluvilevi on 26 August 1915.

6. Compare plates 14, 65, 79, and 82 in *Sexual Life,* and plates XIII and XIV in *Argonauts,* all of which feature *kaidebu* dances, most of them in Omarakana.

7. Fieldnotes, 905–9 (ca. 5 July 1915).

8. *"Baloma,"* 380.

9. Fieldnotes, 1404.

10. Fieldnotes, 926, 1686.

11. Fieldnotes, 1404.

12. Fieldnotes, 1057.

13. Plate 73, *Sexual Life,* captioned "Rehearsal of a *Kasawaga* Dance."

14. Fieldnotes, 1710.

15. Plate 59, *Sexual Life.*

16. *Sexual Life,* 211.

SIX

1. BAAS, *Notes and Queries,* 269–70.

2. BAAS, *Notes and Queries,* 270.

3. *Argonauts,* 51–52.

4. *Sexual Life,* 241.

5. *Sexual Life,* 361.

6. *"Baloma,"* 365; *Sexual Life,* 364.

7. Malinowski to Masson, 23 December 1917 (referring to 17 December), Malinowski Papers, LSE. This sentence was omitted in the published version of this letter (Wayne, *The Story,* 83–84).

8. See plate 126. Linus suspected the row of huts belonged to Touluwa's wives.

9. On reverse: "Village Scene."

10. *Coral Gardens,* 235.

11. *Diary,* 188.

12. Field Notebooks 10 and 11 (August 1915), Malinowski Papers, LSE.

13. *Sexual Life,* 247.

14. *Diary,* 148 (11 December 1917).

15. *Sexual Life,* 258.

16. *Sexual Life,* 258–59.

SEVEN

1. See the published and unpublished essays written between 1910 and 1913 reproduced in Robert J. Thorton and Peter Skalník, eds., *The Early Writings of Bronislaw Malinowski* (Cambridge: Cambridge University Press, 1993). Indicative of their conern with magic, volume 1 of *Coral Gardens and Their Magic* is subtitled "Soil-Tilling and Agricultural Rites in the Trobriand Islands," and volume 2, "The Language of Magic and Gardening."

2. *Sexual Life,* 35.

3. Malinowski's legend to this photograph, one of thirty-three prints he presented to the National Museum in Melbourne in 1920.

4. *Coral Gardens,* 291.

5. Compare to plate VIII, *Argonauts.*

6. See *Sexual Life,* 181–82, for Malinowski's account of the rite that follows. Plate 44 of *Sexual Life* shows the same woman photographed from a different angle.

7. *Sexual Life,* 300.

8. For a sketchy and somewhat benign view of precontact warfare, see "War and Weapons among the Natives of the Trobriand Islands," *Man* 20 (January 1920): 10–12.

9. Plate LVIII, *Argonauts.*

10. See also Malinowski's even less flattering description of Kanukubusi's appearance in a letter to Elsie Masson, 19 June 1918 (Wayne, *The Story,* 157–58).

11. Compare to plate 89, *Sexual Life,* which confirms the general location.

12. *Diary,* 253.

13. *Sexual Life,* 419.

14. Malinowski, "Fishing in the Trobriand Islands," *Man* 18 (June 1918): 53. Malinowski was presumably exempted from the taboo on all strangers.

15. Malinowski, "Fishing in the Trobriands." On the function of magic and Malinowski's use of this particular example, see his essay "Magic, Science and Religion," originally published in 1925 and reprinted in Robert Redfield, ed., *Magic, Science, and Religion and Other Essays* (New York: Doubleday, 1954).

16. Compare to plate II, *Argonauts.*

17. These three "men of rank" appear in the same order in plate IX of *Argonauts,* posed in front of the small display platform which stands just outside Touluwa's *ligisa.*

18. "*Baloma,*" 376.

19. *Coral Gardens,* 431 and caption to plate 83.

EIGHT

1. Malinowski, "Fishing in the Trobriand Islands," 88.

2. *Diary,* 158.

3. See *Argonauts,* 112, for information on the construction, use, and ownership of *kewou* and *kalipoula.*

4. *Sexual Life,* 181–82.

5. See plate 5 in *Coral Gardens* and the description of *kalala* (mullet) fishing in Labai in Malinowski, "Fishing in the Trobriand Islands," 89.

6. See plate x, *Argonauts.*

7. *Coral Gardens,* plate 12.

8. Plate 7, *Coral Gardens.*

9. See *Argonauts,* 187–88; *Crime and Custom,* 22–23; *Coral Gardens,* 42.

10. See plate ii, *Crime and Custom,* which probably depicts the same event. Malinowski's caption does not specify whether it is *wasi* or *vava*: "Bundles of fish taken over from the fishermen by the inland natives."

11. Plate xxxvi, *Argonauts.* See also plate 14, *Coral Gardens,* and plate iv, *Crime and Custom.*

12. *Sexual Life,* 231–36.

13. *Sexual Life,* 403.

14. *Diary,* 171.

NINE

1. See *Argonauts,* 18–21.

2. Compare to plate 84, *Coral Gardens,* which shows the covered wood-carver's platform (*sokwaypa*) pictured here on the right of the *baku.*

3. "The houses are usually squeezed against each other so as to prevent sorcerers from prowling along the lateral walls. For the same reason they are never raised, be it ever so little, above the ground" (*Coral Gardens,* 243).

4. *Diary,* 272.

5. *Coral Gardens,* plate 92.

6. *Sexual Life,* plate 8.

TEN

1. *Argonauts,* 54–55.

2. *Diary,* 273 (11 May 1918).

3. Compare to plate 10, *Coral Gardens.*

4. *Argonauts,* caption to plate xxxv.

5. See plate 6, *Sexual Life,* "Women with carrying pads."

6. See Weiner, *Women of Value,* for a comprehensive account of Trobriand women's wealth, including the techniques of bundle and skirt manufacture.

7. From Malinwoski's unpublished "Descriptive label" on the technology of Trobriand skirt manufacture, the National Museum, Melbourne.

8. "Descriptive label," National Museum, Melbourne.

9. *Diary,* 163.

10. *Sexual Life,* 184. Malinowski credits Hancock with only three (plates 42, 47, and 48), taken in Tukwaukwa in 1917, but comparison strongly suggests that plate 51 was also Hancock's.

11. *Sexual Life,* 179–80.

12. Compare to plate 45, *Sexual Life.*

13. *Diary,* 281.

14. *Sexual Life,* 185.

15. *Sexual Life,* 187.

16. See plates 42, 47, and 48 of *Sexual Life.* She also appears with other women in plate 13, fully decorated though still unsmiling. This photograph too must have been taken by Hancock, though unacknowledged as such by Malinowski.

17. Malinowski's legend to plate 42, *Sexual Life,* which shows the woman in her pregnancy cloak.

18. She is indeed wearing her *yaulai* in plate 13 of *Sexual Life,* confirming that the image here is the second photograph in Hancock's sequence.

19. Hancock to Malinowski, with verso notes on kinship, file 100D, kinship boxes, Malinowski Papers, LSE.

20. Plate 51, *Sexual Life.*

ELEVEN

1. *Sexual Life,* 44–46.

2. "Baloma," 428.

3. *Diary,* 270.

4. *Diary,* 271.

5. *Diary,* 272.

6. *Sexual Life,* 203.

7. *Diary,* 276, 280.

8. *Sexual Life,* 202.

9. See plate 52, *Sexual Life.*

10. *Sexual Life,* 203.

11. *Diary,* 280–81.

12. Fieldnotes, 1751 (ca. 15 December 1915).

13. See legend to plate 55, *Sexual Life.*

14. Malinowski likened it to the game "Oranges and Lemons" (*Sexual Life,* 206).

15. Fieldnotes, 1749 (ca. 15 December 1915).

16. *Diary*, 283.

17. *Coral Gardens*, 211–12. He describes a serious quarrel which erupted between Kwaybwaga and M'tawa villages following a cricket match; it was settled by a *kayasa*, a competitive display of food. A prize-winning ethnographic film on the subject, *Trobriand Cricket*, was made in 1975 by Gary Kildea and Jerry Leach.

TWELVE

1. He dealt with them in *"Baloma"* and in a few dozen pages of *Sexual Life*.

2. *Sexual Life*, 127.

3. *Sexual Life*, 126.

4. *Sexual Life*, 136.

5. I am grateful to Elizabeth Edwards for this observation.

6. Plate LXV, *Argonauts*.

7. *Sexual Life*, 131.

8. Malinowski to Masson, 4 July 1918, in Wayne, *The Story*, 161.

9. Caption to another photograph in the same series, presented to the National Museum, Melbourne.

10. See the similar plate 11 in *Sexual Life*, which identifies the place and the deceased. See also plate 32, showing the decorated corpse of Inekoya, and plate 33, showing the first exhumation of her partly decomposed body, as well as plate III of *Crime and Custom* ("Obligatory display of grief in ritual wailing") showing perhaps Inekoya's mother and sister (with what is surely Inekoya's skirt over her shoulder), posed for the camera on the same occasion.

11. *Diary*, 196.

12. *Sexual Life*, 138.

13. See *Diary*, 191–93.

14. *Diary*, 196.

15. *Crime and Custom*, 77–78; *Sexual Life*, 475–77.

16. Fieldnotes, 814ff.

17. Fieldnotes, 825.

18. *Argonauts*, 171.

19. Fieldnotes, 826.

20. Malinowski to Masson, 23 December 1917, in Wayne, *The Story*, 79.

21. Fieldnotes, 1267–83.

22. Compare to plate 12, *Sexual Life*, the caption to which says "Distribution of Skirts in Mortuary Ritual."

23. *Diary*, 218.

THIRTEEN

1. Chapter 13 of part 4 ("Economics") was to be entitled "Kula and External Trade."
2. Malinowski, "Kula: The Circulating Exchange of Valuables in the Archipelagoes of Eastern New Guinea," *Man* 20 (July 1920): 97–105.
3. Malinowski to Masson, 19 November 1917, in Wayne, *The Story,* 63.
4. *Argonauts,* 112.
5. Caption to plate LX, *Argonauts;* see also page 471: "The chief's share was brought in on a stick, hanging down in a chaplet."
6. *Argonauts,* 474.
7. Plates XVI–XIX, *Argonauts.*
8. *Argonauts,* chapter 15.
9. *Argonauts,* 122.
10. *Argonauts,* 148–49.
11. Plate XXVIII, *Argonauts.*
12. Fieldnotes, 1971.
13. *Argonauts,* 140–41.
14. *Argonauts,* 149.
15. *Argonauts,* 149.
16. *Argonauts,* 150–51. It may be of technical interest to note the times of day Malinowski took this sequence of photographs. The canoes were rigged at 1 P.M., the race began at 3 P.M. and was over by 4 P.M. (*Argonauts,* 154).
17. *Argonauts,* 154.
18. *Argonauts,* 153. See plate XXX, which shows *Nigada Buwa* being launched at Kaulukuba. Meanwhile, as plate 30 of *Sexual Life* shows, Chief Touluwa was sitting on a specially constructed platform surrounded by his wives and some of his children.
19. Plate XXXI, *Argonauts.*
20. See also plate XLI for another in the same series.
21. Malinowski to Masson, 23 December 1917, in Wayne, *The Story,* 80–81.
22. Compare plate 22, *Sexual Life,* showing Kalogusa standing in front of the canoe; also plate XXI, *Argonauts,* with Namwanaguyau standing posed on the same canoe.
23. *Argonauts,* 149.
24. *Diary,* 218.
25. On the basis of his work in the Amphletts, Malinowski planned to write a special ethnographic Appendix to his *Kiriwina* monograph. This subsequently appeared as chapter 11 of *Argonauts.*
26. *Argonauts,* 46.
27. *Argonauts,* 267; see also plate XLII.

28. Compare to plate VII, *Argonauts*.

29. Compare to plate XLVII of *Argonauts*, showing the same canoe from a different angle.

30. *Diary*, 234.

31. See plates XLIV and XLV of *Argonauts*, captioned "Technology of Pot-Making."

32. *Argonauts*, 228.

33. *Diary*, 240.

34. *Argonauts*, 385.

35. See *Argonauts*, 381, for a timetable of these *uvalaku* events.

36. Wayne, *The Story*, 124.

37. *Diary*, 244.

38. *Argonauts*, 387; compare to plate XLVIII, taken some minutes later.

39. Compare to plate LVI (bottom), *Argonauts*. Plate XXXVIII pictures Koutauya outside his yam house.

40. *Argonauts*, 269–70.

41. Malinowski to Masson, 19 March 1918, in Wayne, *The Story*, 120.

42. Plate XX, *Argonauts*.

43. Malinowski to Masson, 10 April 1918, in Wayne, *The Story*, 124.

44. Compare to plate LV, *Argonauts*.

45. *Argonauts*, 386.

46. Malinowski to Hancock, 6 April 1918, series I: 245, Malinowski Papers, Yale.

47. *Diary*, 244–45.

48. Compare to plate LIV, *Argonauts*.

49. *Diary*, 246.

50. Malinowski to Masson, 10 April 1918, in Wayne, *The Story*, 123.

FOURTEEN

1. Most of the prints under this category have the indicative caption "Black and White" written on the reverse.

2. *Coral Gardens*, 480.

3. *Coral Gardens*, 480–81.

4. *Coral Gardens*, 479.

5. *Papua Annual Report*, 1914–15, 39.

6. Rev. J. G. Wheen, *Australian Methodist Missionary Review*, 4 March 1913, 15.

7. *Argonauts*, 302.

8. Compare to plate 24, *Sexual Life*, "The Marriage Gift Displayed," which shows another "exceptionally large" *pwatai*.

9. Wayne, *The Story,* 82. There are in the collection a number of very poor prints of what appears to be a sporting event, held at either Oiabia or Losuia, but the photographic style is distinctly un-Malinowskian.

10. *Coral Gardens,* 19.

11. Malinowski to Masson, 15 January 1918, in Wayne, *The Story,* 103–4.

12. *Coral Gardens,* 20.

13. *Diary,* 146–47.

14. Malinowski to Masson, 23 December 1917, in Wayne, *The Story,* 77.

15. Malinowski to Masson, 23 December 1917, in Wayne, *The Story,* 78.

16. *Diary,* 149.

17. *Diary,* 147. The story he refers to is probably the one concerning Marion's bewitchment when she was a little girl, and the dramatic manner of her cure, described in *Argonauts,* 243–44.

18. *Argonauts,* 243.

19. Malinowski to Masson, 3 October 1918, in Wayne, *The Story,* 174

APPENDIX 1

1. "New Guinea Invoices 1914–18," series I, box 9, file 689, Malinowski Papers, Yale. Details on the Klimax camera were provided by the National Film and Sound Archive, Canberra.

2. See Young, *Malinowski among the Magi,* 5; see also the file in the Australian Archives, "Dr. B. Malinowski: Ethnological Research Papua," CRS A1, item 1914–20, 21/866.

3. Malinowski's estimate given in the acknowledgements for *Argonauts,* page xix.

APPENDIX 2

1. Malinowski to Sinclair, 11 July 1931, correspondence boxes, folder FF, Malinowski Papers, LSE.

Index

Persons identified as informants refer to those Linus Digim'Rina consulted in his photo-interviews, not to Malinowski's informants. —M. W. Y.

dance (*continued*) drums in, 91, 93, 97; inauguration ceremony for, 93; instruction, 90; *Karibom* dance, 99; mimic dances (*Kasawaga*), 94, 95–98; mourning dance (*Vesali*), 214; purchasing dances, 90; ribald dance (*Tapioka*) 100; shield dance (*Gumagabu*) 92–93; shields (*kaidebu*), 92–93; singers for, 98; traditional dance (*Rogaewa*) 90, 91, 93

death: burial rites, 34, 215–16; food offerings, 77; of Inekoya of Oburaku, 214, 299n. 10; of Kimai, at Wakeluwa, 215; mortuary rites, 35, 79, 168, 170, 180, 211, 212, 220; return of the dead/spirits, 34, 79, 80, 89; skull caves, 225–26; taboos, 224; wealth distribution, 34–35, 211, 216–19, 221–23; —, symbolic, 224

Digimrina (informant), 23, 87

Digim'Rina, Linus, 23–24, 291n. 65

Dipapa. *See* Touluwa, son of

Dobu Islanders, 52, 113, 250, 265

dress and adornment, 103–18, 224, 254, 265; *dogadoga* necklace 103, 106, 112, 232; European clothing, 254, 265, 272, 273; maternity, 186, 187, 188; mourning, 80, 169, 181, 272; of native missionaries, 239, 266; pregnancy cloaks, 182, 185; women's skirts, 169, 173–74, 175, 178, 179, 180, 181. *See also* dancing; shell ornaments

Edwards, Elizabeth, 4, 290nn. 45, 56, 291n. 60

fireplough (*kekwila*), 158

fishing: bartering, "fish exchange" and *wasi*, 131, 138–40, 141, 142, 144, 292n. 10; canoes, 132, 133, 135, 145, 146, 147, 150, 259; —, Kula, chap. 8; magic, 127, 131; nets and baskets, 127, 134, 192, 193; smoking (*kevala*), 137; yields, 135

food distribution (*sagali*), 75, 77, 79, 80, 111, 211, 221, 271. *See also* chap. 12

games, 156, 189, 192, 196, 198–210; circle games, 199–207; cricket, 210, 298n. 17; darts, 210; hide-and-seek, 206; pantomime, 208

gardening and gardens: aesthetics, 72; children and, 76; coconut production, 82; economic-magic relationship, 71, 72; modern pride in, 71; ritual burning, 33, 73, 74; "weeding gardens," 144. *See also* garden magicians; harvest; magic

garden magicians (*towosi*): Bagidou of Omarakana, 62, 65, 67, 73; Bwaideda of Obowada, 74; Nasibowa of Kurokaywa, 75; Navavile of Oburaku, 114, 121. *See also* magic

George, Mick, 270–73

Giyomatala (informant), 23, 134, 136, 140

Haddon, Alfred Cort: ethnographic photography of, 4, 288n. 14; and naturalism, 4

Hancock, Billy: friendship with Malinowski, 15; Gusaweta property of, 15, 170, 196; chewing betel nut (photo), 55; at Gusaweta (photo), 268; with Malinowski (photo), 116; in Tukwaukwa (photo), 51; photography of, 15–16, 17, 179, 182–87, 276, 297n. 9, 298nn. 15, 17; postcard prints, 16; on pregnancy rites, 185; in Sinaketa, 53; wife of (Marion), 224, 270, 271, 272, 302n. 17

harvest: competitive (*kayasa*), 84, 86; displays, 62, 77, 78, 79, 81, 83, 85, 86; festivities, 33, 34, 62–63, 83; —, and dancing 89–100; main festival (*milamala*), 81, 87, preliminary feast (*isunapula*), 78, 121. *See also* gardening

houses: in the Amphletts, 246; of chiefs' wives, 195; construction of, 156, 159; interior of, 160; postcontact, 155, 177; traditional, 154, 155, 159, 297n. 3

Itirikibi (informant), 23

Jenness, Diamond, 43, 101, 290n. 59

Kalogusa. *See* Touluwa, son of

Kanukubusi (war magician of Kwebwaga), 123–24

Kiriwinan (language), 29

Kitava Island, 115, 238

Kula: canoes, and cargo, 247, 255–57; —, preparing, 233, 238; —, Touluwa's, *Nigada Buwa*, 233, 238, 239–43, 248; ceremonies, 230, 239; —, *vatai*, 253; Dobuan fleet, 250–61; Kouyaporu of Tu'utauna (trader), 251, 252; as male activity, 228; Malinowski reference about, 300n. 2; and sailing, 32, 227–28, 249–50, 251; —, ceremonial (*uvalaku*), 233; —, racing, 239, 242; sail making, 233–37; Tovasana of Nuagasi (trader), 251, 252

Kwainama (subclan), 90, 104

Kwewaya, Chief (informant), 23, 122, 199; house of, 57

limepots, 55, 87, 112, 160, 230

Losuia station (Government Station; Kebutu), 49

magic: of abundance (*vilamalia*), 114, 130, 229; beauty magic, 122, 163, 183, 187; ceremonies and gardening, 72, 74–75, 77, 83; coral mounds, 130, 229; fishing magic, 127–28; matrilineal transmission of, 119; pregnancy magic, 183–87; rain magic, 125; sorcery, 34, 120; —, protection from, 188, 297n. 3 (chap. 9); spells, traditional, 119, 120, 128, 239; spirits, of the dead (*baloma*), 34, 79; war magic (*boma*), 123, 124; yam poles (*kamkokola*), 74–75. *See also* garden magicians; sorcerers

Makambo (Burns Philp Company ship), 41

Malinowski, Bronislaw Kasper (1884–1942): as collector, 8, 92; commemoration by Trobrianders, 3; in Ceylon, 12; as diarist, 14, 288n. 18; doctoral dissertation, 2, 20; education and early career,

2–3, 12; fiancée of (Elsie Masson), 4; —, correspondence with, 39, 45, 53, 60, 135, 213, 227, 241, 252, 273, 288n. 10, 291n. 66; on Gumawana Island, 246; *Kiriwina* (unfinished monograph), 25, 47, 263, 291n. 66, 300n. 25; on language, 290n. 57; in Melbourne (Australia), 3, 11, 12, 25; myths about, heroic "euhemerist," 3, 27; on Nabwageta Island, 250; nicknames, Trobriand, 3; photographs of, 115–16, 191; —, about, 47; —, by Hancock 52–57; publications, 287n. 8, 289n. 35; on Samarai Island. *See* Samarai Island; on Sanaroa Island, 245; sexuality, 163–64; social anthropology, founder of, 2, 288n. 13; and Spencer, Baldwin, 11, 289n. 33, 291n. 59; and Stirling, Edward, 10, 252; and Stirling, Nina, 10, 214, 252; and Trobriands, 1

Malinowski, fieldwork of, 2; confrontational style, 18; diaries, 8, 22, 60, 288nn. 18, 19; fieldnotes, accuracy of, 25; —, extract of, 143; —, music notation in, 89; —, recording of dance movements, 89; functionalism of, 8; intimate style of, 54; *The Natives of Mailu* (first fieldwork monograph), 10; in Omarakana, 22, 59; Papua expeditions, 3; and photographs, as "control," 8

Malinowski, as photographer: accounts of influences on, 288n. 15; ambivalence to photography, 2, 4, 5–6, 7, 20, 250, 289n. 24, 290n. 45; appraisals of, 4–5; —, self-appraisal, 7; budget, photographic, 7, 276; ethnographic recording, 2; Haddon, A. C., influence of , 4; Hancock, Billy, influence of, 2, 15; Mailu photographs, 10; —, lost, 21; as photonarrator, 1, 5; reflective approach of, 4; Spencer, Baldwin, influence of, 11; Stirling, Nina, influence of, 10; strategies of, 8; Witkiewicz, Stanisław, influence of, 2, 11, 13

Malinowski, photography by: characteristics of, general, 16–17; contextual content of, 18–19, 20; documentation, lack of, 7, 22, 26; equipment, 275–76; flaws in, technical, 21; functionalism in, 19–20; horizontal framing of, 17, 290n. 56; minimizing fragmentation, 20, 290n. 45; landscapes, 16; portraits, 14, 17, 19; posed photographs, 17, 21; realism of, scientific and indexical style, 14, 16; sequencing in, 17

Malinowski, research methods of: anthropometry, rejection of, 4; "control" (data validation), 25; data collection, 47; ethnographic generalization, 25; ethnography, 3, 27; itinerant village census, 53; participant observation, 3, 288n. 16, 289n. 33; prisoner informants, at Samarai, 43; as revolutionary, 3; vernacular, use of, 3

Malinowski, Trobriand photographs by: arrangement of collection, by Malinowski, 22, 277–78; Linus Digim'Rina, photo-interviews by, 23–24, informants from Okebama, Omarakana, Teyava, and Tukwaukwa, 23; notes, from Malinowski's diaries, fieldnotes, letters, 26; selection methods, of M. Young, 21–22

Mitakata, 50, 60–61, 64, 68, 69, 78, 213, 268, 293n. 17; as informant, 79; wife of (Orayayse), 69

Mosiribu (chief of Tukwaukwa), 78

Mwedeli. *See* Touluwa, son of

mythology: origin myths, 126; Tudava, hero of, 3, 128, 288n. 9

Namwanaguyau. *See* Touluwa, son of

Numakala (chief of Oluvilevi), 226

photographs: Edwards, Elizabeth on, 291n. 60; exploitative potential of, 102; as historical moments, 26; meanings of, implicit, 26; as photo-narrative, 26; as virtual witness, 291n. 60

"physical type": and district, 102, 112; of Europeans, according to Trobrianders 116–17; family resemblance, 110; height, 106; as photographic genre, 101; and rank, 102; variation in Trobriands, 102

pigs, 217, 218, 221, 230

Pinney, Christopher, 16, 289n. 29

pottery, 248, 260

Pulayasi, Chief Daniel (informant), 23, 62, 75, 80, 215, 236; on magic, 123, 130; on skull caves, 226; on Touluwa, 242; on yam houses, 67

ringworm, 260

rope making, 161

Samain, Étienne, 5

Samarai Island: Campbell's Walk, 44; in China Strait, 40, 45; colonial port, 37; colors and beauty of, 38, 39, 40, 44; prisoner laborers, as informants, 43; wharf at, 41

Saville, W. J. V., 10, 14

Seligman, Charles G.: fieldwork, Trobriand, 71; as Malinowski's supervisor and mentor, 2, 6–7, 9, 275; photography of, 289n. 29

sexuality: in dancing, 100; courting expeditions, 99, 133; ribaldry, 176, 200; sexual mimicry, 158; women's, 144, 163

shell exchange. *See* Kula

shell ornaments: armshells (*mwali*), 229, 231; headband (*sedabala*), 232; necklace (*solava*), 54, 56, 80, 230, 231; waistbelt (*wakala*), 103, 232, 268

sorcerers: Pilibomatu of Kwebwaga, 90; Toguguwa of Tukwaukwa, 122; —, wife of (Ibo'umli), 122. *See also* magic

Spencer, Baldwin, 11, 289n. 33, 291n. 59

Stocking, George W. Jr, 50

Tabalu (chiefly subclan), 59, 104, 106, 107, 112, 225–26